PRAISE FOR BOB ROSS

"I love Bob because he was sincere."
—KENNY SCHARF, artist

"Bob Ross represents the kitsch that is America, and in so doing became the everyman's Sunday painter. He took art to the masses, and like Andy Warhol, was set on the democratization of imagery. Both Bob and Andy became just as recognizable as the art they produced, and I dare say that their hair had a bit in common as well: big and bold."
—ERIC C. SHINER, director of the Andy Warhol Museum

"Even now, years after his death in 1995 . . . Bob Ross may still be the most famous artist on the face of the earth. . . . His purpose was as much to massage souls as it was to teach painting."
—MICHAEL KIMMELMAN, author and art critic for the *New York Times*

"Paintings should always be magic and there was a moment in any of the Bob Ross TV shows where something appeared from nothing and that was like pure thrilling magic—plus he had the most consistently relaxing voice to nap to; when he was dabbing one could doze perfectly and dream well."
—BILL ARNING, executive director at the Contemporary Arts Museum Houston

"Bob acted like what he did was super simple and made you think that anyone could do it. He was a holy man."
—LARRY "MO" VIOLETT, agricultural inspector and artist wanna-be

"Bob Ross, with his awesome Afro, snowcapped mountains and 'magic white,' will live on forever in my memory."
—CHARLES M. BLOW, visual op-ed columnist for the *New York Times*

"Thanks to Bob Ross, I met lots of new friends and learned the joy that showing someone how to paint in this basic wet on wet oil painting style . . . brings."
—DAVY TURNER, the Painterman and retired utility company worker

"Bob Ross was the first man to softly sensualize nature for me. Every time he asked me if I could feel the soft mountain tops or the wispy clouds, I felt soothed by him and I could feel them all, the purple and red mountain ranges, the chartreuse clouds, the hot pink trees with the dark orange shadows."

—KIM HOLLEMAN, artist and creator of *Trailer Park: A Living Mobile Public Park in a Trailer (If you can't go to the park, this park can go to you!)*

"I'm sure most of us visual artists, a generation of artists in fact, were in some way, large or small, influenced in our formative years by this iconic pop-artist."

—AARON JASINSKI, artist, quote from http://screamingskygallery.com/index .php?id=220

"Probably without even knowing it, Bob Ross was a model for art as a therapy. Ross encouraged the viewers, with an attitude of 'you can do this too,' allowing the viewer to feel that they too can be an artist."

—MELISSA DIAZ, art therapist and installation artist

"I remember watching *The Joy of Painting* as a teenager. Bob Ross gave me the confidence to study art and pursue it as a viable career. He was the master of his technique and made painting look easy."

—PETE HALVERSON, book designer and artist

HAPPY CLOUDS, HAPPY TREES

HAPPY CLOUDS, HAPPY TREES

The Bob Ross Phenomenon

Kristin G. Congdon, Doug Blandy,

and Danny Coeyman

University Press of Mississippi ❦ Jackson

www.upress.state.ms.us

Designed by Peter D. Halverson

The University Press of Mississippi is a member of the Association of American University Presses.

First printing 2014

∞

Library of Congress Cataloging-in-Publication Data

Congdon, Kristin G.
Happy clouds, happy trees : the Bob Ross phenomenon / Kristin G. Congdon, Doug Blandy, and Danny Coeyman.
pages cm
Includes bibliographical references and index.
ISBN 978-1-61703-995-9 (cloth : alk. paper) — ISBN 978-1-61703-996-6 (ebook) 1. Ross, Bob, 1942–1995—Psychology. 2. Ross, Bob, 1942–1995—Appreciation. 3. Art teachers—United States—Psychology. 4. Artists—United States—Psychology. 5. Art and society—United States—History—20th century. I. Title.
N89.2.R67C66 2014
759.13—dc23 2013033562

British Library Cataloging-in-Publication Data available

To all those who dare to paint

And to Bob, with thanks

CONTENTS

ACKNOWLEDGMENTS

This book has been a joy to write. It started as an idea in 2004 and grew from there. When we first discussed the idea with Craig Gill from the University Press of Mississippi, he expressed his support and enthusiasm. Our sincere gratitude goes to Craig Gill and Anne Stascavage at the press and to Karen Johnson for her astute copyediting. Thanks to Karen Keifer-Boyd, who used the Internet to publicize our presentation (Congdon and Blandy's), "The Bob Ross Phenomena," at the 2005 National Art Education Association Conference. From her posting, we met Davy Turner, the "Painterman," a Bob Ross fan from England, who patiently encouraged us to finish this project as he continuously fed us useful information. We salute you Davy. We thank others who have openly expressed their admiration for Bob Ross and their experiences with him: June Wozniak, Dave Wenzel, Doris Young, Scot Kaplan, and Aaron Jasinski.

We also appreciate those who have given us permission to reproduce images: The Andy Warhol Foundation, Scott Guion, Betty Ford-Smith, Aaron Jasinski, and Davy Turner.

We would also like to express our personal thanks to several individuals in our lives who have offered us inspiration and support:

From Kristin G. Congdon: My sincere appreciation and love goes to my husband, David Congdon, who helped me play with ideas expressed in this book and picked up so many of my everyday responsibilities when I was busy writing. I also credit Stephen Goranson, a librarian at Duke University, who often quickly checked facts and helped with details. Thanks, brother. Thanks to my sister Zoe Goranson and her husband, Tom Fisher, who made the connection with June Wozniak and encouraged her to speak with me. And to other friends, family members, and

students who took the time to explore Bob Ross, sharing in his joy, you have my gratitude.

From Doug Blandy: I am grateful to the graduate students and faculty associated with the Arts Administration and Folklore Programs at the University of Oregon who either shared in my curiosity about Bob Ross and the phenomenon that he inspired or provided valuable insights into how to approach the phenomenon. I also acknowledge the importance of my mother, Lula Blandy, in cultivating in me a love and appreciation for popular culture in its many and varied manifestations. The loving support of my wife, Linda Beal Blandy, sustains me through the commitments necessary to completing projects such as this one. For this support I am grateful.

From Danny Coeyman: Love and thanks to my family for buying that first Bob Ross painting kit so many Christmases ago. And thanks to my extended family of friends and creatives who are shaping this world with their vision. Thanks especially to John Scarboro and Kate Fauvell. You two are my sounding boards, co-conspirators, and inspiration. Without you no art and no book would exist.

HAPPY CLOUDS, HAPPY TREES

bob

name (Bob), noun (bob), verb (bob, bob·bing)

1. short for Robert
2. the first name that comes to mind when people are trying to think of names
3. a short, jerky motion
4. a style of short haircut for women and children
5. a dangling or terminal object, as the weight on a pendulum or a plumb line
6. a tap; light blow
7. to move quickly up and down
8. to tap; strike lightly

ross

adjective (ross·er, ross·ome), noun (ross·ity, ross·ness)

1. of or pertaining to something, that, by the carefully judged standards of a select few individuals, is very cool and awesome
2. when something is straight awesome to the Max

Bob like Kosuth, by Danny Coeyman

— 1 —

INTRODUCTION

The Bob Ross Phenomenon

Bob Ross was a man of many contradictions. He's famous, but few know him by name. Show someone a picture of this man with the trademark Afro and house-painting brush, and then they are likely to smile with nostalgia. On TV he emoted a rural naiveté and spoke about happy clouds and happy trees, which he simultaneously marketed to his fans from the helm of a multimillion-dollar company. He was, according to many, a mediocre painter, and yet as an artist he seems endlessly fascinating. And although his physical body has left this world, Bob Ross's presence around the world has only increased.

He was a prolific painter, completing thirty thousand paintings during his lifetime (Kimmelman 2005, 37–38). He acted, and through his television shows continues to act, as a teacher and as a quasi therapist, slowing us down and helping us pay attention to the better things in our lives. Additionally, Bob Ross wishes us to believe that we can all be artists. This democratization of the artist as every person, or the idea of the "artist within," is a notion that ebbs and flows throughout modern history. While it is easy enough to find people who dislike and trivialize Bob Ross's paintings, it is rare to find someone who dislikes Bob Ross, the man, or Bob Ross as personified in his tele-teaching. Can Bob Ross the person exist apart from his work? Can any artist?

Bob Ross was and continues to be a celebrity despite his death from cancer on July 4, 1995. New York art critic Michael Kimmelman (2005) describes how Bob became such a notable artist:

Ross marketed the "wet-on-wet" technique, cultivated under the tutelage of William Alexander, who, in a Shakespearian twist, became his main competitor as a TV painter. By gently wiggling one of his two-inch brushes slathered in a mixture of his blue, green, blacks, crimson paints, Ross confected an evergreen tree in less than a minute for viewers. He used wide house-painting-type brushes with a slick liquid base coat, and also showed how to make "clouds, mountains, trees and water appear in seconds. . . . No previous experience of any kind is required." (36–37)

Although the artist/therapist has long passed away, his message prevails and his stardom continues to grow. His landscape paintings, as many critics have noted, may be cliché (trees on one side, mountains on the other, with a glimmering lake in the middle), but they clearly engage millions of art lovers from all walks of life. Bob's compelling personality has motivated untold numbers of painters, but his reach extends beyond the canvas and brush. His inspirational, quiet speech calms and encourages even the most disheartened amongst us. His love of animals charms viewers from all ages and walks of life. He also inspired an all-girl German band named Hello Bob Ross Superstar, and the Dutch named an amaryllis after him (Kimmelman 2005, 42). His work continues to be celebrated in many ways, as clubs form around his teachings and devotees gather in his name. T-shirts echo his famous sayings, and Internet memes playfully poke fun at his soothing aphorisms.

Individuals who actively participate in the Bob Ross art process quickly identify themselves as Bob Ross practitioners, paying homage to their honored teacher. In doing so, they take on an identity and a community membership. Richard Florida, who writes about social and economic theory, claims that this way of thinking about oneself is part of a new wave of identity, one in which individuals "define themselves both by the creative content of their work and their lifestyle interests" (2002, 114) as opposed to what they do during their work time. This approach to creating an identity is increasingly becoming apparent. For example, ZZ Packer (2012) reports that people in Austin, Texas, see their real work as something other than being a coffee shop barista, a doctor, or a lawyer. Instead, they talk about their creative activities, such as their involvement with music or their unpublished novel. People who paint using the Bob Ross method are Bob Ross painters. They connect with him, for more reasons than just the production of a painting.

This book is about Bob Ross, his life, and the myths surrounding him. It is also about the ways in which his teachings and his artwork fit (or don't fit) into the landscape of the Art World. Bob Ross has come to mean more than what is communicated through the many publications of Bob Ross, Inc. Bob Ross has become a worldwide cultural phenomenon, inspiring a multiplicity of uncontrollable cultural reactions. The purpose of this book is to address the Bob Ross phenomena in an extended manner—beyond the happy marketing of the step-by-step painting books and the carefully controlled image of Bob Ross by Bob Ross, Inc.

The marketed version of Bob Ross is a simplistic one: a happy man on a generous mission of joy. On the back page of *The Best of Joy of Painting with Bob Ross, America's Favorite Art Instructor*, author and Bob Ross business partner Annette Kowalski writes that Bob's life "is truly an American success story" (1989, 256). Kowalski reports that his mother taught him to love nature and that his father was a carpenter. Bob Ross is described as serving in the military, confirming a connection with American patriotism. Less accessible is information on Bob Ross's personal life, such as details about his marriages and children. Bob Ross's struggles with illness are rarely shared, and details associated with Bob Ross, Inc., and Bob Ross's relationship with Kowalski are largely unknown beyond that they were friends and business partners.

What we do know from working on this book is that Bob was a generous man. He was, his sister-in-law June Woznick informs us, the same man you saw on television, kind and loving. The messages he gave to others on his television shows were sincere; he really wanted others to experience great pleasure in painting, just as he did.

Bob Ross, like many celebrities, is a brand, copyrighted and trademarked. As a celebrity he, his image, his teaching method, his art, and the art supplies associated with his name are legally protected and the property of Bob Ross, Inc., a company he helped form. Because Bob Ross has become an international cultural phenomenon, an uneasy relationship exists between those many participating and feeding the phenomenon and the sense of stewardship felt by those associated with Bob Ross, Inc. Bob Ross was a generous man, able to instill a sense of loyalty in those who encountered him. For those who feel a personal relationship to Bob Ross, it is difficult to reconcile the restraints imposed on the expression of that personal relationship with the legal protections freely exercised by the corporation with an economic and personal stake in Bob Ross and the promulgation of his image.

As authors of this book, we take seriously our responsibility to tell the story of Bob Ross in the most comprehensive way possible; but in no way is this book an "authorized" exploration of the Bob Ross phenomenon. Bob Ross, Inc., is very protective of all their intellectual property—trademarks, television series, books, DVDs, and websites. While respecting the legal boundaries outlined by Bob Ross, Inc., our approach is that Bob Ross is a celebrity, much like Elvis Presley, who can fairly be written about by anyone. Aspects of the Bob Ross phenomenon are clearly in the public domain. Although we originally intended to reproduce paintings by Bob Ross in this book (several contacts offered us images of ones they owned), we recognize that this act might be seen as an infringement on Bob Ross, Inc. Consequently, many of the paintings that illustrate this book are by Danny Coeyman, painting at the instruction of Bob Ross. These book paintings are as close to the works of Bob Ross as Coeyman could make them. This is clearly in keeping with the Bob Ross's teachings on his television show. Readers should know that Danny Coeyman is an artist (inspired by Bob) with an MFA from Parsons, the New School for Design, in New York City. He can paint like Bob and he can paint like Danny. For the purposes of this book, he has painted as Bob Ross instructed him to.

Just as the paintings are facsimiles of Bob Ross paintings, truth in the reproduction of an idea and an emotion, the text is also about an understanding we have of Bob Ross and his life. If we had wanted to write an accurate biographical book on Bob Ross, that goal would be difficult to accomplish. When we started research on Bob Ross in the early 2000s, we quickly found that interviews with people who knew and worked with Bob Ross were hard to establish. One devotee who tried to set up a Bob Ross club in the United Kingdom received a cease and desist letter from an attorney associated with Bob Ross, Inc. An interview with this painter, Davy Turner, is detailed in chapter 8, "The Bob Ross Network." The only person who actually knew Bob Ross and was willing to speak with us was June Wozniak, Bob's sister-in-law from his second marriage.

But no one person or group owns the memory or legacy of any public individual. Bob Ross lives on. It is this Bob Ross that we write about, the one that is loved and emulated all around the world. It is this Bob Ross who intrigues and delights us, along with so many millions of other people from varying walks of life. In our experience, many of these people may not readily recognize the name Bob Ross, but they do know of the "Happy Painter" with the Afro hairstyle who continues to charm the

world through his PBS television shows, teaching us that we can all succeed as painters. And they seem to know his message that anyone can learn to paint and that as we learn to create, we can also love animals, fix our mistakes, and become overall better people.

Regardless of his vast popularity, or maybe because of it, Bob Ross troubles many artists, critics, and collectors in the Art World. (We have used the capitalization of this phrase to indicate the elite world of art museums and galleries, academic art schools, and glossy art magazines. The terms "Art History," "Art Cannon," and "Art Theory" follow suit.) This book analyzes the many responses to Bob Ross and his work, while trying to make sense of how we understand art (or perhaps Art, with a capital *A*) as we search for a satisfied and meaningful life in this increasingly global world. We believe Bob Ross, the artist and man, would be grateful for the attention and analysis. Even though Bob taught a particular way of approaching a canvas, he encouraged multiple viewpoints and inclusiveness. In this way, we seek to honor his teachings.

In referring to the artist, we use his full name, Bob Ross, his last name, Ross, and his first name, Bob. At times it seems most appropriate to name him as Bob Ross when speaking about his legend and his legacy. However, because he was such an approachable individual, and someone we welcomed into our homes on our television sets, it sometimes only seems right to refer to him by his first name alone. Occasionally, we use both ways of addressing him so as not to seem too repetitive. We also write about Bob Ross in the present tense in this book since we see him as being "alive" as most of us know him—living on in his television shows, his paintings, and the teachings that continue to spread across the globe. Like Elvis Presley, in many respects, we understand that he is clearly not dead. By using this active way of understanding Bob Ross, we hope that readers will engage with him as he and his work continue to grow and function in our lives. We agree with Nicolas Bourriaud that "when the aesthetic discussion [evolves], the status of the form evolves along with it" (2002, 21). In this way, we hope that many in the Art World who have dismissed him as an artist will reconsider his contributions in a new light. And for all those who fearlessly commit to a love of this man and what he did for art and artists, we invite you to join us in celebrating his legacy.

Doing research on a cultural sensation such as the Bob Ross phenomenon requires multiple approaches. For the purposes of this project we used fieldwork and research methods associated with folklore, art criticism, and cultural and material culture studies. Primary sources were used to the greatest extent possible. This was particularly difficult when researching the details associated with Bob Ross's life and death because of limited access to the people or archives associated with Bob Ross, Inc. In addition, because of the impossibility of reproducing paintings by Bob Ross, this project used an arts-based research method through the paintings produced by Danny Coeyman as he followed a Bob Ross instructional video. Coeyman and others also produced additional visual interpretations of the Bob Ross phenomenon.

Early in our research we encountered many varied and conflicting facts and stories about Bob Ross's life. There is no critical biography to turn to, and the story of his life is largely told through the newsletter and website of Bob Ross, Inc., as well as information circulating among Bob Ross fans. For a man so well known to so many this lack of information is surprising.

Important to describing the Bob Ross phenomenon is crafting to the greatest extent possible a chronology of his life as based on the most credible information available. It is from this life that the phenomenon emanates. Chapter 2, "Bob Ross, Birth to Death," does that. Of great assistance was the biopic *Bob Ross: The Happy Painter*, produced in cooperation with Bob Ross, Inc. This biopic, coupled with other information corroborated through reliable sources, responds to questions associated with Bob Ross's life before he took up painting. Who were his primary influences? What was his personality on and off screen? What about the genesis of Bob Ross, Inc., and the circumstances of his death at a fairly early age?

Chapter 3, "Promising Joy: Bob Ross as Artist and Teacher," recognizes Bob Ross and his method for teaching oil painting that captivated an international audience. The instructional method is based on his own artistry, with paintings by Bob Ross numbering in the tens of thousands. Primarily known as a landscape painter, the artist depicted in oils nature as unspoiled and uninhabited.

Landscape painting is ubiquitous in American art with many approaches evident. Understanding Bob Ross's relationship to landscape painting encourages questions such as the following: Among American landscape painters, where does Bob Ross and his work reside? What new

and/or traditional techniques did Bob Ross bring to landscape painting? What philosophical orientation to the landscape characterizes his approach to the genre? What is the relationship between his own approach to landscape painting and the method he developed to teach it to others? In association with the commercial enterprise Bob Ross, Inc., Bob Ross also developed a certification program so that others could make landscape painting accessible. What is the experience of learning from a Bob Ross–certified instructor? Beyond learning Bob Ross's oil painting method and viewing his paintings, are there other benefits associated with his art, artistry, and teaching?

Bob Ross's healing effect is explored in chapter 4, "Bob Ross as Shaman." Here, Bob's uncanny ability to help people control their own worlds is made visible. In a yoga-class-like manner, he teaches us to become our own teachers. In this chapter correlations are drawn to other artists in the Art World who have helped heal through art.

Bob Ross and Bob Ross, Inc., understood how to promote Bob Ross the artist and Bob Ross the brand. Chapter 5, "Bob Ross as Media Star," analyzes this part of the phenomenon as Bob's humble and affable personality was quickly and effectively translated into a multimedia strategy used to promote his personage while simultaneously promoting the educational experiences and merchandise associated with the man. They also understood the importance of using specific types of media and licensing his image to a variety of commercial interests for reaching different audiences. The results of their success in crafting Bob Ross as a cultural icon quickly led to the public embracing the iconography for themselves. This resulted in a plethora of fan-based cultural expressions across multiple media. Important to understanding Bob Ross as a "media star" is understanding how Bob Ross and Bob Ross, Inc., crafted his image. What were the initial efforts by the man and his company in this regard? What media outlets were used to cultivate popular appeal? How was it possible to appeal to both young people and adults? What is the significance of the Internet to making Bob Ross a media star?

Learning to make and appreciate art is possible within a wide range of formal and informal venues. Chapter 6, "Bob Ross as the Best-Known Teacher 'Alive,'" addresses the artist's approach to teaching. Unique among art educators in that he, as well as Bob Ross–certified instructors, can be associated with many of these possibilities that are both commercial and noncommercial. What is it that Bob Ross brings to teaching so that it can be experienced so broadly? While his instructional method

promotes skill building, his students claim that participating in the method results in so much more. As such, how does Bob Ross compare with other notable and inspiring educators who have captured the public's attention? While he is loved by so many, there are those who are critical of his methods. What is the source of that criticism? Does such criticism have validity or is it based on a limited perspective on what art education is and should be?

Chapter 7, "Assessing Bob Ross's Paintings and His Approach to Art," looks at numerous contemporary artists and the theoretical approaches that underlie their work in relationship to Bob Ross. His work, in a holistic manner, is compared to the work of artists such as Peter Greenway, Bob Dylan, George Condo, Sherrie Levine, Maria Abramovic, and the Highwaymen, Florida's African American landscape painters. Current topics of exploration include ideas about amateur art, imitation and copying, boredom, seduction, democracy, sentimentality, and the ever-changing and ubiquitous subject of the landscape in art. Finally, the question is raised as to whether Bob Ross should be viewed as a painter or a performer. Numerous scholars and art critics add to the conversation.

The Bob Ross Art Workshop, located in New Smyrna Beach, Florida, is the epicenter of a vast network comprising the Bob Ross phenomenon. It is here that the largest number of Bob Ross paintings may be on public view. The workshop is also a major location for training as a Bob Ross–certified instructor. It is also a place to take classes and purchase Bob Ross merchandise. This is but one aspect of the Bob Ross phenomenon that is discussed in chapter 8, "The Bob Ross Network."

Experiencing Bob Ross at the workshop is only suggestive of the vastness of the Bob Ross network and the interests associated with the network. This is a network that includes the careful stewardship of Bob Ross by Bob Ross, Inc., but also by those many teachers, students, and fans who have made Bob Ross their own. By making Bob Ross their own, students and fans feed and enrich the larger phenomenon. Who are those members of the network that operate independent of Bob Ross, Inc.? How do these people experience Bob Ross and then translate that experience for others? Are there theoretical perspectives that can help us understand the multiple and competing interests within the network? What competing individual and collective interests circulate within this network, and is it possible for these competing interests to coexist in a way that honors Bob Ross the man?

The relationship between Bob Ross and Andy Warhol is explored in chapter 9, "Bob and Andy." When Andy Warhol successfully brought Pop to the Art World, he gave artists permission to be entrepreneurs, to engage the everyday with sophistication, and to craft themselves into personalities. His influence champions some of the same themes in Bob's work, but each spoke to very different audiences. This chapter traces Bob's identification with the middle class as the reason he distanced himself from the Art World, and why he is ignored by it today.

Some people compare or confuse Bob Ross with Thomas Kinkade. Consequently, we have added chapter 10, "Thomas Kinkade is No Bob Ross," to make sure there is no confusion. Like Warhol and Ross, Kinkade used bright colors and savvy marketing to share his vision of an America renewed by Christian values and simpler living. At first glance, these two artists seem kindred. But Kinkade's idealizations of real estate on private land are based in vastly different ideas about good living and who gets to own it. This chapter pieces together the decline of Kinkade's life and company and describes Kinkade's use of real estate and fine art to market his brand as a status symbol, while Bob featured imagery of undeveloped nature and gift-giving to share his message

Chapter 11, "The Art World in the Midst of Bob Ross," further evaluates Bob's place in the contemporary Art World with regard to art (and Art) movements. We first look at art pranking and establish how this book might fit into a prank. We then explore the decentralization of art as it becomes more democratic, enticing the audience to participate in artworks as artists. This mixing of roles and redistribution of power is further developed in the section on relational art and aesthetics. The chapter ends with a discussion of two important movements in relationship to Bob Ross: DIY (do-it-yourself) and the Arts and Crafts movement.

Chapter 12, "Bob Ross's Legacy," is primarily a summary of what we have explored in this book. We know that people have an interest in the artist and the man Bob Ross. Our goal has been to show why Bob is more than merely interesting. Instead, we claim that he is a steward of nature, a healer, a democratic builder of communities, and a magnetic teacher. We also demonstrate that Bob's ideas and efforts cannot be contained, for that's the way gift giving works. After all, his gifts are gifts of joy.

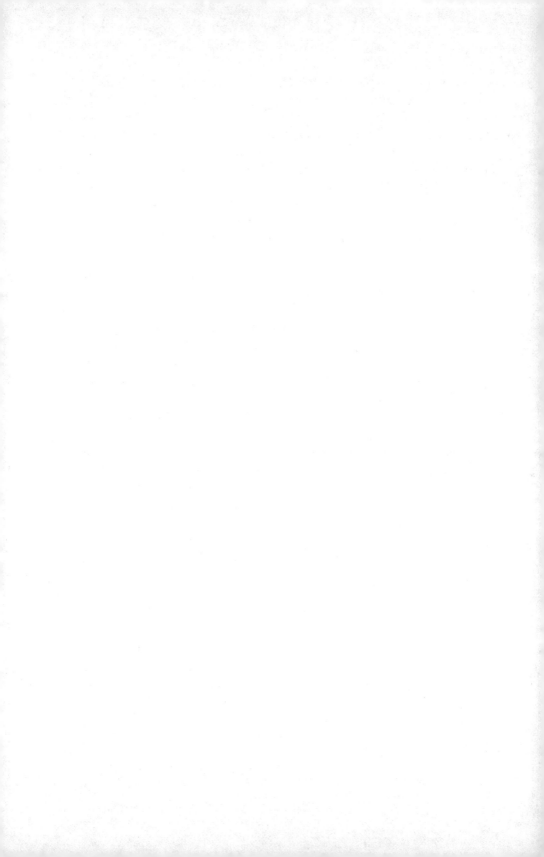

THE LIFE AND TIMES OF BOB ROSS

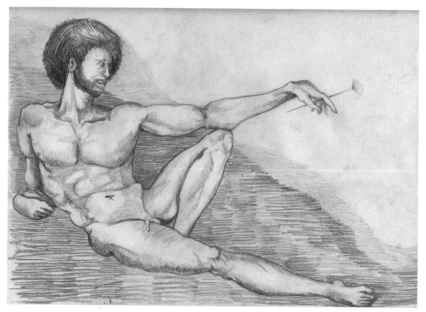

Bob like Michelangelo, by Danny Coeyman

ROB ROSS, BIRTH TO DEATH

Fairbanks, Alaska, is located in the Tanana Valley and bordered by the White Mountains and with the snow-capped Alaska Range in site. In the early 1960s, it had a population of around thirteen thousand residents, augmented by tourists on their way to the wilderness or to see the remnants of the area's past gold rush. An affable, part-time, six foot two inch (IMDb 2013) bartender named Bob Ross might have served visitors in a local tavern. Ross, who joined the US Air Force in Florida at the age of eighteen, was not only a bartender, but a medical records technician at the Eielson Air Force Base, about twenty miles outside of Fairbanks. He had taken painting classes locally and was known in the tavern as a painter of Alaska's mountainous landscape. Along with the drinks he served he might also have sold a gold miner's pan with a landscape painting on it. It was on one of the tavern's televisions that Ross saw William Alexander's (1981) popular television show on how to paint landscapes (*Bob Ross: The Happy Painter* 2011). Shortly thereafter, Ross left Alaska to work with Alexander and launch his career as Bob Ross the painter, achieving international fame as a teacher, landscape painter, and public television personality.

Conceptualizing a Biography of Bob Ross

Despite Bob Ross's international fame, no comprehensive critical biography with substantiated facts from primary sources exists. It is as if Bob Ross lives outside of any larger artistic, educational, or entertainment context. Instead, the Bob Ross story is told through word of mouth, narratives recorded in fanzines, posts on message boards, blogs, Internet

tribute pages, obituaries, feature stories in the popular press, *Wikipedia* entries, and Bob Ross, Inc., publications. Bob Ross's "official" and "corporate" story continues to be written by his business partner and friend Annette Kowalski and has been published in *Brush Strokes: The Official Publication of the TV Art Club*, a bimonthly distributed by Bob Ross, Inc. In addition, Bob Ross, Inc., also includes an "About" Bob Ross section on its website at http://www.bobross.com/index.cfm.

Until recently what is known about Bob Ross could only be synthesized from the myriad, often conflicting, sources described above. This lack of vetted historical information has contributed to the Bob Ross story being best experienced as legend. While known as a historical personage, Ross primarily exists as a legend akin to what is associated with people like Elvis Presley, Ram Dass, Selena, and Frida Kahlo. Like all these individuals, Ross is credited with changing and saving people's lives in time of despair and tragedy through his art, his educational method, and his presence (both in person and as documented on video). Numerous unsubstantiated and conflicting stories about his upbringing, personal life, and professional life continue to circulate.

Recently, an Emmy Award–nominated documentary, *Bob Ross: The Happy Painter*, directed by Sherry Spradlin, produced in conjunction with Blue Ridge PBS, and with the cooperation of Bob Ross's business partners Annette and Walt Kowalski, was broadcast through Blue Ridge PBS. It is available through this PBS affiliate to those who pledge $200 or more to Blue Ridge PBS as a gift. This biopic includes interviews with Ross's business partners, family members, business associates, friends, and others, including celebrities, who knew Ross, learned the Bob Ross method of painting, and/or are appreciators of his artistry. While not constituting a critical biography, to some extent this biopic must be perceived as "authorized" because of the cooperation of Ross's business partners. Additionally, it permits access to primary source material that can be used to piece together Ross's personal and professional life. *Bob Ross: The Happy Painter*, coupled with Kowalski's articles in *Brush Strokes*, provides a much-needed historical context from those who knew him, allowing for an understanding of the man that is distinct from his legend.

Early Years

Robert (Bob) Norman Ross was born in Daytona Beach, Florida, on October 29, 1942, to Jack and Ollie Ross. A number of websites note that his paternal ancestry includes members of the Cherokee Nation (see, for example, *Native American Projects: Cherokee Tribe* at http://nativeamerican.lostsoulsgenealogy.com/cherokee/cherokee.htm). Much of Bob's childhood was spent in the Orlando, Florida, area. These were the years prior to Orlando having an international airport, the opening of the Disney World Resort in 1971, and the downtown redevelopment projects of the early 1970s.

Jack Ross worked as a carpenter and a builder. Ollie Ross worked at various times as a clerk and waitress. They divorced when Bob was a year and a half old. At some later time, after other marriages by each, they remarried. During one of those remarriages Bob found himself with a half brother named Jim (Bob Ross 2013). Jack and Bob stayed in contact, and while in his teens Bob worked with his father as a carpenter. While doing carpentry he lost a finger. Jack died at the age of fifty, shortly after remarrying Ollie (Kowalski 1999a). From his mother, Ollie, Bob learned a love and respect of wildlife. Purported pets include a snake, alligator, and armadillo. Bob's love of animals continued throughout his life, and at one point he had a pet squirrel named Peapod that would accompany him to the taping of his television shows (*Bob Ross: The Happy Painter* 2011).

Bob dropped out of school in the ninth grade, when he began supporting himself through carpentry. Around 1960 Bob joined the US Air Force in Florida, with an eventual transfer to Alaska two to three years later. Bob was first married to a woman named Lydia or Lynda Brown (IMDb 2013) and had two sons, Bob and Steven (Bob Ross 2013). Lydia (or Lynda) and Bob were divorced in 1981 (IMDb 2013). When Bob left for Alaska, his son Steve moved with him (*Bob Ross: The Happy Painter* 2011). Bob's first wife retained custody of the younger Bob (Bob Ross 2013).

While Bob and Steve were living in the Fairbanks area, Bob met and married Jane (*Bob Ross: The Happy Painter* 2011). Jane held a government job, possibly as a member of the Air Force (June Wozniak, personal communication, November 13, 2012). To augment his Air Force pay, Bob took a job as a bartender and sold his landscape paintings to tourists. Seeing William Alexander's television show in his workplace tavern inspired Bob to connect with Alexander and learn the Alexander method of painting.

Bob Ross Commits to Art

In the 1960s William Alexander (1915–1997) combined landscape painting with an educational program that he made available to the public through workshops, publications, and television. He was a former mural and decorative painter of coaches in East Prussia, and he taught an oil-painting technique across the United States that he described as "wet-on-wet" (Alexander 1981). This technique, also known as alla prima (*Bob Ross: The Happy Painter* 2011), has been used by oil painters since at least the sixteenth century, as it allowed them to create imagined landscapes illuminated by evocative lighting. Alexander's purpose was about "capturing dreams and putting them on canvas" (Alexander 1981, ii).

Alexander promoted himself and the wet-on-wet method through personal appearances, a 1979 publication, and a television show consisting of thirteen episodes broadcast on KOCE-TV in Huntington Beach, California. Alexander described his wet-on-wet technique as enabling

> the artist to express freely and creatively any scene of which he or she may be thinking or dreaming. The success of the method depends upon the use of specific paints, standard as well as specialized tools and equipment, and particular techniques. . . . The Alexander Magic White paint is essential to the success of the technique. The paint, which is used as an undercoat for almost all paintings and as a thinner for other paints, provides a wet, smooth surface on which to apply and blend colors. (1981, 1)

This approach seemed like magic to all kinds of audiences, and Bob Ross quickly saw its potential.

Bob Ross retired from the Air Force, temporarily left Jane and Steve in Alaska, and traveled to the continental United States to study and work for Alexander. Under Alexander's guidance, he taught classes all over the country. While in the Air Force, Bob said that he held positions requiring him to be "mean" and "tough." After leaving the military and reflecting on this uncomfortable way of being, he said that "it [he] wasn't going to be that way any more" (Shrieves 1990). At some point he acquired the nickname "Bust 'em up Bobby" (IMDb 2013), a characteristic that was definitely not what his art students experienced.

Annette Kowalski took one of his classes in Florida. In the documentary *Bob Ross: The Happy Painter*, she recounts an experience typical of those who encountered Bob Ross. She was "mesmerized" by him and believed that what he had to offer people should be "packaged and bottled" (*Bob Ross: The Happy Painter* 2011). Kowalski goes on to describe how she and her husband, Walt, had a dinner with Ross where they asked him to travel to the Washington, D.C., area to teach classes. This dinner would ultimately lead, over time, to Ross quitting the Alexander Magic Art Supplies Company and going into business with the Kowalskis. However, prior to taking that step, in 1982, Jane and Steve had moved from Alaska to Glasgow, Kentucky, for the purpose of distributing Alexander's products on the East Coast. Jane complained to Bob that the house that they had occupied was haunted (Kowalski 1999b). His work as the East Coast distributor of art supplies for Alexander would be short lived.

In the Blue Ridge PBS biopic, the Kowalskis' discuss the early years of their partnership with Ross as financially challenging. The classes that Ross was offering in shopping malls and art stores were yielding few students. As a cost-saving measure Ross had his hair permed so as to require fewer haircuts. According to the documentary, as time passed, Ross came to hate his frizzy hairstyle, but maintained it out of necessity because it was how he was depicted on Bob Ross, Inc., products (*Bob Ross: The Happy Painter* 2011).

The business took over the home with boxes everywhere and customers that needed attending to. Jane invited her niece to live with them to help run the business. June Wozniak, Bob's sister-in-law, confirmed that Bob's family's life at this time was consumed by making the business work and that family activities could easily be disrupted or delayed by a phone call or mailing that needed attention (June Wozniak, personal communication, November 13, 2012). As the business grew it moved to larger quarters. Jane oversaw the company and was featured in the September/October 1990 issue of *Brush Strokes*.

In 1982 Ross approached Alexander about doing a television commercial together to promote Ross's painting classes. This commercial was taken to public television station WNBC in New York City. As recounted in *Bob Ross: The Happy Painter*, this commercial led to the television station working with Ross to do the series *The Joy of Painting with Bob Ross*. Each thirty-minute episode featured Ross completing one painting. According to those involved in the production of the series, every aspect of it was well thought through. This included the clothes

that Ross wore (he wanted them to always look current no matter how many years the series would be broadcast), the minimalist set, and Ross acting as if he were only talking to a single viewer (*Bob Ross: The Happy Painter* 2011).

After a single series, the partnership with WNBC dissolved. Shortly thereafter another series of episodes was taped as the *Joy of Painting II* at WIPB in Muncie, Indiana. The taping schedule was grueling, with thirteen episodes produced in three days. Generally, each episode was produced live to tape. Ultimately, thirty series were produced constituting four hundred episodes (*Bob Ross: The Happy Painter* 2011). The WIPB series contributed significantly to Ross's success and the success of Bob Ross, Inc. Publications and a line of products were forthcoming as were appearances on nationally televised talk shows, an appearance on the *Grand Ole Opry* in 1987, and periodically being spoofed on MTV or HBO. Concurrently, Ross continued to travel the country teaching classes and selling books and art supplies. Eventually, a three-quarter-ton white truck, known as the "white warehouse," would be outfitted to support his teaching (Kowalski 2003).

Brush Strokes: The Official Publication of the Association of Television Artists began with the November/December 1988 issue. The front-page headline read "Here's What You've Been Waiting For!" Edited by Louis Clayton Jr., with assistant editors Jane Kowalski and Pat Smith, this was "a publication about art and artists, read by people interested in the same" ("Here's What You've Been Waiting For" 1988, 1). The first issue featured, in addition to Bob, the television artists Gary Jenkins, Dorothy Dent, and Pricilla Hauser. There was also a story of Bob Ross appearing at the Grand Ole Opry at the invitation of country music star Hank Snow. Annette Kowalski was profiled as the "Artist Close Up." Full color prints of *Irises* by Kowalski and *Lonely Road* by Ross accompanied the how-to-paint instructions. This first issue included a list of certified Bob Ross instructors. A subscription to the publication was available for $11.98. Eighteen volumes later, this publication to a great extent continues in this format. Periodically, nods to what was capturing attention in the larger Art World would appear. For example, the March/April 1993 issue included a non-judgmental overview of graffiti art in the story "Spontaneous, Limitless, Free: Graffiti: Expression of Human Emotion" (7). Announced in the March/April 1997 issue of *Brush Strokes*, beginning with the May/June 1997 issue, and continuing to the present day is Kowalski's "How the Joy Began" series. In this series she lovingly

recounts Bob Ross's personal story, her relationship with Bob, and the emergence of the teaching enterprise. The first installment is a tribute to William Alexander, the Magic White Company, and Bob and Jane traveling to Oregon and living in a motor home so that Bob could study with William (Kowalski 1997). Through this series by Kowalski, you learn of their strong and collaborative relationship. The series is also illustrated with numerous historic photographs of Bob, Annette, his pets, his work with students, public appearances; and these convey a personality that appears to be jovial, open, and affectionate.

A decade after Bob launched himself as an artist and art educator, a *New York Times* article (Stanley 1991) described *The Joy of Painting* as being the top-rated art program carried on 277 public television stations. Bob Ross, Inc., was described overall as a $15 million enterprise comprised of books, videos, and art supplies. There were three hundred certified instructors and a million Bob Ross painters. His success, however, had cost him his friendship with William Alexander. At this time Alexander is quoted as stating, "He betrayed me. . . . I invented 'wet on wet.' I trained him and he is copying me—what bothers me is not just that he betrayed me, but that he thinks he can do it better" (Stanley 1991).

Bob Ross Returns to Central Florida

In 1990, after twenty-seven years of being gone from his hometown, Ross moved back to the Orlando area on a permanent basis. His home was described by *New York Times* reporter Alessandra Stanley (1991) as a "sprawling ranch house" with its interior walls covered in gold-framed paintings by Ross along with similar works he had found in antique shops and at garage sales. Ross's home also included an extensive collection of nineteenth-century American glassware. Stanley described Ross's studio as being in the basement, where he painted at a desk and an easel. Caged squirrels and crows were both inside and outside the house (Stanley 1991). Linda Shrieves, a reporter for the *Orlando Sentinel*, also described a visit to Ross's home. She noted, "His inspiration comes not from exotic sojourns, but from a pile of postcards, calendars and snapshots strewn on his basement floor" (Shrieves 1990). In that interview Ross also admitted that he didn't seek out publicity, accounting for an absence of public knowledge about him. He is quoted in the article as saying, "I stay hidden. . . . I'm sort of hard to find." He also explained

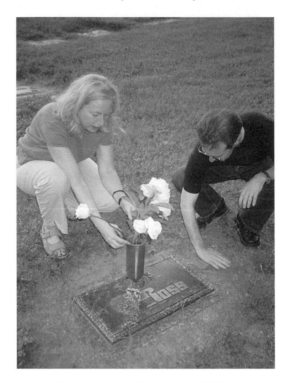

Authors Kristin Congdon and Doug Blandy at Bob Ross's Grave

to Shrieves the philosophy he brought to his teaching: "We have been brainwashed to believe that Michelangelo had to pat you on the head at birth. Well, we show people that anybody can paint a picture that they're proud of. . . . And that's what it's all about" (Shrieves 1990).

After returning to Florida, Bob would be personally challenged. His mother, Ollie, died in 1991. Jane, profiled just a year earlier in *Brush Strokes*, died of cancer in 1992 (*Bob Ross: The Happy Painter* 2011). According to her sister, June Wozniak, her body was taken to Pennsylvania for burial. Wozniak also describes her sister, one of six children, as being a very private person and someone who liked to paint flowers. She describes her brother-in-law, Bob, as being a private person as well, but who did enjoy the attention he received as an artist and teacher. According to Wozniak, Bob was the same person in real life as he was on the *Joy of Painting* (personal communication, November 12, 2012).

During his career as a television artist Bob had periodically experienced health challenges. In 1983 he suffered debilitating cluster

headaches, requiring him at one point to be hospitalized (Kowalski 1998). In 1986 he was diagnosed with a heart problem (Kowalski 2005). Three years after Jane's death, on July 4, 1995, Bob Ross died of lymphoma. He was fifty-two years old and at the height of his popularity. According to *Bob Ross: The Happy Painter*, this was a recurrence of a cancer that had developed some years before. In the months before his death Ross chose to maintain his image by wearing a wig as a response to hair loss associated with radiation and chemotherapy. There are reports that he had married a woman named Lynda (perhaps with the same name as his first wife) in April, prior to his death in July (IMDb 2013). Although Ross had prepared paintings for a thirty-second series, he was too weak in travel to Muncie for taping (*Bob Ross: The Happy Painter* 2011). A *Washington Post* obituary ("Bob Ross PBS Instructor" 1995) reported that 2.5 million copies of his books were in print and that there were one thousand Ross-certified art teachers. An obituary in the *Orlando Sentinel* reported that he was "survived by his wife, Lynda [unclear if this was first or possible third wife], a son; a brother; and a half brother" (Shrieves 1995. Bob was interred at Woodlawn Memorial Park in Gotha, Florida. An in-ground bronze marker is inscribed with "Bob Ross," "TELEVISION ARTIST," and birth and death dates. A portrait of the painter is inscribed into the marker. A pull-up vase is available for flowers.

After Death

The July/August 1995 issue of *Brush Strokes* announced Bob Ross's death to his followers under the headline "Saying Goodbye to an Old Friend, Our World Will Never Be the Same" (1). The story beneath the headline recounted Bob's life and a promise that the company was committed to "Bob's dream" (1). Following his death, Ross's popularity continued to grow. Increasing numbers of visitors experienced the permanent exhibit of Ross's paintings installed on the walls and ceiling at a Bob Ross, Inc., gallery and teaching studio in New Smyrna Beach, Florida. In the mid 1990s a Baton Rouge indie rock band formed with the name "Bob Ross Experience." Bob Ross and Jerry Springer fight one another in the *Celebrity Death Match* video game. In 2004 Bob Ross appeared on Mary Ann Stankiewicz's history of art education timeline as a significant event in the 1980s (1983) along with Andres Serrano, Keith Haring, Watchmen comics, and the opening of the National Museum of

Author Danny Coeyman at Bob Ross's Grave

Women in the Arts (http://www.personal.psu.edu/faculty/m/a/mas53/timelint.html). Bob Ross T-shirts have been sold through Urban Outfitters, Target, and by independent T-shirt artists. Demonstrating that the Bob Ross image still has power in the popular imagination, Nitrozac and Snaggy (2010) in their "The Joy of Tech" comic pictured Bob Ross in front of a painting of the Gulf of Mexico, stating,

> *Once you've painted your happy ocean, take a blob of oil and start by dabbing, using the corner of the brush. . . . As you work across the water, push a little harder, spreading more, then just go on and on, smearing the oil everywhere. And don't forget the happy little tar balls.*

In 2013 nearly 450 public television stations broadcast his show, reaching 93.5 million households. The show is broadcast in Japan, Mexico, the Philippines, South Korea, Taiwan, Hong Kong, Turkey, the Netherlands, the United Kingdom, Germany, Switzerland, Belgium, Austria, Costa

Rica, and Canada. Five million copies of Bob Ross's books are in print, and there are three thousand certified instructors in the United States alone (Bob Ross, Incorporated 2013). The next chapter will explore ways in which Bob Ross has spread his joy, both as an artist and a teacher.

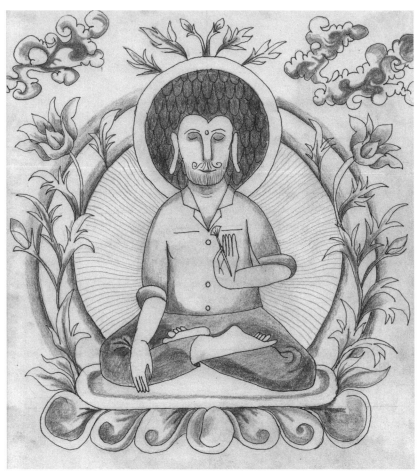

Bob like Tibetan Thangka, by Danny Coeyman

⫷ 3 ⫸

PROMISING JOY

Bob Ross as Artist and Teacher

Bob Ross's PBS television series and art classes based on his "joy of painting" method have captivated an international audience by promising participants that they can create immediate oil-painted masterworks worthy of framing and hanging. Significant to the success of Bob's television series, the classes, and the enterprise is Bob's charisma, coupled with a philosophy of education informed by a utopian impulse to promote the potential in all who participate.

Daniel Chodorkoff described the utopian impulse as a "response to existing social conditions and an attempt to transcend or transform those conditions to achieve an ideal" (1983, x). This impulse is evidenced broadly in culture and society, including the arts. Barbara Novak (1974), in her classic and still definitive study of American landscape painting in the early nineteenth century, argued that this impulse coalesced in American landscape painting around a belief in the redemptive qualities of "unspoiled nature." This impulse was shaped by the writings of Jean-Jacques Rousseau, William Wordsworth, and Ralph Waldo Emerson, among others. In the United States it contributed to the formation of an artistic identity by a group of artists living near the Hudson River who expressed their love of nature through landscape painting (Novak 1974). Known now as the Hudson River School painters, these artists included Thomas Cole, Frederic Edwin Church, and John Frederick Kensett. Among these artists and their admirers, contemplating the landscape, including the painted landscape, was equated with the "contemplation of virtuous deeds" (Novak 1974, 62). In this regard, in 1830, a contributor to the *North American Review* noted that beauty in nature and the arts

is "nearly allied to the love of that which is good. So close is the association that it has often been doubted whether beauty can be anything more than a visible manifestation of those amiable moral qualities of which the mere idea fills the heart with delightful emotions, and confers a charm on every person or thing with which they appear to be associated" (Novak 1974, 62).

The landscapes produced by the Hudson River School painters depicted nature as a paradise on earth, undefiled and with few human traces. It is important to note that the landscapes painted by these artists, despite the implied realism in their work, were often synthesized and idealized versions of landscapes. While sketches might have been done in the field, the actual paintings were generally accomplished in the studio.

Among the transcendentalists influencing the Hudson River School, there were some, like Bronson Alcott, who promoted a link between transcendentalism, education, and utopian social change. Alcott participated in a number of utopian projects. Of these, one of the best known may be his founding of the Temple School with Elizabeth Peabody in Boston in 1834.

This school, described in detail in Peabody's *Record of a School*, published in 1835, emphasized a course of study that was student-centered, self-explorative, and accommodating of the non-rational and intuitive. Foundational to the course of study at the Temple School was the belief by its founders that under the right circumstances all people could realize their full potential.

Novak concluded her study of the stylistic, social, cultural, and philosophical character of landscape painting in America by demonstrating the continuation of these impulses in painting by artists associated with the Immaculates in the late nineteenth century, the Ash Can group in the early twentieth century, the Abstract Expressionists in the mid-twentieth century, and even Pop and Conceptual Art later in the century. The transcendental and utopian impulse continued in education as well. Michael Peters and John Freeman-Moir (2006) argue,

The connection between imagination and utopia that brings out the foundations of both in human development is of particular significance for education theory. Education is intrinsically connected with the utopian. . . . Indeed utopias can be thought of as fundamentally education in the sense that they are "designs" for living . . .

designed explicitly for encouraging the development of certain kinds of habits, dispositions and attitudes. (3)

Leisure Time, Art Instruction, and the Utopian Impulse

Industrialization in nineteenth-century America brought leisure to many people for the first time. Steven Gelber (1999) argued in *Hobbies: Leisure and the Culture of Work in America* that a basic distrust and discomfort of leisure or free time encouraged Americans to engage in hobbies of various types including crafts. This engagement with the crafts was so extensive that there was an emergence of a craft industry following World War II. Painting was among the activities that people chose to participate in. Classes and publications of various types were available to people who wanted to learn to paint. Engaging with crafts and other hobbies was seen as virtuous in that they kept idle hands from dealing in the devil's work.

In the 1960s William Alexander combined landscape painting with an educational program for hobbyists in keeping with the utopian impulse. His wet-on-wet technique permitted the rendering of landscapes illuminated by evocative and luminous lighting. Evidence of brushwork was minimal in achieving the desired effect. There is no evidence that Alexander, like the landscape painters of the nineteenth century, was painting actual locations. In fact, Alexander's purpose was about "capturing dreams and putting them on canvas" (Alexander and Lee 1981, ii).

In 1981, Bob Ross, who had just retired from the US Air Force, studied with Alexander in Salem, Oregon. Ross learned of Alexander through his instructional series broadcast on television.

As discussed in the previous chapter, Bob was not new to painting. Prior to learning of Alexander, Ross had been painting and selling Alaskan landscapes depicted on the bottom of gold pans that were sold as souvenirs. After having Bob as a pupil, Alexander invited Bob to assist him in his educational enterprise.

Alexander's and Bob's medium of choice was oil paint. They also aligned with the tradition of easel painting. Oil painting combines pigments with an oil such as linseed, poppy seed, walnut, or hempseed. These oils are used alone or in combination for varying effects associated with drying times and appearance. Oil painting also requires the use of a thinner such as turpentine. Easel painting, emerging in

fifteenth-century Europe, permitted artists to use portable supports such as wood or stretched canvas for their paintings (Mayer 1991). By taking up oil painting and easel painting, Bob associated himself with a long and distinguished tradition of painters and painting traditions from the Renaissance to the present day. Learning to paint with oils is commonplace in art schools, university fine arts programs, high school art programs, and community-based art programs, although less so today with the introduction of acrylic paints, which are water based and easier to work with. The basic materials used to do an easel oil painting include a surface such as canvas, Masonite, or wood; pigments that are now commonly available in tubes; oils; a thinner; brushes of various sizes (may be composed of synthetic hair or hog bristle or the hair of minks and sables, among other animals); palette knives; and some type of nonporous palette upon which to place and mix the pigments for use with the brushes and knives. The wet-on-wet or alla prima style of oil painting employed by Alexander and Bob was not of their invention or unique to them. This style involves layering wet paint of different colors in quick succession in one distinct time period. Students of Art History know this to be a style in evidence early in the history of oil painting and continuing to the present day.

Beginning sometime in the 1970s and continuing until his death in 1995, Bob produced a reported thirty thousand oil paintings (Stanley 1995), a large portion of which are landscapes using the wet-on-wet technique and are heavily influenced by Alexander's style. While both painters wanted to create luminous landscapes, Bob's goal was to make his work more glowing than Alexander's.

With titles such as *Valley Waterfall, Delightful Meadow Home, Secluded Forest,* and *Golden Glow of Morning,* Bob depicted landscapes that, while referencing what he experienced in Alaska, are clearly, much like the work of the Hudson River School painters, synthetic representations of unspoiled and uninhabited environs. If there is any evidence of the presence of people, it is through the inclusion of a single, abandoned, sometimes ruined cabin.

There are conflicting reports about the circumstances of Bob leaving Alexander and his business, the Magic Art Supplies Company, to go independent as an art educator. Following Alexander's method of teaching his oil-painting technique, with the backing of a business partner and student Annette Kowalski, Bob began documenting and teaching his artistry through taped oil-painting instructional broadcasts airing on

a Washington, D.C., area TV station. Together they are packaged as the *Joy of Painting*. Additional sessions were taped as *The Joy of Painting II* at WIPB in Muncie, Indiana.

Promising Joy

While art instruction through certified instructors, correspondence, television, or other forms of multimedia is not unique to Bob Ross, Inc., what is unique is what learning to paint with Bob Ross or through his method promises. Those being taught to paint by Bob, through his method, or even by watching Bob doing a painting through the method, are promised not only a finished product worthy of framing in a relatively short amount of time, but also joy.

Bob's teaching method is comprehensively documented in *The Joy of Painting* broadcasts, books, and DVDs. It continues through face-to-face instruction by instructors certified by Bob Ross, Inc., who teach classes at craft stores, shopping malls, and in their homes. Certification is available in landscape painting, wildlife painting, and florals (Bob Ross, Inc. 2013).

Certification as a Bob Ross landscape-painting instructor is open to all and is possible by registering for a series of three certification seminars. Official acceptance follows registration. Bob Ross, Inc., advertises tuition for a certification course of study within the United States at $375. Certification is offered in New Smyrna Beach, Florida; Waseca, Minnesota; and Chantilly, Virginia. Those wishing certification must complete three levels of instruction, each requiring attendance in classes over five days, from 9:00 a.m. to 5:00 p.m. Participation in the seminars primarily focuses on "painting and teaching skills." Success as a CRI (certified Ross instructor), according to the training brochure, will also depend on "one's own business sense and ingenuity. . . . Bob's personally appointed teaching staff" provides instruction (Bob Ross, Inc. 2013).

In the course of study, level 1 is foundational, concentrating on the "proper use of painting tools and techniques involved with completing Bob's landscape and seascape paintings." "Participants are promised excitement and an opportunity to make lifetime friends." Level 2 requires completing level 1, and its projects are more advanced and build on what has already been taught. It is at this level that students learn instructional techniques. "Special coaching" is provided on "motivating beginners and correcting your student's mistakes." Level 3 requires successful

completion of levels 1 and 2 and projects are still more advanced. Skills associated with teaching the Bob Ross method continue to be a focus and include demonstrations. Guest speakers from Bob Ross, Inc., discuss products, class setup, promotion, and job opportunities. Level 3 leads to the start of a "glorious new life as a Certified Bob Ross Instructor!" (Bob Ross, Inc. 2013).

Experiencing Joy

Testimonials by those who have participated in the Bob Ross method confirm that people believe the method delivers on what is promised. We routinely encounter people who attribute the method to getting them through depression, divorces, major illnesses, and bouts of loneliness, despair, and isolation.

Bob Ross' New Joy of Painting, by Annette Kowalski (1993), begins with Kowalski discussing the principles, purposes, and results of Bob's teaching and method. Consider these principles in relationship to the preceding discussion of the utopian impulse, the Hudson River School painters, and the Temple School.

The method assumes that there is a creative person living inside of every human being that can be released through the Bob Ross method. Participating in the method will help participants cope with the travails, sometimes severe, of everyday life.

Kowalski's (1993) text confirms that central to Bob's teaching was a love and respect for nature and the environment. Bob also believed and imparted to his students that "there is no failure in painting, only learning" (Kowalski 1993). Bob also assured his students, "There are no great mysteries to painting. You need only the desire, a few basic techniques and a little practice" (Bob Ross, quoted in Kowalski 1993). Students are advised to "use each painting as a learning experience, add your own ideas, and your confidence as well as your ability will increase at an unbelievable rate" (Kowalski 1993). Again, keeping in mind the utopian impulse and its emphasis on an individual's character and potential, consider this affirmation of that impulse by Kowalski:

> *By making Bob Ross and "The Joy of Painting" a part of our lives, it's*
> *more than an interlude, much more than just a pleasant half-hour*

experience. We are developing a healthy, lifelong interest in nature's
beauty, and in our own personal sense of expression. As Bob says,
"While 'The Joy of Painting' might be responsible for creating the
spark, it is you, viewer and friend, who has nurtured and fed the
spark into a warm and wonderful glowing fire." (1993)

Experiencing the Method and, by Extension,
Bob Ross Firsthand

To experience the method, Doug Blandy and Kristin Congdon took a
Bob Ross landscape-painting class from certified Bob Ross instructor
David Wensel at the Bob Ross Gallery in New Smyrna Beach, Florida.
The walls and ceiling of this gallery were covered with paintings by Bob
Ross and Annette Kowalski. In addition to hosting classes, the gallery
sells Bob Ross painting supplies and is a frame shop.

Upon entering the gallery, we saw that work stations were set up for
seven participants, ranging in age from seven to over sixty. Each indi-
vidual's painting area included a canvas, brushes, paint on a palette, and
solvents. A few simple pencil marks had been placed on the canvas to
guide us in the placement of the landscape elements such as the horizon
line and the larger and smaller trees. A lavender color was mixed for us
due to the time, we were told, that it would take for each of us to accom-
plish that task. Over the next two and a half hours Wensel led us through
the process of doing a landscape painting. The landscape we painted was
one created by Wensel in the style of Bob Ross.

Several people in the room had taken painting classes previously.
One participant claimed to have painted "hundreds" of Bob Ross–style
paintings. Some, like us, were newcomers. Some expressed some anxiety
about participating, claiming they had no talent. Step by step, we were
instructed in several of the Bob Ross techniques for creating a landscape
bathed in evocative lighting. Wensel used the most positive of language
to guide us through the process. If we were having difficulty with one of
the techniques, such as achieving the details on the trees, he asked if he
could take our hands and guide us through the technique. Clearly, his
goal was to create an environment in which each of us could achieve the
desired effects that he was teaching. No one failed. Wensel encouraged
all of us to take pride in our work and to express this pride through the

purchase of a frame for our painting at the conclusion of the class. No one seemed to mind this suggestion, and several people did purchase a frame for their painting.

We learned from Wensel (personnel communication, July 1, 2004) after the class that he himself had used the Bob Ross method of painting to transcend significant health and financial problems. Wensel spoke enthusiastically about the sense of community that is possible when people believe that all can be artists and that by engaging with the Bob Ross method one can experience personal satisfaction, delight, well being, and peace.

Spreading Joy

A writer in an 1830 issue of the *North American Review* stated that landscape painting "produces happy and civilizing influences upon society" (Novak 1974, 62). Several generations of artists later, Bob Ross was promoting this same sentiment through his own landscape painting and teaching. The patient and soothing voice of Bob, described by Kowalski (1993) as like a "liquid tranquilizer," encourages creating "happy trees" and "happy clouds." Spreading joy, Bob Ross style, has similarities to healing practices practiced by other artists and shamans.

THE LEGENDARY LIFE OF BOB ROSS

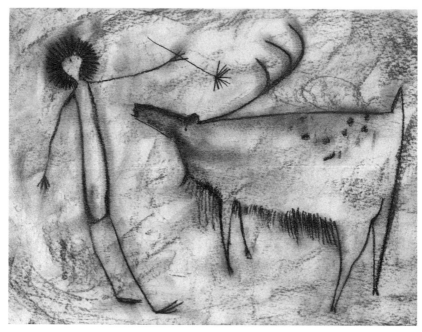

Bob like Lascaux, by Danny Coeyman

◄ 4 ►

BOB ROSS AS SHAMAN

Fortunately, more Art World members are beginning to recognize Bob Ross as a person worthy of their attention. Even New York art critic Michael Kimmelman acknowledges Bob Ross's cult like status, especially among "an ironically inclined segment of Generation X" who know the artist from a series of promotional spots on MTV as well as his *Joy of Painting* TV series (2005, 42). Referred to as a "televangelist" by Kimmelman (2005, 33), Bob Ross teaches not only painting techniques, but also a way of life. Bill Ivey (2008, 117) has a somewhat different take on Ross, claiming his message is linked to independence and achievement, as Bob massages budding artists as capable and able to make decisions. By repeatedly informing his followers about self-esteem in a yoga-like manner, he claims that working through difficult challenges (for him on the canvas, for yogis on the mat) can transfer into lifelong lessons. Once you learn the basics, you become your own teacher. It is then that you make your own decisions and independently control your life. The message about how to paint is straightforward and easily demonstrated. The message about independently acknowledging control over your own canvas and life comes with practice.

There is nothing fancy about the way Bob Ross's shows were filmed. Much like Bob's approach to painting, his setup could not have been simpler. During his shows, there is one static camera focusing directly on Bob and the painting. The artist divides his attention between the canvas and his audience, slowly explaining the pleasures of creating. With a soft voice that is calm and encouraging, he makes viewers believe that like him, they too can be great painters. And like him, they too can take control of their lives. It doesn't need to be complicated, but it does take practice. Bob's softly spoken words of encouragement calm viewers and make them believe that they can follow his lead.

The Engagement of the Masses

Bob's words are a call to faith in the creative power of the everyday person. Grandma Moses set a precedent in the popular imagination decades before. Her paintings were ubiquitous on holiday cards, china, fabrics, and calendars. She was on the 1948 cover of *Life* magazine, and her work was shown all over the world (Congdon and Hallmark 2012, 71–73). Bob Ross took his cue from Grandma Moses, who claimed, "Anyone can paint if they want to. . . . All they have to do is get a brush and start right in, same as I did" (quoted in Kimmelman 2005, 42). Modeling his message directly on Moses, he preached the same kind of Horatio Alger–like message of the American dream of being and becoming anything you want.

The reoccurring belief that everyone has the capacity to be creative is one that art educators often promote when they teach elementary school. It is only when students get older and become aware of the hierarchically ordered and institutionalized Art World that they come to the conclusion that only a certain few individuals will be recognized as artists. The narrow view of the artist as genius, often associated with modernism, focused on individual expertise and originality. Bob Ross's message challenges the concept of artist as genius as he quietly persuades his viewers of their artistic potential through easy-to-follow demonstrations accompanied by sermons of love and kindness. His message is communicated as a perennial truth.

Bettering oneself is a value that is well established in the American mainstream. Ubiquitous self-help books, popular in the second half of the twentieth century through today (Dolby 2011), can be likened to how-to craft books. They both provide a rather formulized way to accomplish something seemingly difficult. Simultaneously, Bob Ross, with his message of self-realization and step-by-step instructions for creative expression, grew in popularity. The phenomenon continues today through such series as the ubiquitous books for "Dummies." Anyone can learn math, investment practices, computer skills, philosophy, auto repair, how to get a divorce, and how to play a musical instrument. There is even a book called *Cool Careers for Dummies.* Easy-to-follow art instruction books also abound, responding to a strong public demand by the general public to participate in the arts. From the paint-by-numbers kits, toy model kits, and quilting projects to the garage bands and folk

singing of the 1960s, Americans learned to participate in the arts at varying levels and did (and do) so with pleasure. Ideas about becoming better at something, be it painting, yoga, a sport, or singing, are often linked in our minds to developing more satisfying lives. Ivey claims, "It would scarcely be a surprise if research were to discover that arts learning aids fill the same 'happiness gap' targeted by books about relationships, parenting, and spiritual tranquility" (2008, 123). Bob Ross was clear about the connection.

Not only has his ongoing television series attracted many devotees to his message, but his personal appearances garnered massive audiences as well. Bob Ross demonstrated his painting techniques to vast audiences in what were called "Bob Ross Paint Ins," which were held in large spaces free of charge. One in New York City's Central Park reportedly drew 250,000 participants. When a "Paint In" was held in the Midwest, the first 250 arrivals received a complimentary souvenir button. Some people painted along, and others watched. It was widely advertised that no experience in painting was needed. Instructors moved amongst the crowds, helping others move their brush or giving words of encouragement. The May 1991 "Paint In" that took place in Muncie, Indiana, drew both young and old attendees from Ohio, Illinois, Michigan, and Kentucky. Ross sometimes performed two "Paint Ins" a day, signing his book for participants between events (Bavender 1991, A9). Bob was like a star preacher, and participants listened carefully to his instructions and words of encouragement. Each person hoped to create a painting that was worthy of praise or perhaps even one that could be hung on a wall. They came, however, not just to learn to paint. They came to listen and to watch a man who could make a something blank turn into a thing of beauty.

Bob as Healer

Bob Ross's *The Joy of Painting* broadcasts also echo the language of client-centered psychology, which emerged in Ross's lifetime. In 1961, Carl Rogers, the founder of this approach to therapy, wrote articles that caused a landmark shift in how psychologists heal their patients. In a book entitled *The Characteristics of a Helping Relationship*, Rogers notes that being "genuine," practicing "empathic understanding," and responding with "unconditional positive regard" are fundamental to the growth and

health of both therapist and patient during treatment (1961, 47–48). With phrases like "Oh, you'd be in Agony City by now" and "People might look at you a bit funny, but it's okay" or "Artists are allowed to be a bit different," Bob Ross understood and appreciated the anxieties and emotions of his viewers at home and responded with a Rogerian kind of empathy. Bob Ross's ability to transport himself and others to his world of joy may not seem like a sophisticated form of therapy, but it certainly echoes the language of healing that was developing in parallel with his show.

Today art and therapy are studied together by art therapists to help patients heal and process all kinds of psychological states. But Bob Ross's work is also similar to the shamanistic traditions practiced for centuries before psychology was founded. Shamanism feels particularly relevant because Ross was not alone in cultivating the creative impulse and visualizing sacred or surreally beautiful realms as a healing property for their audiences. We compare Ross's relationship with shamans because of his similarity with the most famous of all artist healers, Joseph Beuys, one of Bob's contemporaries. Known for inventing a personal mythology that blended his factual life with epic stories of survival and healing, Beuys was *the* original art shaman in the Art World. As a teacher at Düsseldorf Academy of Art, Beuys encouraged students to over-enroll in classes, opening art instruction to anyone who wanted it (Stachelhaus 1991). Like Ross, Beuys mixed selected personal anecdotes with a democratic teaching style to create a mythological persona. Using humble materials like animal fat and felt, Beuys performed art actions specifically designed to engage the politics and psyches of his viewers. From planting trees to sweeping up the gallery floor, Beuys's work took actions of care and elevated them to "social sculpture" (Stachelhaus 1991, 79). Similarly, Bob's humble-looking house-painting brush was imbued with a talismanic power because of the ritualistic phrases he gingerly repeated during each program. On screen, the real Bob recites the same encouraging phrases over and over, while imagining that he is speaking "to one specific person that I care about" (Newman 2011).

Over and over, Bob tells viewers "You can do it," "This is your world," and "There are no mistakes, only happy accidents." The effect is "hypnotic" and "magical," leaving many viewers in a kind of transcendent TV trance (Schor 1997, 176). While shamanism is a tradition with its own lineage and distinct context, it is worth noting that Bob Ross's method, like Joseph Beuys's art shamanism, incorporated nature, personal mythology, and an act of transporting viewers to sacred realms.

In fact, numerous people around the world believe that artwork can heal. From mandalas, icons, and Native American sand paintings to fertility figures, people grant power to, or recognize the power of, varying kinds of artwork. Chinese tradition claims that having images of the kitchen god in your cooking area can bring you good health and that wearing images of the dragon can provide strength. Art therapists engage clients in making art in order to diagnosis or treat an illness or feelings of discomfort. Among contemporary artists the work of Alexander Melamid is but one example that illustrates the juxtaposition of healing and art.

In 2011, Alexander Melamid, who previously had worked with Vitaly Komar on the People's Choice project, opened the Art Healing Ministry. This storefront clinic in New York City treats people with numerous kinds of illnesses and psychological problems. Medical terminology, which is posted to his walls, reminds Melamid of language used in art criticism. He sells items such as shoe soles with a Vincent van Gogh self-portrait, candles, prayer cards, and other items with artistic images on them. For Melamid, Pablo Picasso is the motorists' patron saint and George Seurat is the saint for radiant and healthy skin. Melamid claims, "We all know the power of art, its power to galvanize, fortify, stimulate, rouse, soothe and enlighten. . . . I was always told that art was good for me, but until recently I didn't know what it was good for. What is good? What is good in the U.S.A. is health and health projects" (quoted in McGrath 2011, C7). He counsels his patients not to be overexposed when visiting an art museum, as too much art can be dangerous. He is specific about what artworks will heal and are needed in certain situations. "If you have hay fever," he explains, "you go to see Claude Monet, that's for sure" (McGrath 2011, C7). One person was instructed to look at Paul Cezanne's paintings, as they are powerful in a pacifying way. No doubt Melamid is being somewhat ironic as he points the finger at the American public and their relationship with consumer culture and interest in health products (McGrath 2011). Odd and humorous as Melamid's clinic might seem to some, to others it may make sense, and there is little doubt that some of his visitors are helped by his instructions, as the placebo affect (if it is only that and not something more) is well documented.

Bob Ross doesn't offer good health quite the same way Melamid does, but his approach clearly includes a healing component. In a 2004 interview with Dave Wenzel, a fifty-nine-year-old Bob Ross instructor in New Smyrna Beach, Florida, and Doris Young, a woman about the

same age who worked in the studio, Doug Blandy and Kristin Congdon were told about numerous stories of healing. Wenzel said he had owned a construction business in Pennsylvania before becoming a Bob Ross teacher. He got cancer and had severe back problems, causing him to miss many days of work. Eventually, he lost his job, and his wife lost hers at the same time. Depression set in, along with other illnesses, and he said he spent two years in bed, removed from any kind of meaningful living. Out of desperation, they packed up their belongings and moved to Daytona Beach, looking to start a new life. One day he was walking by the Bob Ross studio in New Smyrna Beach and decided to go in. Before long he was painting landscapes. When he painted, he found that he didn't think about his problems. Soon, his depression lifted. A few years later he was certified, teaching, and feeling healthy.

Doris Young, who was also suffering from depression and isolation, said she got into Bob Ross through the Internet. Someone in a chat room told her to take a class. Like Wenzel, she too is a certified teacher. She claims that outsiders would be surprised to find out how many people start painting when they really need something in their lives. Wenzel agrees, emphasizing the therapeutic aspects of the process: "It's not a great art school thing; it's a community thing. Some [people] come for years" (personal communication, July 1, 2004).

As someone who experienced cancer, Bob was aware of his work's ability to comfort those in psychological and physical pain. Jim Needham, who worked with Bob, remembers an elderly woman buying an original Bob Ross landscape during a PBS fundraiser. Needham recounts how she called the station and asked to meet Bob after buying the painting. He remembers that she drove an hour to meet him and came in using a walker, saying, "I don't have too many good days anymore and when I watch your show, that's the best part of the day. I just want to thank you for that. That's why I had to have your painting." Needham continues that Bob hugged the woman, thanked her, and replied, "That's why I do this" (Newman 2011).

Even as he helped others cope with illness, Bob was also actively healing the critters at his local animal shelter. Diana Shaffer, one of Bob's neighbors, remembers him building elaborate cages for animals in need of rescue and shelter: "He would have made me one of these enormous wire cages, and they were lifesavers" (Newman 2011). Lovingly crafted with the carpentry skills he learned from his father (a parallel to Jesus that seems appropriate to note), Bob's cages encapsulate his teaching

practice of giving people support and structure through which they can confront their challenges. Bob's paradigm of healing is to offer his followers a space within which they can be themselves within the safety of a world they craft together. His therapeutic effect on people may be stronger today than it was when he was living.

Bob and Elvis

Like Elvis Presley, and perhaps, in some ways, like Jesus, Bob Ross lives on past his physical death. Most everyone is aware of the ongoing popularity of Elvis since he passed away in 1977. Both superstars enjoy lives beyond their physical deaths, Elvis in his music and films and Bob in his television shows, publications, and certified teachers and art supplies. But for both public figures, it's more than that. In her book *Elvis Culture: Fans, Faith, and Image*, Erika Doss (1999) describes the ways in which Elvis has become a kind of religion to various followers. Referring to the many Elvis worshipers who make shrines to his memory, Doss writes, "While distancing themselves from the real-life problems of contemporary mainstream religions, Elvis fans subvert and appropriate religious styles and sensibilities to construct special private spaces where Elvis holds center stage" (1999, 84). In a like manner, many participants who take Bob Ross classes recognize that by coming to class your needs are taken care of. Coffee and cookies await you. Your painting space is prepared at a table where other students of the Bob Ross painting style work with you. You can't fail. If you have trouble with a technique, a disciple or perhaps an angel, similar to a certified Bob Ross instructor, of Bob Ross comes to your aid. You are saved from your weaknesses and inabilities. In only a matter of time, you are able to leave the sacred space (the classroom) with a finished, even framed, painting of a peaceable kingdom. It is taken home to place on your wall or given to a loved one. It symbolizes your redemption as it memorializes your time in communion with others.

The timing of the creation is also important to note, as there is something magical and godlike in the world that Bob creates for his audiences and participants in such a quick and immediate fashion. It is as if a space is opened up for those who are longing for something magical. Bob Ross, with calm and knowhow, creates a landscape in thirty short minutes (or two hours if you are taking a class). For many, there is something meaningful in the timing of the act.

Bob in the Religious Realm

If the Judeo-Christian God of Genesis took six days to create the entire universe, then it must have looked something like Bob Ross's half hour of painting his world. Bob Ross's approach to constructing a landscape directly mirrors the creation story, even in its sequencing. Out of the darkened void of the studio, Bob Ross begins each canvas with a gradient of bright color. Always dazzling, it is the painted illustration of Yahweh's or God's "Let there be light." And delighting in his work with his viewers, "pleased that it is good," Bob Ross proceeds to make sky, water, land, foliage, and even animals in a manner so quick and spontaneous it seems miraculous. It is easy to look at his abundant, uninhabited landscapes and think of Eden, where "the Lord God made to grow every tree that is pleasant to the sight, and good for food" (*New Hendrickson Parallel Bible* 2008, 4)

References to the natural environment are a shared motif in spiritual imagery across cultures, time, and geography. Many Western traditions ground their mythology in the wilderness, where great religious truths can be found. Artists have built on this theme for centuries. For example, Caspar David Friedrich's (1774–1840) romantic visions of the natural world are depicted as a deeply powerful source of mystery, and Thomas Cole's (1801–1848) paintings of the Hudson River valley are seen as pristine examples of Divine perfection. Even the pragmatic, unreligious mind of Henry David Thoreau utilized the transcendent simplicity of Walden Pond to contrast the superfluous and trivial in his contemporary life.

Within Roman Catholicism, a counterpart to Bob Ross can be found in St. Francis of Assisi, the tender, animal-loving saint, popularized as a cement monk surrounded by wolves and birds in people's gardens. With titles like *Divine Elegance*, some of Bob Ross's painting titles directly celebrate nature as a manifestation of divine beauty; and others, like *Serenity* and *Rapture*, hint at a spiritual power in the land. Just like Bob on TV, Assisi's "Canticle of the Sun" anthropomorphizes nature, calling out and praising his "Brother the Sun," "Sister the Moon," "Brothers the Wind and the Air," and "Sister the Water," among others. Bob Ross was also fond of describing trees and animals as if they were human, giving them friends, noting when they were happy, and imitating the noises they make. In this way, Bob is a contemporary saint. His Afro is his halo.

Bob's associations with kitsch, such as Bob Ross T-shirts and St. Francis lawn ornaments, only reinforce the popularity and enduring power of the messages they both preached. In a sense, Bob and St. Francis were both mystics. St. Francis lived a life of poverty and was prone to visions, miracles, and great periods of solitude. Like Bob, he was an outsider. But most importantly, St. Francis claimed to know God directly. And that is where the value of a mystic is also a threat: it devalues institutions that people normally use to live a better life. Against the hierarchical models of the Catholic Church and the Art World, St. Francis and Bob Ross, respectively, preached a message that anyone could participate in a simple life of communion with nature, animals, and God's blessings. Bob's fundamental dogma was that anyone could paint and that they didn't need to earn an MFA or go to a fancy art school. It centered creativity, joy, and happiness away from schools of self-help or professional advancement and instead offered them freely to anyone who believed in his teachings.

Using nature to teach goodness wasn't just a Western phenomenon. Given Bob's approach to landscape painting and his commentary on *The Joy of Painting* episodes, the parallels between Bob's words and some Taoist texts are uncanny. For example, the *Tao Te Ching*, credited to Lao Tzu, describes "The Tao" (translated as "The Way") as a spiritual force that animates all things. Lao Tzu describes the experience of nature for a person who is in touch with that spirit:

> In harmony with the Tao,
> the sky is clear and spacious,
> the earth is solid and full,
> all creatures flourish together,
> content with the way they are,
> endlessly repeating themselves,
> endlessly renewed. (Lao Tzu 1992, 39)

Lao Tzu's endlessly repeating creatures and clear and spacious skies have much in common with Bob Ross's endlessly repeating episodes of crisp blue horizons and happy critters, for both are worlds of happiness derived from oneness with nature.

Bob Ross's happiness—his *joy* of painting—seems similar to what Lao Tzu called *harmony* and St. Francis called *brotherhood*. Ross preaches joy, a very powerful spiritual tool. "Follow your bliss," says eminent mythology scholar Joseph Campbell, who explored the recurring themes

in all the world's mythologies. Campbell speaks about the connection between art and mythology often, saying, "The work of the artist [is] to interpret the contemporary world as experienced in terms of relevance to our inner life" (1989, 22).

Bob nourished his inner spiritual life through contact with the natural environment, and painting was his way of sharing his spirituality in a form his viewers could literally see. His painting process and his paintings both have sacred value for many, the way an icon gathers power as an object of repeated contemplation. Perhaps this is most obvious in the way his paints are marketed specifically for the production of his works. From his show to his products and even on his tombstone, Bob's logo—a simplified portrait of him smiling, his head surrounded by his Afro the way a Byzantine Christ is surrounded by a halo of light—serves like an icon of benevolence and protection. Bob created iconic landscapes. On *The Joy of Painting* he acted in way similar to the televangelist leading his television congregation through the psychological and spiritual arc of creating for the purpose of cultivating joy.

It is possible to recognize Bob Ross as a spiritual master preaching a beautifully transcendent world. As Lao Tzu writes, "The Master observes the world but trusts his inner vision. He allows things to come and go. His heart is open as the sky" (1992, 12). On *The Joy of Painting* Bob Ross conjured up an imaginary world of joy as boundless as the skies he painted. Viewers may tune into the hypnotic movement of his hand as it paints, rest and take refuge in his voice, or feel connected to the mythos of the world he is conjuring. Choosing to tune into Bob as teacher, healer, guru, or saint can mean relating to something sacred in his calming presence. His charismatic personality and loving message fed into his presence as a media star.

5

BOB ROSS AS MEDIA STAR

From the beginning of his career as a painting instructor, Bob Ross understood the value of diversifying the ways in which students could experience instruction and the instructor. His mentor, William Alexander, had demonstrated to him how to construct a successful business model of face-to-face teaching coupled with book publications, an art supply product line, and a television show. Bob and his associates at Bob Ross, Inc., copied and sophisticated this approach. Like Alexander, Bob cultivated students and fans through face-to-face classes, art supplies, instruction books, and a television show. However, unlike Alexander, Bob and his associates understood the power of the image and personality in telling the story of Bob Ross and communicating the story and experience of Bob Ross across multiple media in an entertaining way.

Creating the Bob Ross Image

The Bob Ross business coupled Bob's affable and humble personality with a distinctive hairstyle and dress-down costuming of open-necked shirt and jeans. Bob and Bob Ross, Inc., created a backstory for Bob that was very short on biographical detail. It emphasized humble beginnings, an appreciation for nature, an every-person philosophy, and a loving character who extended to students, his television show viewers, and the injured animals he cared for and rehabilitated. This narrative was communicated by Ross and continues to be communicated through Bob Ross, Inc., through his television show persona; the way in which these shows were scripted; Bob's appearances on other television shows, such as *Phil Donahue*; personal appearances; *Brush Strokes*, the newsletter

47

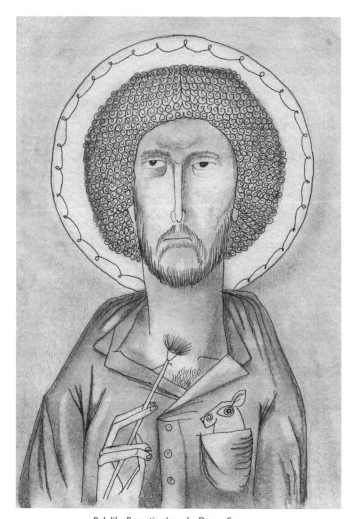

Bob like Byzantine Icon, by Danny Coeyman

publication of Bob Ross, Inc.; the business website; social media on the Internet; the Bob Ross Art Workshop in New Smyrna Beach, Florida; and, most recently, the authorized documentary *Bob Ross: The Happy Painter* (2011). Exemplary of the sophistication brought to this endeavor was the decision by Bob in the early 1990s to do two promotional spots for MTV. In each he appeared in his characteristic open-necked shirt and jeans, standing at an easel with pallete and brush in hand. In just a little over twenty seconds each, he paints two landscapes that morph into the distinctive MTV logo. Ross ends one spot by saying, "MTV, it's

all just fluffy white clouds." The other spot ends with Ross saying, "MTV, the land of happy little trees." At the time of this writing both of these spots were available on YouTube. Michael Kimmelman (1995), writing in the *New York Times* shortly after Bob's death, observed, "Perhaps there is nothing more American about him than the fact that at the end he became an icon for Generation X-ers. Following in the unlikely footsteps of Tony Bennett, he achieved cult like status after starring in a series of promotional videos for MTV. Ross was so unhip that he became hip."

Posthumously, Bob Ross, Inc., continued to capitalize on this association with MTV with an animated Bob Ross appearing in the *Celebrity Death Match* video game opposite Jerry Springer. Again wearing his signature outfit of open-necked shirt and jeans, a muscle-bound and acrobatic Bob Ross takes on Springer. Contrary to the affable and peace-loving Bob Ross of the TV show and MTV promos, this Bob Ross is brutally aggressive. At one point in the trailer for the game, Springer does pull out one of Bob Ross's eyes without breaking the connective tissue, thus allowing it to snap back (GAMESPOT 2013).

More recently, Bob's relationship with public television no doubt resulted in Bob Ross being featured in the PBS icons remixed series. John Boswell, who did an earlier remix titled "Garden of Your Mind" honoring Fred Rogers, created the "Happy Painter" based on Ross's *The Joy of Painting* series that runs on many PBS affiliates. Posted to the PBS website on July 26, 2012, and running nearly three and a half minutes, Boswell, aka Melodysheep, creates a catchy, hummable melody mixed with cuts from *The Joy of Painting* series, where Bob Ross is auto tuned to sing, "Believe you can do it," "Relax, let it flow," "This is your world; you are the creator," "Everyday is a good day when you paint," and painting will "bring good thoughts to your heart" (PBS Digital Studios 2013).

Creatives Respond to Bob Ross

The official and authorized experience of Bob Ross, as strategically crafted by Bob Ross, Inc., over the years, is carefully controlled. Allegiance to the narrative is secured through the Bob Ross TV Art Club, the teaching certification program, and a very assertive effort on the part of Bob Ross, Inc., to control use of the Bob Ross image. However, this has not prevented numerous parodies of Bob Ross across a variety of media by creatives working outside of the corporation. Universal to these parodies

is a painting setup similar to that found in *The Joy of Painting*; a character resembling Bob Ross, with emphasis on the hair; a persona and manner that initially resembles Ross's affability, and then finally ending with a break in character, revealing a less affable and stable art instructor.

An early effort was a 1970s Bob Ross parody that purportedly aired on *Saturday Night Live*. Titled "Episode 11: Desert Village Sunset Scene," it is now available on YouTube (http://www.youtube.com/watch?v=RKcMfQrqC7I). In the comedy sketch a Bob Ross look-and-act alike begins to paint a desert scene that includes "Mr. Sun," "a happy little tree," a "little hut where native villagers live," and eventually a "little soldier," carrying an AK-47 assault rifle, who sets fire to the hut and leaves dead children behind. The painter signs off by stating, "It looks like this village has been ethnically cleansed" and "No, it's never done until you get off your lazy ass and do something about it."

Even after Bob's death, parodies continued to be aired. For example, in an April 25, 2000, episode of the animated series *Family Guy*, titled "Fifteen Minutes of Shame," the main character, Peter Griffin, is shown learning to paint from an animated *Joy of Painting*–like episode featuring a painter looking like Bob Ross. Painting a landscape, he uses a fan brush and hunter green paint to place a "happy little bush" in the right-hand corner of the painting, telling viewers that it is "our little secret." Suddenly he experiences a personality change, warning his audience, "If you tell anyone that bush is there, I will come to your house and cut you!" At a certain point Griffin ignores the directions from Bob Ross and instead paints the Keaton family from the television series *Family Ties* (Wood 2000). *Boondocks*, an animated series based on the comic strip of the same name, included a February 19, 2006, episode titled "Riley Wuz Here," in which the character Riley, without permission, paints the side of a neighbor's house. An art critic with a very strong resemblance to Bob Ross wanders by and critiques the painting. Riley gets in trouble with his granddad for vandalizing the neighbor's house. As punishment he is forced to take art classes from the critic. He and the teacher go on after-dark paint raids, spray-painting an image of a giant fruit bowl on one house and "Ol' Dirty Bastard" on another. The episode comes to a close with Riley wanting to convince his granddad of his ability by painting a mural of his deceased parents. This later paint raid involves the art teacher and Riley in a car with "Trees" as the license plate, being hotly pursued by the police. At one point the art teacher pulls out a gun and shoots out the tires on the police cars, all the while talking Riley

through the encounter in a soothing voice. The episode ends with Riley's granddad being impressed and touched by the image of Riley's parents. However, once he photographs it, once again he forces Riley to clean it up and advices him to keep his art confined to canvas (Lee 2006).

Creatives, who identify as artists working within a fine arts gallery context, have developed a more-nuanced and less-predictable response to the Bob Ross persona and experience. Scott Kaplan is a member of the Art Department at Ohio State University. In the fall of 2006 Kaplan participated in an installation and performance titled *30 Days, 30 Minutes, 30 Paintings* at the Mahan Gallery in the Short North area of Columbus, Ohio, near the university. Kaplan installed in the gallery a studio environment mimicking Ross's *Joy of Painting* setup that included an easel, platform, palette, similar brushes, palette knife, all in similar locations to Ross's. Wearing blue jeans and a white T-shirt, Kaplan, with a long, distinctive mane of his own, painted along to a *Joy of Painting* episode. Videoed by Alive TV in Columbus, with the video now available at Vimeo.com/161984, it is possible to see Kaplan painting with Bob Ross while a throng of onlookers cheers him on, shouting, "Paint those trees!"

Prior to the installation, Kaplan spent a great deal of time researching Bob Ross and his instructional method and painting techniques (details that follow are from personal communication October 22, 2006). Kaplan was inspired by Bob's appeal, which he attributed to Bob's gentle nature. Calling him the "Tony Robbins" of the Art World, Kaplan perceived Bob as a motivational speaker able to encourage and empower his viewers. He also admired Bob's ability to make the painting of images appear like a magical trick. Kaplan was also intrigued by the idea of groups of people all doing the same paintings in random locations, remarking on the irony of "all of these people painting landscapes that do not exist, but done in different locations." Kaplan admits to knowing other artists, like himself, who begrudgingly respect Bob Ross for the number of paintings he completed and his adept mentoring and for being the "constant video professor." Kaplan considers his performance/installation an investigation of art practice. Associated with this investigation was his engagement with the dialogue in the Art World of what constitutes high art, low art, and craft. Kaplan also likens his performance/installation to the "plein air" approach to painting. Although, in this case, Kaplan is not painting an outdoor scene while being in the outdoors, but instead is painting along with an indoor painter painting a landscape indoors.

From September 27, 2012, through October 21, 2012, the Screaming Sky Gallery in Portland, Oregon, hosted the exhibit "Happy Little Trees: Contemporary Artists Take On the Iconic Television Painter Bob Ross." Located in the hip and gentrifying Alberta Street neighborhood of Portland, the exhibit featured the work of twenty-six artists. Aaron Jasinski, who also contributed a painting to the exhibit, curated the exhibit. Jasinski, born in 1974, fondly remembers watching *The Joy of Painting* as a child (details that follow are from personal communication, November 23, 2012). He went on to study graphic design and illustration at Brigham Young University, earning a BFA. Since graduating he has moved away from illustration and toward making art inspired by the popular culture/surreal art movement that emerged around 2000 and as featured in the art magazine *Juxtapoz*.

Jasinski believes that he is part of a generation of artists whose work is informed by nostalgia for childhood, with many artists using childhood references in their work. For this pre-Internet generation of artists, childhood, according to Jasinski, was a magical time in which popular cultural references could be held in common rather than fragmented, as they are now because of the Internet. He and other artists like him pine for this commonality.

For Jasinski, Bob Ross and *The Joy of Painting*, being an early introduction to art, are two of those references. In turn, this inspired Jasinski to curate "Happy Little Trees," a first effort at curating on his part. His goal for the exhibit was to bring together a group of artists responding to the influence of Bob Ross or the artistry of Bob Ross. A second goal was to bring attention to the influence of popular culture in people's lives. The artists that Jasinski invited to participate were artists that he knew and admired or were associated with the Screaming Sky Gallery. Many of the artists were from the Pacific Northwest, with others being from other parts of the United States, Canada, and the United Kingdom. While most of the artists participating were familiar with Bob Ross, some were not. Artists were free to pay homage or critique Bob Ross and his technique.

When considering what to paint for the show, Jasinski considered doing a portrait or a landscape. Eventually, he combined the two by doing a portrait of a smiling Bob Ross with his hair as a basis for a landscape in which other popular culture figures such as Smurfs, Woody Wood Pecker, Yogi Bear, and Bambi were nested. In doing so, Jasinski realized that many of his childhood favorite characters were in some way associated

with the woods. (Jasinski's painting can be found on his website at http://
www.aaronjasinski.com/. Paintings by other contributors to the exhibit
can be found on the Screaming Sky Gallery website at http://screaming-
skygallery.myshopify.com/search?q=happy+little+trees.)

Jasinki described the response to the exhibit as being positive, with
many artists selling their work. He described the opening as being well
attended and with good energy. He has not received any communica-
tions from Bob Ross, Inc., to date.

Bob Ross on the Internet

On October 29, 2012, Bob Ross would have celebrated his seventieth
birthday. Visitors to Google on that day found the popular search engine
celebrating it by posting a "google doodle" of Bob Ross holding a palette
with his squirrel Peapod on his left shoulder painting a mountainous
landscape with the lowercase Google "g" floating on a foregrounded
roaring river. It was more than fitting that Google celebrated the artist's
birthday, given Bob Ross's presence on the Internet. On December 29,
2012, a Google search of "Bob Ross" yielded 50,200,000 results. Search-
ing for "happy little trees," "*The Joy of Painting*," and "Pea Pod squirrel"
yielded high numbers as well.

Bob Ross, Inc., takes full advantage of the Internet through its website
(http://www.bobross.com/), Twitter feed (https://twitter.com/BobRoss),
Myspace page (http://www.myspace.com/bobross), and Facebook page
(https://www.facebook.com/pages/The-Joy-of-Painting-with-Bob-
Ross/150008825045842?sk=wall). On December 29, 2012, the "Joy of
Painting with Bob Ross" Facebook page showed 927,045 "likes." Those
following this page receive periodic quotes from Ross as well as notifica-
tions about merchandise such as the 2013 Bob Ross calendar, T-shirts,
and the Bob Ross app available through iTunes. The official Bob Ross
Twitter feed showed 21,183 followers as of December 29, 2012. Followers
receive inspirational Ross quotes on a variety of topics including paint-
ing techniques, embracing nature, and observations about life.

Beyond the official and authorized presence of Bob Ross on the In-
ternet, his unofficial and unauthorized presence can only be described
as extraordinary in variety, purpose, and the number of ways his image
appears. An easy way to grasp the ubiquitousness and variety associated
with the image of the man himself is to do a Google image search of "Bob

Ross," where the result will be a rich display of permutations of the man and his paintings. Another place to experience the Bob Ross phenomenon on the Internet is to search for "Bob Ross" on Followgram, the web interface for Instagram, the photo-sharing application. The result will be an assortment of fifty Bob Ross–inspired hash tags associated with over ten thousand Bob Ross–inspired photographs such as these: a man holding a Bob Ross–inspired painting (http://followgram.me/i/3617157 83842197631_274806083), an arm with a Bob Ross–inspired landscape within a heart (http://followgram.me/i/358941790186894871_12742172), and a man wearing a Bob Ross T-shirt (http://followgram.me/i/361490 448851714568_252620047). Hash tags include bobross, bobrossstyle, bobrosswouldbeproud, bobrossismyhero, and bobrossforpresident, among others.

A similar search on social media such as Twitter and Tumblr yields similar results in text and images. On Twitter a search of Bob Ross (https://twitter.com/search?q=bob%20ross&src=typd) yielded tweets like the following:

> Adam Wilson@theleanover: Bob Ross just picked up a brush full of oxblood red and told us to paint "a happy little pentagram?"

> Darren Elmore @darrenelmore
> @ShittingtonUK@theleanover: Remember, there are no mistakes . . . only burning seas of acid and endless torment.

> Tom Otero@lockebyproxy: Someone please tell me someone is making a Bob Ross biopic starring Jeff Bridges.

> Samuel Gilliam@TheGilliMAN: My official first painting with my Bob Ross painting kit! I call it "Snowtop River."

> LeVar Burzum@drugleaf: Imagine Bob Ross seductively whispering "do you want to see a happy tree?"

On Tumblr, searching for "Bob Ross" (http://www.tumblr.com/ tagged/bob+ross) yields a cross-stitched portrait of Bob Ross, a café menu board featuring Bob Ross, Harrison Ford as Bob Ross, and Bob Ross painting Spartans falling off a cliff, among many others. "Happy little trees" search (http://www.tumblr.com/tagged/happy+little+trees)

yields a Lego Bob Ross, a road sign with a picture of Bob Ross and the words "Happy Little Trees Ahead," Bob Ross at a canvas smoking a joint and painting marijuana, and a child dressed as Bob Ross.

Those looking to purchase Bob Ross–inspired crafts can go to etsy. com and search "Bob Ross." By doing such a search it is possible to choose from 180 items (on December 29, 2012) featuring Bob Ross in some way. Items include buttons, T-shirts, puppets, posters, stationary, cell phone cases, and jewelry, among other items. "Happy little trees" will yield similar results. Searching "Bob Ross" along with some of his other catch phrases on Vimeo and YouTube will provide hours of entertaining spoofs of the painter as well as serious treatments and excerpts from the *Joy of Painting*. The website *Know Your Meme* documents Internet phenomenon (Know Your Meme, 2013). One such phenomenon, dating to 2002, is "Photoshop Bob Ross." The "Photoshop Bob Ross" meme takes as its image of origin a well-know "official" picture of a smiling Bob Ross standing in front of a painted landscape with brush and palette in hand. From this original image it is impossible to estimate the number of other images that have been created showing Bob Ross painting erotica and nuclear bombs, Bob Ross as a Lego figure, and Bob Ross as tattoo artist (http://knowyourmeme.com/search?utf8=%E2%9C%93&q=bob+ross).

A fitting way to conclude a discussion of Bob Ross's web presence is by referencing his placement on the website *Find a Grave* (2013). There you will find his birth and death information, a brief description of who he was, pictures of him, and a picture of his grave marker in Woodlawn Memorial Park in Gotha, Florida (http://www.findagrave.com/cgi-bin/ fg.cgi?page=gr&GRid=19437). As of January 4, 2013, 1,243 "flowers" have been submitted to the site. Animated and non-animated icons such as clapping hands, balloons, flower arrangements, and holiday greetings often accompany flowers. Some also include tributes to Ross and his importance to a contributor's life. On Bob's page he is rated at 4.5 stars out of 5.0 on the "famous" scale (303 votes cast). As a point of comparison, Andy Warhol is rated the same, with 217 votes cast. He has received 300 flowers there as of January 4, 2013 (http://www.findagrave.com/cgi-bin/ fg.cgi?page=gr&GRid=1459).

Bob's extreme presence as a media star feeds into his persona as a hip and loving teacher. The following chapter will explore his role as a teacher.

REFLECTIONS ON BOB ROSS AND HIS WORK

Bob like Picasso, by Danny Coeyman

6

BOB ROSS AS THE BEST-KNOWN TEACHER "ALIVE"

It is hard to imagine that there is a more well-known art teacher in the world than Bob Ross. While he isn't studied in art education classrooms (certainly not routinely), he's "out there" as a force that entices and cajoles thousands of individuals to paint. And while only a small portion of those who watch Bob on television actually paint, all the rest learn something about painting—whether university-schooled art educators like what he has to say or not.

The formal field of art education is full of theories and approaches to teaching art. Since the mid-1900s, scholars and teachers have promoted art education that is child-centered, creativity-based, theme-based, environmental, discipline-based; and the field expanded recently into visual culture and material culture. Regardless of all the in-school attempts to promote participation in art, often as an elite pursuit, numerous people credit Bob Ross as their most relevant and inspiring art teacher. It is not so much that they mimic the artist; rather they see him as a point of entry into the art world (or in some cases, the Art World).

Charles M. Blow, who writes for the *New York Times*, is one of many people influenced by Bob Ross. Responding to 2012 presidential candidate Mitt Romney, who threatened to stop federal support for PBS if he became president, Blow wrote:

> *I never went to art or design school. In college, I was an English major before switching to mass communications. Still, I went on to become the design director of* The New York Times *and the art director of* National Geographic *magazine.*

That was in part, because I had a natural gift for it (thanks mom and dad and whatever gods there may be), but it's also because I spent endless hours watching art programs on PBS. (Bob Ross, with his awesome Afro, snowcapped mountains and "magic white," will live on forever in my memory.)

I don't really expect Mitt Romney to understand the value of something like PBS to people, like me, who grew up in poor, rural areas and went to small schools. These are places with no museums or preschools or after-school educational programs. There wasn't money for travel or to pay tutors. (2012, A17)

Successful artists and everyday practitioners all over the world give credit to Bob for their artistic ventures. What is especially important, because of the widespread availability of his broadcasts, is that he has been able to reach those who are most underserved due to their geographic location or economic status. Bob Ross, for any number of reasons, has captured the attention of people from all walks of life.

Art Education Today

In 1997 the Ninety-Second American Assembly released a groundbreaking report, *The Arts and the Public Purpose*, that defined the arts in the broadest possible way for the purpose of "resisting the conventional dichotomies of high and low, fine and folk, professional and amateur, pop and classic" (1). In doing so, the report also legitimized that people can learn to make and appreciate art beyond the educational institutions that we associate with the nonprofit sector (i.e., public schools and universities); they can also learn through commercial enterprises and in venues that are neither commercial nor nonprofit. The Ninety-Second American Assembly report promotes a view of art education in which children, youth, and adults can learn to make and appreciate art within a vast network of formal and informal venues that includes community arts centers, schools, museums, universities, places of worship, hobby shops, and health care facilities, among many others. It is also possible to learn to make and appreciate art within informal settings such as clubs, interest groups, and people's homes. Bob Ross is unique among art educators in that he taught across all of the sectors recognized in the Ninety-Second American Assembly report, as do Bob Ross–certified

instructors. Bob Ross, when teaching on behalf of William Alexander's company or Bob Ross, Inc., participated in art education that occurred as a commercial enterprise. Bob Ross, when broadcast on public television affiliates, joined in art education practices that occurred within a nonprofit endeavor. Bob Ross's method, as taught by certified instructors, occurs across all three venues, with teachers being independent contractors or volunteers or teaching within nonprofit community-based locations.

Bill Ivey's (2008) ideas about art and education are equally expansive. His view is that everyone should have access to the arts and diverse forms of the arts should be embraced. Amateur artists should be encouraged and localized expressions valued. Ivey claims that three things are needed for art to prosper. First, he acknowledges that originality needs certain conditions to flourish. Aspiring artists need access to the Art World and a way to enter into it. Bob Ross's teachings, both his formal classes offered by Bob Ross, Inc., and his television series, present a way in. Second, Ivey claims that aspiring artists need respect for their approach to problem solving and adequate financial support to sustain a creative life. Bob Ross offers a safe haven for varying approaches to painting. His approach is a beginning; his students are encouraged to use his techniques and go their own way. The financial support Ivey says is necessary to a creative life is hard to materialize in our present economic system. However, Ivey also recognizes that the gifts that come from creative activities are often seen in myriad ways besides monetary. And last, and perhaps most important, Ivey recognizes that aspiring artists need to be able have access to other artists so that they can build on their creative efforts. Perhaps no artist or educator makes his or her work more available to others than Bob Ross.

The monetary issue that Ivey raises deserves more discussion. Bob Ross's instruction may or may not lead to a monetary reward. In the case of Charles Blow and many others, Bob's teachings provided beginning instruction and a place of acceptance and safe experimentation. But most people who listen to Bob Ross and engage in his painting style don't become professional painters or proficient artists of any kind. Nonetheless, they engage in the process as leisure, as opposed to a profession. Robert Skidelsky and Edward Skidelsky (2012), in their article "In Praise of Leisure," revisit a idea posed in 1930 by John Maynard Keynes, who believed that by 2030 we might live in a world where labor is distributed more equally and people work only fifteen hours a week. Keynes

believed that because technology would provide for our needs more efficiently, we would have more leisure time. According to the Skidelskys, the important thing about Keynes's idea was not that it isn't becoming true, or certainly doesn't seem like it will be true in spite of the rise of machines doing more and more of our work. What is more relevant is that he raised a question regarding what wealth was for and how could we live a good life. Following his line of thinking, wealth was not an end in itself. One cannot live a satisfying life only by making money (and Ivey would certainly agree). One needs to do something else to be happy. The Skidelskys believe we should have more leisure time, by which they do not mean more idleness. For them leisure, as it was with Kant, is "purposiveness without purpose," or an activity without extrinsic end. There is no other end than doing something well. Even if there is a monetary component to the effort, such as may be the case with a musician working on a performance or a teacher discussing a difficult idea, the income is not what drives the activity. Instead, it is doing what motivates them. It is nice to be paid to do what you love, but leisure does not demand it. The Skidelskys explain, "Insofar as action proceeds not from necessity but from inclination, insofar as it is spontaneous, not servile and mechanical, toil is at an end and leisure has begun. This—not idleness—is our ideal. It is only our culture's poverty of imagination that leads it to believe that all creativity and innovation—as opposed to that specific kind directed to improving economic processes—needs to be stimulated by money" (2012, B14). It is clear that so many of Bob Ross's followers paint to perfect a scene. They are not motivated by money, but by the sheer pleasure of engaging in the activity. Leisure time spent in painting can lead to a good life. Numerous Bob Ross participants have confirmed this fact to us. Not everyone would call his or her artistic activities a leisure pursuit (some would indeed say it was work), but the end goal is to make something pleasing or understandable or (maybe) truthful.

One important question to ask about Bob Ross's teaching is the same question that should be asked of any art teacher: Does the teacher want you to do what he or she is doing or does the teacher want you to do what you want to do? Bob Ross makes it clear that he wants his students to do what they want to do and that working alongside him in a seemingly rote manner might assist in getting you there. He only provides a structure, one that is accepting, sharing, and imaginative. "This is your world," Bob continuously reminds us.

David Gauntlett (2011), in his book *Making Is Connecting: The Social Meaning of Creativity from DIY and Knitting to YouTube and Web 2.0*, builds on the work of Ivan Illich, who claimed that education should teach students to shape their own worlds. Gauntlett's idea of education, much like Bob's, is to help create a relationship between people and their environments. Individuals, he claims, should learn about what they are interested in, when they are interested in it. This kind of schooling seems to pop up every so often and was echoed in the Summerhill school ideology of the 1960s.

Perhaps the most relevant part of Bob's thinking, which is echoed by A. S. Neill (1960) in his book on Summerhill, along with Illich and Gauntlett, is that education should be supportive. It should ensure participation, at whatever level someone is able to engage. The problem with schools, Illich and Gauntlett say, is that they too often lead people to believe that they can't do something and that the only way to do something is the way big institutions tell you something has to be done. Moreover, there is often a loss of joy in participation. Perhaps this is why Bob Ross, Inc., markets his work as being joyful. Certainly, Bob Ross's style and even his classes with cookies and coffee offer friendliness and acceptance. Where someone goes after creating that first happy cloud and happy tree is up to the participant. But in Bob's world, there are no mistakes and you can't fail. What Bob does is liberate his students as he paints. He teaches us that we can participate, and we can make our own creations.

Finding Your People

Those who appreciate Bob Ross often do so because they find their community in him rather than through a specific art education venue. This is a response that people express in relationship to all kinds of art communities. Individuals who make scrapbooks, zines, quilts, and jewelry continually voice a desire to engage in creative activities but were turned off by art in schools because it was too serious or analytic. As Christy Petterson said when she discovered getcrafty.com, "I realized that I had found my people" (quoted in Gauntlett 2011, 65). If you make something yourself, you are not just a consumer; rather, you are a producer. In this role, you become more thoughtful and aware. In the case of painting like

Bob Ross, you explore his thinking process so that you can (if you want) develop your own.

Least you think that these art communities are only crafty (read, mostly incorrectly, as of less value that so-called Fine Art), consider the response of Jessica Bruder, who in 2002 went to the Burning Man festival for the first time. As a writer and not a visual artist, she wasn't sure what she would do, but she knew no spectators were allowed; everyone was expected to participate. She attached forty Chinese fish-designed kites to her bicycle, and once she got one flying, she passed the string on to a stranger. Admitting that her performance wasn't particularly creative, she saw this act as transitional. Bruder explains, "I'd be lying if I said that particular act changed my life. What felt transformative was this: I spent a week outside my comfort zone, with thousands of people who were also exploring their boundaries, and whose artistic efforts succeeded or failed magnificently" (2012, A25). After that experience, she learned to cut and weld steel, and she began installing sculptures at the festival. Bruder reflected on her first time there, saying, "If Burning Man hadn't set the bar low enough to trip over in the first place, I never would have made it out there" (A25). Unfortunately, she says, today's Burning Man is much harder to get into. Bob Ross, gratefully for many, democratically accepts everyone and gives them a chance to start where they need to, like it was in the early years of Burning Man. In so doing, many people "find their people" as they explore their creative way in the world.

Learning from Bob Ross

Examining Bob Ross's skills as an art educator and the continuance of those skills among those trained in the method assists in understanding Bob Ross's strength as an art educator as well as those who find his approach less compelling. There is no doubt that contributing to Bob's effectiveness as a teacher is his charisma both on and off screen. Annette Kowalski, in the documentary *Bob Ross: The Happy Painter* (2011), found Bob to be "mesmerizing," a word that reappears when people describe the artist/teacher. She also noted that people found his voice to be like a "liquid tranquilizer" (Kowalski 1993). There are numerous references throughout this book demonstrating that both in person and on video Bob was (and is) experienced as a charming and attractive personality. He was, and is, perceived as kind, gracious, inclusive, loving, creative,

supportive, and virtuous. With that charisma comes an authority allow-ing Bob to guide people to artistry, as well as, according to some, to hap-piness and a good life.

There is an extensive body of scholarly literature in education and related fields that examines the relationship of a teacher's personality to success and effectiveness in teaching. (See, for example, the "Teacher personality" section of the Psychology Wiki at http://psychology.wikia.com/wiki/Teacher_personality.) However, of greater interest, and much more nuanced, are those novels, memoirs, and films that have ex-plored the importance of a teacher in shaping one's relationship with the world and coping with the challenges of everyday life. Consider, for example, James Hilton's (1934) *Goodbye, Mr. Chips*, Bel Kaufman's (1965) *Up the Down Staircase*, and Rig'dzin Dorje's (2001) *Dangerous Friend: The Teacher-Student Relationship in Vajrayana Buddhism*. Consider also memoirs such as Erin Gruwell's (1999) *The Freedom Writer's Di-ary: How a Teacher and 150 Teens Used Writing to Change Themselves and the World around Them*, Sylvia Aston Warner's (1986) *Teacher*, and Jonathan Kozol's (2008) *Letters to a Young Teacher*. On film there are excellent teachers portrayed by Robert Donat in *Goodbye, Mr. Chips*, Sidney Poitier in *To Sir with Love*, Sandy Dennis in *Up the Down Stair-case*, and Hilary Swank in *Freedom Writers*. Common to these examples are teachers who while having vivid personalities also have high expecta-tions of their students. They are passionate about what they are teaching and encourage others to join with them in the pursuit of knowledge. These teachers are fully focused on the educational experience and com-mitted to advancing a student's critical thinking skills. They also resist distractions, some very dramatic at times, that dilute the educational experience. They build strong relationships with their students and assist their students in understanding and appreciating that while they may be concentrating on a specific subject, there are much broader implications associated with what they are learning and the way that the learning takes place.

How is Bob Ross perceived as a teacher? Marion Boddy-Evans (2013), who blogs about painting on About.com, invited readers to post on the topic "The Bob Ross Method of Painting: Love or Hate It." The com-ments submitted are largely positive and consistent with the qualities of the teachers described above. Contributors praise Bob for introduc-ing them to art, inspiring them to paint, helping them find their talent, introducing them to landscape painting, and helping them learn more

about painting. There is also praise for assisting in building self-confidence and self-esteem. However, there are comments on the blog that are less positive. Bob's parting ways with William Alexander comes up as an act of betrayal. His paintings are criticized for a lack of variety and being easily cloned. He is also criticized for the impressionistic quality of his work and the fact that his landscapes are imaginary. Another source of annoyance is that his depiction of nature is unnatural. He is criticized for having his students' paintings all look alike.

"Dan" (2007), writing in the "Art Opinion: Articles and Insights for the 21st Century Artist" section on the Empty Easel blog, is very critical of Bob Ross. While acknowledging that Bob did a "lot of good" by encouraging people to start painting, he identifies significant problems with the method. Dan does not appreciate that the work of Bob's students looks like Bob's work. In Dan's opinion, this creates a dependence on Bob Ross. He writes, "What happens when a truly dedicated 'Bob Ross Methods' painter wants to paint a scene that Bob never covered?" He answers his own question by stating, "They're stuck, because they were never taught how to come up with ideas for painting on their own." Dan is also concerned that Bob's students only know how to paint from their imagination, which, in Dan's opinion, pales in comparison with what reality has to offer. He writes, "Look at all those 'happy trees' Bob Ross taught people to paint. They don't really look like *actual trees*. . . . [T]hey look like, well, 'Bob Ross' trees." Bob is criticized for not assisting his students to learn to "look" at what is around them. He concludes his critique of Bob Ross by criticizing his paintings for showing little or no variation over the course of his career, thus failing to demonstrate growth as an artist. For Dan, this is not the model of artistry that he would want people to emulate.

Painting along with a Bob Ross instructional episode or participating in a class taught by a certified teacher can provide an experience consistent with Dan's observations. Bob assumes we will be able to create the instructed oil painting and assumes that the painting will look like his. Bob and his certified instructors teach techniques that persuade participants to follow along, brushstroke by brushstroke. In his soft-spoken way, he encourages students through an obvious love for what he is doing that he wants to share. Bob's effectiveness as a teacher is supported by his organization. His approach is methodical. All necessary components to the process are explained and, if in a workshop setting, available. For the broadcasts, it is known that Bob painted a preliminary

picture of what he would be teaching during the broadcast so as to be able to fully anticipate the results and the process associated with the results.

Contributing to Bob Ross's effectiveness as a teacher is the way in which he reinforces participation with verbal praise. There is a strong behaviorist component at work in Bob Ross's teaching and in the classes taught by certified instructors. However, there is no evidence to suggest that Bob Ross was aware of behaviorist theory and its use in educational contexts. An educator using a behaviorist approach identifies what is to be learned as well as the reinforcers that will be used to guide student behavior toward that learning. Reinforcers can be both positive and negative. Learning is measured through some type of visible end product that is observable and measurable. At times what is being taught will be broken down into reinforceable sub-skills, leading to more complex tasks. This is a strategy known as chaining. Within the Bob Ross method, at least superficially, what is to be learned are the components leading to the completion of a successful painting as measured by its congruence with the instructor's original. Instruction takes place through the teaching of a series of oil-painting skills, leading to the completion of the painting. A chaining methodology is used to move, step by step, from the blank canvas to the finished painting. Reinforcers are all positive and of two types. There is the reinforcement that comes from the apparent mastery of the sub-skill, such as painting clouds, foliage, or mountaintop snow, as well as verbal praise. It is almost impossible to believe you are not succeeding when your teacher, throughout the lesson, is telling you that you "have unlimited power," "any time ya learn, ya gain," and "we don't make mistakes, we just have happy accidents."

Teaching Effectiveness

On the surface, Bob Ross's critics may be correct in what they are observing. However, an equally compelling argument can be made that Bob Ross's effectiveness as a teacher transcends the limited focus of his method as compared to what might be learned from others with a broader and more varied approach. As is evident from testimonies in this book and elsewhere, Bob's seemingly limited focus can and does permit achievements that go beyond rote copying and skill as a painter. Bob Ross never claimed that he was providing a comprehensive art

education. All he and his certified instructors promise is the cultivation of a "joyful" attitude, resulting from a fully focused immersion in the technique taught, and the reward of achieving success in an early effort through the use of a limited range of art materials. Bob's focus is on the "whole" person, rather than on the narrowly defined, skill-based purpose most often associated with art education. In this regard he is similar to those exemplary teachers encountered in the novels, memoirs, and films cited above. Along the way he encourages his students to maintain a sense of humor, to not take things too seriously, to rejoice in small successes, to be thankful for what life brings, to appreciate the world around us, to learn self-acceptance, and to celebrate that what was achieved was done so in the company of others. Bob Ross offered his skills as a non-expert, someone not accepted in the Art World. Participants in his world can disregard hierarchies of experts and elites. It is a place where validation and acceptance come easily and don't depend on harsh critiques so commonplace in the Art World. Painters can simply enjoy and move on if they wish. The celebration of the finished work may be amateur, but it recognizes participation in the creative world.

In other words, Bob's greatest success as an educator is not that he taught an approach to painting. Rather, it is that he taught an approach to *learning and living.* By demystifying at least some of the tools and techniques of oil painting, he made it possible for many who saw themselves as "untalented" to pick up a brush. Results will vary, and that is normal, but Bob's welcoming style afforded people from all walks of life—and of all levels of self-esteem—to make pictures of his happy world and their own. But most importantly, his methodology was infused with a "try it and see" quality that is fundamental to anyone who intends to gain knowledge, to grow, or to practice a skill in the face of self-doubt. His charisma as a teacher made him vulnerable to the guru effect. Instead of copying the master's message, many just copy the master. But for those who interpret Bob as an example of a way of being and not so much a way of making, Bob's message that "this is your world" offers just enough encouragement to find one's own path in that world.

While readers might agree that Bob could be considered a good teacher, questions remain about the quality of his painting. The following chapter will discuss his approach to artwork.

⊸ 7 ⊷

ASSESSING BOB ROSS'S PAINTINGS AND HIS APPROACH TO ART

As we write this book, our friends and colleagues ask us about our current project. When we explain that we are writing a book on Bob Ross, there are mixed reactions. What is interesting, however, is that, generally speaking, the more involved someone is in the Art World, the more excitement they have for our book. This private confirmation for Bob is in contradiction to the public view, which seems to articulate an Art World snobbery for Bob Ross. The reaction from some, however, is something like dismay. Still others either aren't sure who Bob Ross is until we describe him or they question why anyone so connected to the Art World would want to write about such a lowly art character. Some even believe his work diminishes the role of the artist and that his paintings should be panned as sentimental, fakery, kitsch, or just plain bad art. For the most part, however, the response is one of joy. This leads us to ask several questions: Why do so many people, from all walks of life, love his landscape paintings? Is it possible to love Bob Ross the artist and not care so much about his paintings? Should we think of Bob Ross as a professional artist or an amateur? How should we think about the Bob Ross phenomenon?

Amateur Art

If being professional or an expert means making it financially, then Bob Ross, through Bob Ross, Inc., has done quite well. If it means that major art museums and galleries recognize and show your work, then Bob Ross has failed in this regard. His language and approach is homespun,

Bob like Rembrandt, by Danny Coeyman

his work is quickly produced, and his paintings are formulaic. These characteristics might be indicative of an amateur.

Today, art of the amateur is mostly thought of as lowly, but it was once important in Western culture. The value of the amateur was diminished with the beginnings of the Industrial Revolution, as the idea of the modern expert began to take root (Sennett 2008, 246).

If Bob Ross's paintings seem like amateur art to some, his teachings also may be thought of as amateur art education. If we were to agree that Bob Ross was an amateur painter, how would that affect the way we value his art and his educational approach? Michael Kimmelman (2005) claims that amateur art can be appealing when we distance it from art that we call professional. The amateur paints with no expectations from

the public, apart, perhaps, from family members or a few friends (Kimmelman 2005, 46–47). The idea of being an amateur is appealing to other art figures as well. For example, Marcia Tucker, founder of the New Museum in New York City, claimed, "If being an expert means being deeply involved with what you already know, I have never been interested in being one" (2008, 197). Not only did she write that she herself was not an expert, but she reportedly liked amateurs, people whose work was not perfected. Others seem to agree. She noted that the Art Mob, after twenty-five years, was still drawing a strong audience, in spite of the fact that they do no major advertising. (The Art Mob, founded by Terry Allen in 1979 in New York City, is a group of nonprofessional singers and punsters.) Tucker writes that it is more fun to hear the untrained voice than the polished professionals that you can't possibly imitate, just as "it's more fun to watch the Big Apple Circus than Ringling Brothers and Barnum & Bailey, because at the Big Apple the acrobat might actually fall off the horse" (196).

This sense of risk is at play in Bob Ross's painting videos. Many people have noted that they hate it when Bob "ruins" a painting by putting a giant tree in the foreground, covering up the mountains and skies that he just beautifully crafted. So part of a viewer's engagement is not only to see and marvel at how Bob Ross does it, but also to wonder if—and when—he'll mess it up.

Others, however, may dismiss Bob Ross's paintings and his teachings for their step-by-step format, one reminiscent of the paint-by-number craze that captured the nation in the postwar years. This was a time when everyone envisioned himself or herself as a painter, including various Hollywood stars such as Frank Sinatra, Henry Fonda, and Claudette Colbert. No matter the social class, painting attracted men and women and was seen to be self-expression within certain prescribed boundaries (Kimmelman 2005, 31–39).

Few painters who follow the Bob Ross method and claim to be Bob Ross painters and not something else would think of themselves as professionals. Rather, they are hobbyists or, more simply, amateurs. In today's world, to be seen as a hobbyist or an amateur is not particularly good. Instead, in the institutionalized Art World, one must excel at something or cease doing it. Elite art schools, college and university art programs, and established and well-recognized galleries would all agree, perhaps not by what they say, but by their actions. (Folk art museums and galleries may be the exception.) But others would disagree.

Bill Ivey suggests that it is precisely because of this way of thinking that so many people have stopped making art or playing an instrument when they become adults. When they put down their paintbrush or their instrument, they are then placed in the realm of a passive receiver of the arts as opposed to being actively engaged in them (2008, 121). Richard Florida, along with an increasing number of do-it-yourself enthusiasts, also supports the work of the amateur, noting that the best ideas often start in garages and small rooms (2002, 184).

Imitation Art: Copying the Object

For many, and particularly those not that familiar with him, Bob Ross's teaching is about instructing others to reproduce his paintings, perhaps in a way similar to how he copied Bill Alexander's approach. For many students, the closer your work looks to the original, the better. At least this is true in the early stages of face-to-face Bob Ross instruction. Within the context of Modernism, imitating another artist was deemed to be formulaic and in contrast to what art was supposedly about. But critics, aestheticians, and artists are increasingly questioning ideas about originality and authenticity.

For example, filmmaker Peter Greenaway projects images onto the surface of major artworks, including Leonardo da Vinci's *Last Supper* and Rembrandt's *Night Watch*. He claims that some artworks have become so familiar that we have lost the ability to see them. One twenty-minute projection used light, sound, and text on da Vinci's *Last Supper*, as he created the illusion of daylight and movement in individual figures. Wine (or blood) spilled over the side of the table, and a soundtrack of broken chords pulsated. The entire scene was filmed. While many critics and scholars were horrified by Greenaway's use of the original works, he retorted by calling them snobs. Afterward, visitors to Milan were given a choice of seeing the original work, the appropriated Greenaway version, or a digital copy of the original. The copied version, "produced through digital panoramic photographs and multilayered printing technologies in super-high (1200 dpi) resolution on a 1:1 scale and printed onto a surface that mimics the original's cracks and bumps, set within an architectural production of the refectory, looks exactly like the original" (Tallman 2009, 76). Greenaway and his producer, Franco Laera, refer to this work as a "clone." While many questions are raised by Greenaway's

clone, one of the most curious, raised by Susan Tallman, is this: "How does our awareness of the clone's clone-ness affect what we see?" (2009, 76–77). In relationship to Bob Ross's work and that of his students, we might ask whether the student's work is better if it is closer to the original Bob Ross painting or more different from it. While Bob Ross preaches independence, he teaches you how to mimic him.

Issues regarding copying are pervasive in the Art World; art sections of major newspapers and Art World magazines are filled with questions about artists who copy. Sometimes artists who intentionally copy raise issues about the artistic value of copying, like Greenaway; at other times critics condemn the use of copying by an artist. For instance, Dave Itzkoff (2011) scrutinized Bob Dylan's artworks that were recently displayed at the Gagosian Gallery. Dylan's works, titled *The Asia Series*, were about his travels on the continent. While advertised as "firsthand depictions of people, street scenes, architecture and landscape," many of Dylan's fans recognize their subject matter as coming from widely available photographs, including one by Henri Cartier-Bresson and another by Léon Busy (Itzkoff 2011, C1, C8). Responding to this discovery, Michael Gray, an author who has written extensively about Dylan, described the copying on his blog: "The most striking thing is that Dylan has not merely used a photograph to inspire a painting; he has taken the photographer's shot composition and copied it exactly. He hasn't painted the group from any kind of different angle, or changed what he puts along the top edge, or either side edge, or the bottom edge of he picture. He's replicated everything as closely as possible" (quoted in Itzkoff 2011, C8). This sounds precisely like a class of Bob Ross students, carefully replicating an original Bob Ross painting. Gray continues, "That may be a (very self-enriching) game he's playing with his followers, but it's not a very imaginative approach to a painting. It may not be plagiarism but it's surely copying rather a lot" (quoted in Itzkoff 2011, C8). Other Internet bloggers were less concerned. They saw copying as commonplace and part of the art-making process. The Gagosian Gallery responded to the criticism with this statement: "While the composition of some of Bob Dylan's paintings is based on a variety of sources, including archival, historic images, the paintings' vibrancy and freshness come from the colors and textures found in everyday scenes he observed during his travels" (Itzkoff 2011, C8). It's an interesting side-stepping of an old issue. Copying works for some and not for others. It depends on who is doing the copying, what the intent of the copying is, and what the focus

is. The assessment of a work of art also has to do with who values it and what theory they use to make us see it in a particular way. For Bob Dylan, it helped that the famed gallery owner Larry Gagosian made the defense. Interesting enough, Dylan has been questioned about potential plagiarism in his songwriting as well. For instance, his album *Modern Times* has lyrics that strongly resemble verses in poems by Henry Timrod, and *Love and Theft* contains passages from the novel *Confessions of a Yakuza*, by Junichi Saga (Itzkoff 2011, C8).

Another well-known contemporary artist is being hailed for his imitative work. Peter Plagens (2011) writes about George Condo's 2011 exhibition at the New Museum:

> Condo has consumed . . . a lot of undergraduate art history and, instead of going straight for the cartoon jugular, eventually opted for what he called "fake old master"—by, well, painting like they teach you to paint in painting class; making volumetric portrait heads with well regulated brushstrokes, doing a little Cezanne dance with the light-dark relation of the subject to the background, keeping color clear and reasonable. . . . The wonder is that Condo's freshness hasn't pooped out over the years. His style may be formulaic, but it's a damned good formula." (35)

George Condo and Bob Ross are part of a long line of artists who learn their techniques from master teachers. Peter Paul Rubens is often cited as an artist whose masterpieces were produced by entire workshops of apprentices. But even masters like Rembrandt and Goya had students who carried on their lineages. Most recently, the Prado re-accredited the iconic painting *The Colossus* to one of Goya's assistants. Previously, it had hung in a place of honor in the Prado and was considered to be one of Goya's best paintings (Tremlett 2009).

Sometimes copying feels downright progressive. Sherrie Levine became famous as an appropriation artist who showed copies of famous male artists' work as her own. In 1980, she exhibited photos she had copied from Walker Evans. The original photos were iconic and well known, and Levine's looked exactly the same. Without altering the images at all, her photographs were reproductions of catalog copies of Evans's photographs. That is, they were a copy of a copy of a print. But through her calculated use of appropriation, she was able to comment on issues like gender and the representations of poverty that mattered to her.

Mike Bidlo claims, "Appropriation art brings masterpieces to a whole new generation" (quoted in B. Pollock 2012, 83). Bidlo creates exact copies, or as exact as possible copies, of works by famed artists such as Jackson Pollock, Marcel Duchamp, Andy Warhol, and Henri Matisse. All his pieces are created from postcards and other reproductions. Flying in the face of copyright laws, Bidlo explains, "New generations need blood to live. Yes, they need fresh blood continually. If we have to do that by standing on the shoulders of giants and penetrating their necks like vampires, then that's the spice of life" (quoted in B. Pollock 2012, 83).

Debates and discussions about copying have been around for a long time. In his 1936 essay, "The Work of Art in the Age of Mechanical Reproduction," Walter Benjamin (2001) addressed the idea of the copy. He claimed that when a work of art is copied, it loses its aura. This idea is repeatedly passed on to art history students as they sit in dark classrooms looking at slides. They are told that seeing a slide of a famous painting is nothing like seeing the original piece. Certainly we would agree that seeing a Mark Rothko or a Claude Monet in a slide pales in comparison to the experience of seeing the original work. But Benjamin goes on to say that if a work of art is reproduced so many times, it loses its aura because aura comes from its metaphysical distance. This is akin to the experience of seeing the *Mona Lisa* in the Louvre. For most people, it is a disappointment, given the ubiquitousness of its many reproductions. Benjamin says it has lost its ritual value. In essence, it has become a thing, or a commodity that can be manipulated for political goals. One might think about the ways in which Bob Ross's teachings and materials have become controlled and sold by Bob Ross, Inc. But has his work been diminished because there are so many Bob Ross paintings in the world?

Jean Baudrillard (1994) might think the question misguided. He points out that Modernism taught us that there is something real and then there are copies, which are of less value only as they refer to that with is authentic. But this way of thinking is problematic. Take, for example, an Annie Lebovitz photograph of the Rolling Stones. The reproduction refers to the actual band. But Lebovitz created something else: a thought about the Rolling Stones. She made reference to them; but today, her photographs of them are no longer thought of as copies of the actual band. They are, instead, powerful works in and of themselves; they transcend the band and are said to be Annie Lebovitz photographs as opposed to images that refer to the Rolling Stones. From Baudrillard's

perspective, we all create by copying something else. Postmodernism, associated with Baudrillard's thinking, is, in part, about simulations. It displaces the idea of the real and makes it obsolete. He says the power is not in the real; rather, it is about the reproduction, which is manipulated and readjusted to new contexts. Truth (and the original), in our world today, is but a hallucination. We have murdered the original by over-examining everything. In doing so, we create something else.

In this sense, the reproduced Bob Ross paintings may have their own aura and they may be seen as objects with their own original meanings. They may signify a copied Bob Ross, but they may be more about a time and place where an individual decided to learn to paint, come out of depression, or become aware of the landscape. Copying, in our world today, is what we all do. We take from the past and re-create something new. British philosopher Gary Peters (2009), who is interested in the entanglement of the old and the new, writes about the *situatedness* of the creator. For him, making something new necessitates a reproductive movement, utilizing that which has gone before us. It can never be the same as it was before. We all create from our past and the past that others have left for us; there is no other way to make anything.

Today, the act of copying takes on a new meaning, in large part because of the increasingly technological world we live in. Copying is no longer seen as an uninventive process. Instead, it is an activity that has the power to reveal and open up possibilities and ways of knowing. And the copy is never really a copy anyway.

The Ubiquitous Landscape

Bob Ross is known for his painted landscapes, although certification courses are offered in both landscapes and florals, extending the range of what Bob Ross, Inc., has to offer. However, Bob, the artist, is all about painting mountains, trees, and lakes.

Before the eighteenth century, landscapes functioned like portraits or still lifes; they were conversation pieces that focused on talk about design as opposed to nature. But that view changed. When writer Sara Maitland (2008) wanted to further develop her creative potential, she went to nature to seek silence. She equates the physical landscapes she relished to the landscapes of her mind. Bob understood the connection

and repeated pointed his viewers to the landscape's ability to open one-self up.

Landscapes have long been a popular subject matter for paintings, regardless of social class. Depopulated landscapes that are tranquil and sedate seem to be the most preferred kind of landscape in the twentieth century, perhaps, as David Halle (1993) claims, having to do with suburbanization and the movement away from nature as rural people knew it. Vitaly Komar and Alexander Melamid (1998) confirmed the popularity of the landscape in their scientific study on the topic. People like tranquil, blue landscapes that are realistically depicted. It is no surprise, then, that when Bob Ross's landscapes became public through his television shows, they became an instant draw, especially for Americans. Bob depicted our national heritage with purple mountains and lots of fruited plains. He left out people, never explaining why (Kimmelmen 2005, 37). Perhaps it was to allow viewers to create their own worlds inside that space through their imaginations.

The way Bob Ross talked about his landscapes gives us clues as to how he hoped we would see nature. He wanted us to see it as a pictorial space of beauty and a metaphorical one of possibilities and liberation. Neil Harris claims that much of contemporary landscape art today "mocks the liberating vision it once inspired" (1994, 99). Bob's paintings do not mock liberation; instead, his works frame the concept of the open wilderness as a place where one's mind can rest and experience freedom. It is an open space, a place of possibility.

Bob Ross's landscapes, like those of most artists, are best seen contextually, with some understanding of the artist and the intention. While some viewers might respond apathetically to one of his paintings if they didn't know who painted it, once the recognition of the creator comes about, an added element of pleasure is gained. After all, Bob Ross is a superstar whose kind personality is constant and consistent, whether you enjoy his work or not. As Kimmelman suggests, "his purpose was as much to massage souls as it was to teach painting" (2005, 34). Creating a look-alike Bob Ross painting, then, is to create a landscape of hope and possibility. If one is connected to Bob the artist and educator, engaging in the act of painting is taking control of one's world. Bob whispers, "You can do anything that your heart desires here. You have absolute and total power" (quoted in Kimmelman 2005, 196). Therefore, his landscapes are not just pretty pictures; they are metaphors of constructing a landscape (actual or of the mind) where life slows down and becomes peaceful and

dreams have an opportunity to take shape. It is as if Bob Ross were telling us that envisioning a new kind of reality is the first step in making that reality possible.

If creativity is linked with problem solving, as it often is, then, according to aesthetician Ellen Dissanayake (1992), ordinary things, perhaps like Bob Ross paintings, become more than ordinary when they are experienced and understood in a transformative way. Bob Ross's soft, yet confident and powerful message is that all things are possible in the world he creates (or the ones we can create) on canvas. His message heightens the emotional effect of the landscape, causing us to pay attention to what the act of painting one might mean. Dissanayake claims that this experiential and reflective way of dealing with our understanding of the world moves beyond the pragmatic. To Dissanayake, it is "universally human, and yet uniformly overlooked" (1992, 98).

Certainly our connection to nature has changed over time with increased urbanization and the introduction of air conditioning and computers. Bob Ross's landscapes remind us of what it was like to be more fully alive in the wilderness and in the wildness of our imagination. For some people, his paintings facilitate this goal extremely well. For others, his paintings are unimaginative and even boring.

Boredom

Many people demand art that jars them out of their complacency. If it can't do that, it isn't worth their time. This might explain the popularity of some contemporary artists such as Marina Abramovic, who uses fasting, butcher knives on a ladder, and nudity in her much talked about performances (Madoff 2002). Likewise, much of today's entertainment is quickly paced, and our need for more of everything seems to consume our lives. Our films move more quickly, and our fast-paced lives seem to demand more and more stimulation. Easily, the repetitive nature of Bob Ross paintings could be deemed boring. Same compositions, scenery, and colors are emphasized again and again. However, one of our most acclaimed artists, Andy Warhol, celebrated boredom, and he liked routine. It has been suggested that Warhol and others embrace repetition in order make order out of a chaotic world (Cooke 1999). Consequently, many of Warhol's artworks are repetitious, and his films are slow and, for many people, well, boring. Warhol wrote in his memoir *Popism*, "Of

course, what I think is boring . . . must not be the same as what other people think is, since I could never stand to watch all the most popular action shows on tv, because they're essentially the same plots and the same shots and the same cuts over and over again. Apparently most people love watching the same basic thing, as long as the details are different" (quoted in Dargis 2011, AR10). Steve Martin, comparing Warhol's approach to varying art movements, wrote, "If Cubism was speaking for the intellect, and Abstract Expressionism was speaking from the psyche, then Pop was speaking from the unbrain, and just to drive the point, its leader Warhol closely resembled a zombie" (2010, 102).

This idea of boredom being appealing may work in certain circumstances, as it does with Warhol's work. According to Manohla Dargis (2011) the film *The Hangover Part II* was just a rehash of the same boring jokes that took place in original movie. But it took in $137.4 million over the 2011 Memorial Day weekend. Maybe, Dargis claims, it's the kind of "boring that many people like, want to like, insist on liking or are just used to, and partly because it's the sort of aggressively packaged boring you can't escape, having opened on an estimated 17 percent of American screens" (2011, AR10). Dargis suggests that this kind of boring, the kind of boring that enticed Warhol (and, we might add, perhaps the boring of a Bob Ross painting), is boredom that allows you time to let your mind wander. When you return to the artwork, you won't have missed much, or it will be repeated again so you can catch the message or idea the second or third time around. Dargis writes that the point of works that seem boring is that they make you think. If you are being entertained in a fast-moving, pay attention kind of way, there may be no time to escape and create your own ideas. Boring work, therefore, has an upside.

Boredom works in other art forms as well as visual art. Interviewed for the *Chronicle of Higher Education*, David Bellos, professor of French, Italian, and comparative literature at Princeton University, commented on the topic. Responding to the question about a recent book he read that stood out, Bellos replied that Victor Hugo's *Les Misérables* is important because it is "a book that 'stands out' in every imaginable way—for its size, its complexity, its emotional intensity, its fantastic range of vocabulary, its images, its vast stretches of boredom, its quantity of sheer piffle, its moments of drama, its good-heartedness, its naiveté, and its constant reminders of almost every book that has been written since" (2012, B2). It appears that Bellos lists boredom as a positive characteristic along with all the other things that make Hugo such a master of

the novel. The reader might balk at any comparison of Bob Ross to Victor Hugo, but many of the descriptors used for Hugo besides boredom could also be applied to Bob Ross.

With a similar recognition of the power of boredom, on July 8, 2012, in the *New York Times Book Review*, Bruce Handy wrote an essay titled "My Fabulous Boring Book Collection." While this may sound unreasoned, as who wants to be bored by books, Handy explains:

> *I don't mean boring in the sense that an out-of-date psychology textbook or a 900-page history of dairy farming in the Hebrides is boring. . . . [T]hey wear their boringness on their sleeves. . . . What I'm after are books that are uniquely, exquisitely, proudly boring— books whose boringness intrigues, if that is not a contradiction in terms. (2012, 27)*

Highlights from his collection include *Soap Bubbles: Their Colors and Forces Which Mold Them*, by C. V. Boys (1890, revised and expanded in 1911, reprinted in 1959); *A Bunch of Flowers for Girls*, by Jennie Willing (1888), and *The Complete Bean Cookbook*, by Victor Bennett (1967). Handy claims the titles "must meet a standard of boring intrigue that I have a hard time putting into words, beyond 'I know it when I see it'" (27). The titles are not only boring, they are everyday and they emulate sentimentality. But, at least to these authors, they do have their attraction, like Bob's television shows of repeatedly painting yet another mountainous landscape in thirty minutes.

Although Bob's paintings and shows are definitely formulaic, his television program seems to contradict the idea that the epitome of boring is to "watch paint dry." In 2010, Marina Abramovic, known for her shocking performances, had a retrospective at the Museum of Modern Art in New York City. The most talked about performance was the one where she logged seven hundred hours sitting in a chair in MoMA's atrium staring at visitors who would sit in the seat facing her. Some lasted for a minute, others for an entire day. Visitors to the museum watched the artist and participant watch each other. Internet visitors were numerous, around 800,000 hits a day. Holland Cotter wrote about the artist: "Always her hair, in a braided plait, was pulled forward over her left shoulder. Always her skin was an odd pasty white, as if the blood had drained away. Her pose rarely changed; her body slightly bend forward, she stared silently and intently straight ahead" (2010, C1). Being able to

sit quietly with the artist became a status symbol. Would-be participants waited for hours in line, and celebrities like Bjork, Marisa Tomei, Isabella Rosellini, Lou Reed, and Rufus Wainwright took the visitor's seat (Cotter 2010, C1). Was Abramovic's sitting performance boring? If so, an extraordinary number of people were intrigued.

Just as HBO released a 2012 documentary titled *Marina Abramovic: The Artist Is Present*, focusing on her compelling ability to sit and stare for hours on end (Abramovic 2012), a very different one was produced on Gerhard Richter. Richter is a blue-chip painter who works in many styles, but at the time of the documentary he was making large abstract canvases with squeegees. Throughout the film, he shares thoughts, gets curmudgeonly with Art World elite, and drives around in his car musing on art and beauty. But mostly he just paints—silently. That's it (Richter 2012).

As an idea, the proposition for *The Joy of Painting* is similar. Artists like Richter and Bob Ross are part of a long lineage of artists in films that simply show the magical act of painters at work. Appropriately titled, a film called *Painters Painting* (1973) gave its audiences views of enormously influential artists like Robert Motherwell and Willem de Kooning working on their canvases. Bob may not have liked the comparison, but even Jackson Pollock is a kindred spirit in this regard. In a legendary film by Hans Namuth, Pollock drips runny paint onto a canvas at his barn in Long Island. Another shot, with the camera angled beneath a pane of glass, shows Pollock dripping paint overhead. It's a painting's-eye-view of exactly how it feels to be painted on (J. Pollock 1951). There is something compelling about watching a great artist or a superstar such as Bob make a painting.

Even in parks around the world, artists at their easels receive furtive glances from strangers passing by. Why is it so immersive to watch a painter work? Why is it so fascinating? Certainly there is a novelty. But when characters like Ross and Richter hold our attention in a sustained way, we wonder if repetition becomes comforting or meditative. Are we lulled into pleasure rather than jarred into it?

As we zone out in front of a snowfall or relax on the shore as an ocean slowly ripples or watch patterns form and reform on the surface of a lake in the rain, nature itself is mesmerizing. Painting echoes those same patterns. It may happen slowly, imperceptibly, but also according to a logic that even the artist may not comprehend. Shapes form and are lost. Entirely beautiful passages are covered in messy globs and then replaced with new and intricate details. Layers of paint are cut into. Bright colors

are suddenly exposed and remembered. Gradients form as paint mixes with itself, with the medium below it, and then browns when it meets its complement. Bob Ross paints more quickly than most artists, so we are drawn into his meditative presence more quickly. Watching Bob is like a lava lamp or a Christmas tree slowly twinkling. It's patterned, but not quite predictable. And so we watch.

Seduction

On the TV screen, the ability we have to watch Bob paint teeters toward the erotic. Without shame, in his darkened studio, Bob would often tell us to "make love to the canvas." His language was spiced with phrases like "liquid white," "big ole bush," "makes me feel good," and "caress her." Along with sighs of satisfaction, grunts, and appreciative looks, he encouraged himself and his viewers to employ an array of gentle strokes, long strokes, and even rough strokes to bring a painting to completion. Taken all at once, Bob sounds positively perverted in numerous YouTube videos that jokingly compile his "dirtiest" phrases. The camera angles on the program only reinforce a graphic feeling. Close-ups of Bob's hand showed him mixing, spurting, spilling, whacking, and stroking paint all over the studio. Bob made paint porn.

Whether or not he made the connection himself, Bob openly relished the pleasure of painting the same way others celebrate sex. But it wasn't solely an erotic pleasure; it was carnal. One could just as easily relate his moaning to the appreciation of a satisfying meal. Think about the paint itself. A dollop of alizarin crimson might look like a blob of ketchup as it sits next to a mustardy cadmium yellow. Titanium white glows with the creamy, wet aliveness of yogurt or mayonnaise. His palette could please a range of palates.

There is an eroticism to food and art. They are messy and ethereal. They must be consumed before the moment is lost. They offer fleeting pleasure and have to be used up before they dry up or go bad. Food and paint make great bedfellows.

The connection starts at an early age. As kids, we paint with our fingers and marvel when adults tell us not to eat it. Somehow it makes sense that anything so squishy and colorful belongs in our mouths. Retailers like Crayola expect this, and Crayola assures us that its paints and silly putties are not harmful if ingested ("Are Crayola and Silly Putty Products

Nontoxic Even If Ingested?" 2013). Online, we learn that a person can cook recipes for air-dry clay with anything from confectioner's sugar to salt, cinnamon, flour, or applesauce. Painters in studios across the United States seem to intuitively rinse and store brushes in coffee cans, cups, emptied mason jars, and squeeze bottles. Pigments are ground in mortar and pestles. Dyes from foods like saffron and beets color our fingers and our clothes. The oil in oil paint itself comes from grape seeds, flax seeds, sunflower seeds, or some other piece of edible nature. Tempera developed from the use of egg whites as binders, and still other paints are held together with milk or honey. Is it any wonder that everyone jokes that Vincent van Gogh ate paint? Perhaps we're jealous.

Now when a TV personality cooks with tight close-ups, smoky light, and shameless pleasure, it is called food porn. Nigella Lawson, a saucy and lovely cooking star, was dubbed the "Queen of Food Porn" for her beautifully produced, seductive cooking segments and cleavage. Lawson is, incidentally, married to Charles Saatchi, one of the largest art collectors in the world. Similarly, Giada de Laurentiis, host of *Giada at Home* on the Food Network, is known for her beautiful face and low-cut tops. Men also get cheeky and flirty in the kitchen, as when Jamie Oliver branded himself "the Naked Chef."

Bob Ross is part of a long line of teachers who actively take pleasure in their professions. It is no surprise that people pick up on the eros of Bob's work, for painting is seductive. It is color. It is alchemical. It brings forth something that did not exist before. It takes great work and offers immersive, somatic pleasure. It cannot be enjoyed mentally; it is enjoyed sensually. It is consumed and delighted in. And it is a way of creating something new and living.

It may seem strange to think of a painting or a Bundt cake as progeny. But perhaps, on some level, it is the natural result of its sexiness. Perhaps creation is like procreation. For all its fleeting pleasure, sex can change lives—or make new ones. And a painting is a bit like a living, breathing child. Even as a static object, an oil painting is indeed alive. It is always in flux: changing, drying, curing, stretching, cracking, fading. It requires our protection. It is always growing up or growing old. We might hope that it outlives us, goes out into the world, or makes a name for itself.

To see *The Joy of Painting* as porn is perceptive and fun. But it's a spectator's perspective. It's a kind of voyeurism. Bob embraces the eroticism of art making as lovemaking because it isn't shameful or base to compare art to sex. For him, it can be a vehicle of great pleasure, a means

to bond, and a way that people can create something new that carries a part of them within it. Relating Bob's work to food, porn, and seduction is only one way of thinking about its relationship to democracy.

Democracy

Vitaly Komar and Alexander Melamid's People's Choice project was the catalyst for other crowd-sourcing undertakings in the Art World. In crowd-sourcing, a task is given to an unknown group of people. Many of these projects now use the Internet to poll individuals about art preferences. Stephanie Cash (2011) reports that the democratization of art has even reached NBA players and average Joe's, who have been invited to curate exhibitions. In Grand Rapids, Michigan, individuals have been asked to vote for the best artwork, resulting in a $25,000 prize. And like in the television shows *American Idol* or *America's Got Talent*, the public chooses who has the most talent, giving a contestant the chance to become a superstar and the public a place at the table as critics. This participatory way of making judgments is spreading. In March 2012, over three million voters selected the winner of the Smithsonian American Art Museum show titled *The Art of Video Games* (Cash 2011).

In keeping with the democratization of the Art World, in 2011 the Sean Kelly Gallery connected to the masses using Robert Mapplethorpe's photographs and engaging a "curator" from each of the fifty states as a way of demonstrating the tastes of the American culture. In this case, however, so-called experts had already vetted the photographs. Nonetheless, the selections were surprising. Very few erotic images were selected. Instead, images of flowers and casual portraits prevailed (Cash 2011, 40). Stephanie Cash raises good questions about this increasingly popular way of doing business: "Is crowdsourcing in the arts a good thing? Will the democratization of taste/opinion kill the art expert? Or will it engage the public in a way that can only benefit the arts in the long run? One thing is certain: the art world is getting crowded" (2011, 40). One can only wonder how this trend has helped Bob Ross keep and expand his own message.

Democracy—by which we mean the notion that everyone's opinion matters and should be heard, seen, and shared—was a part of how Bob Ross approached his painting. Not only did he encourage everyone to paint, with the promise of achievable results, he also encouraged viewers

to mail in photos of scenes they wanted to see turned into artworks and TV shows. Bob would also regularly share images of paintings made by his fans on the *Joy of Painting*. This gesture cemented the democratic nature of his show and captured the breadth of his demographic. Not only did he display viewer's snapshots of their landscapes and flowers, he also mixed in paintings of animals and even paintings by young children. Bob went further, holding competitions where selected artists would get to "exhibit" their works over the airwaves. These competitions were broken into age ranges. Why? Because it's fair. And democracy requires a feeling of fairness and freedom if its constituents are going to participate. The freedom isn't just access to the tools of painting so that you can make your own statements. It's also a process of being heard. Within a limited scope, Bob actively listened to his viewers and let them influence the way he painted. Viewers effectively "voted" on the imagery they wanted to see in his programs, and Bob in return "elected" to run images of his favorite viewers' paintings on TV for all to see.

Sentimentality

Many people we have spoken to see Bob Ross's paintings and paintings by his students and claim that they are sentimental. Manohla Dargis (2011) describes sentimentality as something usually involving familiar images, such as kittens and puppies, that conjure up a wellspring of feelings. The image functions to "try to make us feel good, even virtuous, simply about feeling" (Dargis 2011, C10). Sentimentality can also be defined as a softening of the world, an approach that idealizes various aspects of our lives. For example, the US Army may be depicted as overly patriotic and glamorous. It would be sentimentalized if portrayed as a place where you can travel the world and get educated, instead of as a place where you might die in an unpopular war. Sentimentality is a sanitization of life. In art it may be an idealistic portrayal of a particular aspect of life, but according to Ira Newman (2008), it has its place. Sentimentality can function, as it does with Bob Ross's work, as an aesthetic refuge; it can be a catalyst for escapism and can play a role as a psychological ally. It seems that Ross wanted his landscapes to function precisely in this manner. Critics may continue to argue whether Bob Ross paintings should function in this manner, and if they do, whether they can be valued as good art.

But Bob Ross's sentimentality not only pervades his imagery, but also infuses his teaching practices. For example, his encouragement has a gooey tone. Hearing that "we don't make any mistakes, we only have happy accidents," a viewer might become suspicious of Bob Ross's sincerity. Many are taught that there is a right and wrong, and that being hard on one's self is the only way to get better at something. Loving tough, working hard, and striving for perfection keep people buying products that can "improve them," but can we trust someone who says painting is easy? That we can't make any mistakes? Even if he is sincere, Bob's worldview might seem naïve next to someone who says life just isn't that easy. Putting it bluntly, Mira Schor writes that Bob's message is that "painting is easy, painting is safe. Painting . . . is meant to be soporific [and] prevent troubling thoughts from disrupting the surface of the picture plane" (1997, 176).

Within the boundaries of that picture plane, Bob's world admits no complexity. As with all idealized places, something unknown is at the threshold of these imaginary worlds. Outside of Bob's paintings are everyday worries about health, bills, status, family, loneliness, conflict, and survival. But outside of those paintings, Bob is very much a participant in the real world. While some might doubt the rigor of a mentality in which no one can make mistakes, others will note that it reveals a deep acceptance of life's difficulties. So often, wisdom and foolishness or denial and acceptance look the same. The sage and the fool are both always smiling.

Bob was no stranger to suffering. As a cancer survivor, a divorcee and widower, and someone who had tough experiences in the US Air Force, Bob knew a thing or two about the real world. On his painting show, he would talk about how the news is full of depressing stories and say that his show was about inspiration instead. But that doesn't mean he denied the worldview broadcast by the nightly news; he simply rejected the idea that it was the only "real" version of how the world works. It's a wisdom akin to both Buddhism and Jean Baudrillard (1994) because it asserts that both his reality and the one on the news are equally real and accessible.

From Mayan calendars to millenium fears, the "news" that the world is ending, that politicians are corrupt, and that poor people don't do well has the same repetitious surrealism of any kitschy sofa painting. Baudrillard would similarly equate the evening news to spectacle because it is consumed like entertainment. Instead of pictures of trees, it churns out photos of human suffering and scandal. But they are still just pictures. It

would take action—a sense of connection—to get someone off the sofa and engaged with the world that works to help the human condition.

To have that kind of commitment to change, people must become part of a community that draws them outward. Bob offered community, connection, and meaning to the people who shared his vision of a happier world. But it was not an easy world to inhabit. Just as the world beyond the picture plane is not safe, neither was the world inside it. For the few who dare to paint, it is a world of frustration and uncertainty. Instead of telling us painting is safe, Bob actively anticipates the fears of his viewers and assures them that they can safely enter in. Bob may rely on formulas to share the message, but his mindset is radical. He tells people that participation is just as successful without any self-doubt, uncertainty, or fear. It's a recipe for community and for engagement. And it's an idea that can carry on into everything from protests to volunteering to teaching.

Bob is not universalizing his view of painting. He isn't saying that all painting everywhere is free of risk. Although Bob insists that his skills should be copied, there's no need to use an inherited vocabulary of mountains and trees once you learn to paint. If you want to add an oil slick to your painting of the ocean or a scene of political turmoil to your dessert, then you have the tools to do so. You can paint your United States (or China or India or Mexico) and share it with others as a protest poster, fine artwork, or gift.

The Art World is often critical of work that is this idealistic. As the Art World changes, new ways of seeing and understanding art are presented. The result often expands our approach to art as we learn to embrace more and different kinds of artworks. One way of analyzing art does not necessarily serve us well for all artworks. For some, Bob's sentimentality is one of the reasons why he is so loved. For others, it might be his emphasis of art techniques that make him complicated and relevant. There are other artists who in some ways might fall into this same category.

In 2010, the Brooklyn Museum exhibited the paintings of Norman Rockwell, another artist who is often dismissed as being too sentimental. The Brooklyn show presented Rockwell as a competent illustrator and tempered the sentimentality of his imagery by revealing the artist's process of using photographs to help make his later work. Like Bob Ross's TV show, this exhibition gave viewers a glimpse of Rockwell's techniques and nudged them to pay less attention to the paintings themselves. Bob

Ross's adorable anecdotes about childhood and his videos of cute critters certainly can function to manipulate his audience into feeling safe or escaped from a troubling world. Bob plays on our desire for simplicity, escape, and refuge. Perhaps in revealing their own process and craft, both Bob Ross and Norman Rockwell help others to see beyond their imagery and find something to value.

In the end, Bob's paintings are sentimental inasmuch as they are idealizations and fantasies. But how he places them in the world at large matters a great deal. Are these bucolic pictures of simpler times now past that he is eulogizing in paint? Or are they somehow a vision of a future that could exist through conservation and caring? If it is merely sentimental, it is like a form of dangerous nostalgia. It would mean that Bob's world is empty because we are far too complex and flawed to exist in its standards. But if these abundant landscapes are a vision of a future, then Bob's work is incredibly challenging. They are empty because they are invitations. Mentally and imaginatively, Bob asks us to project ourselves into the picture plane. Every tree and every blade of neon grass is a reminder of what might be. Seen that way, Bob's work is quite provocative, for it requires us to do more than passively escape into the imaginary impossible; it asks us to question, interrogate, and engage in the world at large with compassion and belief. We believe that the power of Bob's art is that it encourages everyone to envision a better world. With some tips on painting and some tools on how to believe in yourself, Bob suggests that what we envision, we can become.

The Highwaymen: Florida's Landscape Painters

In a most tangible way, painting landscapes was a way for one group of African Americans from Fort Pierce, Florida, to recreate their world. In the late 1950s and '60s, these painters have several things in common with Bob Ross. They were all from Florida, they painted landscapes using oil, and they painted fast. Dare we note that they all, or most, sported Afros as well? (Bob's Afro was the most pronounced.) Decades after they had established themselves as landscape painters, these artists would be called the Highwaymen.

The story is now legend in Florida. In the 1950s, high school art teacher Zanobia Jefferson, believing her student Alfred Hair showed some artistic talent, introduced him to the white landscape painter

Albert Ernest "Bean" Backus. Backus was a well-established Ft. Pierce artist who was friendly to African Americans, a trait all too uncommon in the Jim Crow South. Instead of charging Alfred Hair the usual fifty cents he requested from his young students for an art lesson, he taught him in exchange for cleaning duties around his studio. Hair brought some of his friends to the studio and he passed on his knowledge to others. They too became interested in landscape painting. Hair and his friends believed painting might offer them a more lucrative way of making a living than working the citrus groves and farm fields, jobs they knew all too well. This young group of aspiring painters, which continued to grow in numbers, believed in their power to paint and their power to make a different life for themselves, in spite of the limitations society had placed on them. Because they were black and had almost no black artist role models, besides their art teacher, they decided that they would paint faster than Backus and would sell their landscapes cheap. While Bob Ross didn't promote the sale of his paintings, as they were mostly made for enjoyment and teaching purposes, like the young Highwaymen, he too painted landscapes quickly. For both the Highwaymen and Bob Ross, painting needn't be a long drawn-out process. One could make something of value if one were knowledgeable and possessed a willingness to learn. In Bob's case the skills originally came from Bill Alexander, and in the case of the early Highwaymen, they came from Backus. Soon, like the followers of Bob Ross, the early Highwaymen painters taught their friends and family members. As the core group of five to six Highwaymen had financial success, more young men and one woman, Mary Ann Carroll, learned to paint quickly, following their lead. Also like paintings by Bob and his followers, the Highwaymen paintings became easily distinguishable as a group. Twenty-six African American landscape painters were inducted into the Florida Artist Hall of Fame in 2004. However, the number of Highwaymen was and continues to be debated since teaching friends and family to paint was and is as fluid a process in Florida, as it is with fans of Bob Ross.

These artists garnered the name of Highwaymen because many of the group regularly sold their paintings up and down the highways on the east coast of Florida. Some were known as terrific salespeople, and others spent more time making paintings, often using an assembly-line technique with several canvases being painted at one time. They worked on Upson board in the early days because it was cheap; skies would be painted on several boards at a time, for example, so that using the same

color of paint could save time and the brush could be employed without a change. They set out to make as many paintings as they could each day. In a like manner as Bob Ross, skies were painted first, then waterways, and finally trees and other objects in the foreground. Because the Highwaymen painted Florida landscapes, sunsets and tropical foliage were emphasized and mountains were not depicted. Although figures were occasionally painted by a few of the Highwaymen, people were generally not placed in the landscapes, as is the case in Bob Ross paintings.

In 1970 Alfred Hair was killed in a bar fight and Al Black went to prison for fraud and possession of drugs. Sales diminished as their charismatic leader was gone and no-soliciting laws were enforced. Most of the Highwaymen turned to other ways of making a living, although some continued to paint. In the 1990s, as an interest in folk art in the South grew, collectors starting searching for old paintings by these ambitious artists and they became known as a collective. Early works by the most well known Highwaymen can now sell for thousands of dollars (Congdon 2004; Congdon and Hallmark 2012). While debate remains over the quality of the work by these artists, everyone who knows about them enjoys their story, and frequent exhibitions always draw a good crowd. Much like the work of Bob Ross, the work is best appreciated in context. Coincidently, the work of both Bob Ross and the Highwaymen has increased substantially in value. Bob Ross paintings are hard to find, as most are owned by Bob Ross, Inc. Early Highwaymen paintings are now mostly in the hands of collectors, and recently painted works often sell for decent prices.

Most all the Highwaymen now take time to paint well, perhaps partly because they can command higher prices as their reputations have grown. Some say they were always interested in painting technically proficient landscapes. All of the remaining painters now care deeply about the quality of their work, and in recent interviews they acknowledge that over the years Bob Ross taught them a thing or two in terms of painting techniques. Carnell Smith (personal communication, July 20, 2012) and Al Black (personal communication, September 19, 2012) both praise Bob's work and teachings. Smith, who is now living in Pennsylvania, reports that after seeing Bob Ross in 2000, he started putting mountains in his paintings. Jimmy Stovall, a younger landscape painter, also says he's watched Bob Ross on television as one of many ways to improve as an artist (personal communication, July 25, 2012).

It is hard to say whether Highwaymen paintings will hold their value or continue to increase in monetary value as time passes. However, it's

a safe bet that Bob Ross's work will continue to be sought after and his legacy will grow. What is more difficult to say is how Bob's work will be assessed in the future. For now, his popularity continues to grow and his work is increasingly loved. Some people like him in an ironic way. Others are mesmerized by his skill, claiming him to be a genius. And still others like the Bob Ross story of the man. Like the story of the Highwaymen, the legend of Bob Ross is growing.

Painter or Performer?

To succeed as artwork, Bob's paintings cannot be removed from the context of his television show. If the paintings are boring, the show makes them immersive and mesmerizing. Bob's real artwork is a dialogue between his paintings and his performance. He mediates their display to us as his viewers, and in so doing he gives them a meaning far beyond their imagery. The paintings may not demonstrate extreme artistic mastery, but they hold a space for a viewer to project into them. Whether we stand before his work or we see it through the media of the television screen, it is almost as if Bob's artwork is based in transporting us to the worlds he paints.

Remember in the film *Mary Poppins* when the characters jump into the chalk drawing? Bob's painting does that. We've looked at how the magic happens. He can coo or flirt or even seem hilariously kinky. He can ask us to send a postcard of a picture for him to paint. Or he can insist that we paint whatever we like within it. Crowd-sourcing, democratizing, hypnotizing his viewers for a safe, predictable thirty-minute "soul-massage," this is part of why his art is interesting. It doesn't just happen through his paintings, it happens through the force of his personality. And more importantly, it happens in a way that requires participation. Get out there and paint. Or at least make the world a happier place.

It may not sound revolutionary, but the idea of a painter in an ongoing public dialogue with his audience was the seed that grew into the hash-tagging and tweeting of today. Bob demonstrated that an artist could be more than just a lecturer or a genius demonstrating his ability to a passive audience. Whether at easels or on couches, his audience was called to action within a vast network of viewers, consumers, and teachers. Bob's shows and others like his are a form of proto-social media. They pushed technology and networks to tell stories, share resources

with groups, gather feedback in real time, and help others grow through dialogue. In the following chapter, we look at Bob's network and how that dialogue has continued even after his death.

Dawn Winter Lake, by Davy T. Painterman

Mountains Renewed, by Davy T. Painterman

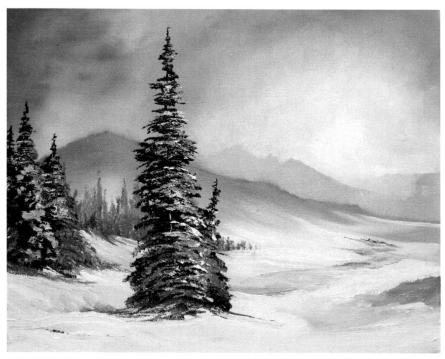

Winter Grace, by Danny Coeyman

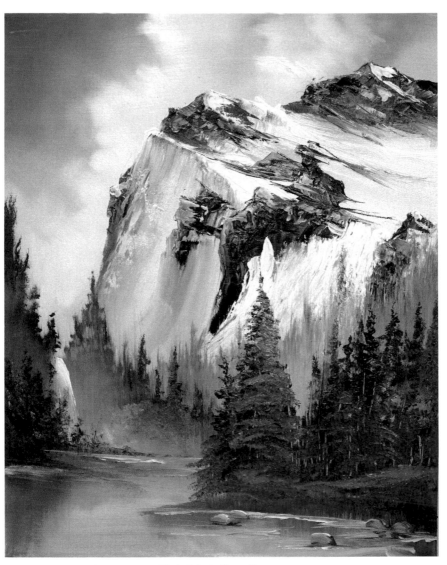

Glacier Lake, by Danny Coeyman

Saturday Morning Sanctuary, by Aaron Jasinski

Untitled, by Al Black (courtesy of the Betty Ford-Smith Collection)

Portrait of Bob Ross in 30 Minutes Using His Techniques, by Danny Coeyman

Do It Yourself (Landscape), 1962, by Andy Warhol, © 2013 The Andy Warhol Foundation for the Visual Arts, Inc./ Artist Rights Society (ARS), New York

Good vs. Evil: Bob Ross in Mortal Combat with Thomas Kinkade, by Scott M. Guion

8

THE BOB ROSS NETWORK

Driving State Route 44 East, turning to State Route A1A across the South Causeway, will take you to the ocean-side district of New Smyrna Beach, Florida. New Smyrna Beach is located on the central coast south of Daytona Beach and north of Titusville. Established as a colony by Dr. Andrew Turnbull of Scotland in 1768, New Smyrna Beach was incorporated as the town New Smyrna in 1887. It was a hideout for rumrunners during prohibition. It became New Smyrna Beach with the annexation of Coronado Beach in 1947. With a population of approximately twenty-three thousand residents, New Smyrna Beach attracts many times that number of tourists visiting nearby beaches and wildlife preserves.

Approximately one mile east of the South Causeway is the Indian River Shopping Plaza. This nondescript collection of small stores and restaurants includes what is likely the epicenter of the Bob Ross phenomenon. Located at 757 East Third Avenue is the Bob Ross Art Workshop. This workshop is probably the best place in the world to see a large selection of original paintings by Bob Ross or inspired by Bob Ross. It is also the primary location for becoming a certified Bob Ross instructor. The workshop also offers classes and sells Bob Ross art supplies and frames for Bob Ross–inspired paintings.

Experiencing the Bob Ross Art Workshop begins to suggest the vast international network of relationships and interests contributing to the larger experience of Bob Ross. Looking around the workshop, one begins to understand that this network includes, but is by no means limited to, a class alumni group numbering in the tens of thousands here and elsewhere, the friends and family appreciating the results of those classes, the network of certified art instructors conducting those classes, exhibit spaces showing the work of those instructors, the frame shops

Bob like Close, by Danny Coeyman

here and elsewhere preparing the paintings for hanging, the manufacturers of the Bob Ross line of art supplies and all who are employed in the manufacture of those supplies, the locations where those art supplies can be purchased, and the publishers and distributors of the books and multimedia associated with the Bob Ross teaching enterprise. There is, of course, the connection between the Bob Ross Art Workshop and Bob Ross, Inc., with its publications, programs, attorneys protecting the Bob Ross image and product lines, accountants tracking the profits, and the stewardship of the master's legacy. Imagine also the impossible- to-estimate number of viewers who have encountered *The Joy of Painting*

worldwide and the many commercial and do-it-yourself parodies of those videos. Consider the importance to this network of the writers, camera people, stagehands, wardrobe keepers, set designers, animators, directors, and producers associated with this media. Two of the authors associated with this project (Congdon and Blandy) took a class at the Bob Ross Art Workshop and then went on to present and publish on Bob Ross in scholarly venues, influencing other scholars to take Bob Ross as a personage worthy of study and inclusion in the larger history of art education. Finally, there is this volume and its readers. This includes the university press publishing the book and all of the personnel associated with bringing it to publication and those to whom readers of the book will talk about its contents. As you contemplate the preceding, remember also that these connections to the epicenter also merge and connect and motivate additional connections that in combination only begin to suggest the range of Bob Ross's cultural, social, and economic influence.

Appreciating the breadth and depth of the network associated with Bob Ross is key to understanding Bob Ross the person, Bob Ross the icon, Bob Ross the teacher, and Bob Ross the legend. This network is dynamic and nonlinear. Links within the network are physical (locations), personal, and conceptual. The individual people, places, and concepts associated with this web of interrelationships, if considered theoretically, can be described as individual nodes connected to one or more nodes ad infinitum. A data analysis of this network would be fascinating and likely to reveal clusters of relationships as well as paths between relationships. Also of interest would be an analysis of this network that would determine which nodes are the most influential in either blocking connections with other nodes or cultivating the connections between nodes. One wonders if a distributed Bob Ross intelligence exists across this network and what constitutes that intelligence? What contingencies regarding individual and collective choices are at work within this network? What would a map of this network look like?

Considered systemically, an analysis of this network could reveal what events were most significant to the development of this network, what constitutes change within the network, what is contributing to the stability of the network, and what modes of communication exist within the network. Centers and edges of the network could be identified, including how the system is bounded and what actors are trying to push or constrict the boundary. This is a system within which subsystems exist, for example, Bob Ross, Inc., those connected by love of Bob Ross

parodies, and so-called fine artists connected through an incorporation of Bob Ross into their work. Thinking systemically about the Bob Ross network raises important and as yet unanswered questions about the existence of authority, hierarchy, and the tolerance of transgression within the network.

While a full exposition of the Bob Ross network falls outside of the scope of this chapter, discussing two distinct nodes or participants within the network does suggest what characterizes the network and the people and their motivations associated with it. It is also possible to begin to appreciate who is contributing to a Bob Ross–distributed network intelligence. One participant is Davy Turner, aka the "Painterman." (Turner's quotes herein are from his emails with author Kristin Congdon, 2005–2013). Another is Danny Coeyman, one of this work's authors. Including Coeyman's case assists in illustrating the relationship of this book and the people associated with it to the larger Bob Ross network as described above.

Davy Turner, the "Painterman"

Davy Turner, known as the "Painterman," is one huge Bob Ross fan. Turner was born in 1953 to a working middle-class family living in Wolverhampton in central England. He grew up with pets and continued his love for animals into adulthood. As a child, he created characters like the Lone Ranger and Batman that came from model kits. Painting the figures or other objects that he created from plaster was the only painting he did as a child, although he watched Rolf Harris, a United Kingdom entertainer who painted with a large brush at the beginning of his show as he sang a song that related to his painting. Davy left school at sixteen and began working for a utility company. He married and had two children, who are now grown. In 2009, after thirty-nine years with the same company, he retired in Kingswinford, where he has lived since 1978.

In 1997, when recuperating from an illness for three months, Davy came across *The Joy of Painting* on television and was hooked. He was mesmerized by Bob's ability to create such a fantastic painting in thirty minutes. But it wasn't just Bob's painting ability that attracted him. It was also "his demeanor [that] was wonderful, the way he'd tell stories about his 'little critters,' the guy was just captivating." Davy knew he had to learn more. He found a Bob Ross instructor in the United Kingdom

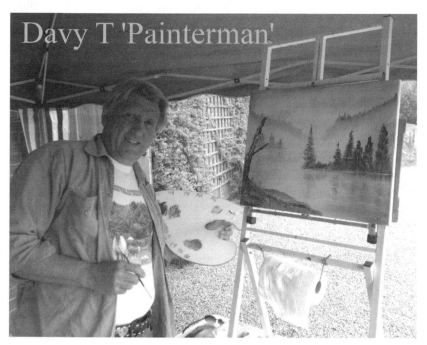

Davy T. Painterman

on the Internet and began taking lessons—three lessons for three birth-days over three years.

Davy explains that Bob's influence over him was "100%." Only later did he learn that Bob's mentor had been Bill Alexander, which enticed him to watch Bill's painting shows. Nonetheless, Davy claims that Bob is still number 1 in his book. Even if no other instructional painters existed, Davy writes in an email, "[Bob] would be enough for me. . . . Although without Bill there would have been no Bob!"

Davy came to teaching later in life. Davy explains that a close friend nearing seventy years of age asked him if he would teach him the wet-on-wet painting technique for his birthday. Davy obliged and his friend began painting every day until just before he died four years later. The older man had tinkered with many things, but he confessed that of all the many things he had experimented with in his life, painting with the wet-on-wet technique gave him the most pleasure, and he encouraged Davy to teach others.

Following Bob's footsteps as a student of Bill Alexander, Davy taught his daughter to paint. He then looked into the cost of becoming certified

as an instructor and "opted for the Alexander course over the Bob Ross company one."

Davy continues to paint with exuberance. He gifts his work to family and friends, just as he did as a child. He explains his love for painting: "I don't profess to be an 'artist' but a 'hobby painter' and I hold 'paint-alongs' rather than 'teach'... I allow my students to choose what subject (landscape) they would like to paint and show them the techniques and we end up with a finished painting. I have taught an 8 year old and an 80 year old in the 4 years I have been certified an Alexander instructor." Some of his students only take one lesson, and others come back again and again. Davy acknowledges that his teaching and painting functions as a social pastime. It's like an art community. Some people in his group paint only paintings from Bob's television shows. Others learn the techniques and then move on to painting landscapes from photographs or their imagination. Davy stresses, "That is what Bob wanted, not for everyone to copy his, but to learn the skill of the brush and palette knife and then go out and paint your own composition." Reflecting Bob's ideas about painting, Davy explains:

> Painting makes or should make you happy, whether in a group or alone in your studio. What the elite art world think, is usually, we paint "rubbish," but we are a happy group of "painters" and some do go on to become fine artists. If it gives a start to an upcoming person to go further, art school maybe, whatever . . . it must be a good thing and if not, well, we don't hurt anyone with our paint brush painting happy little trees and clouds and mountains.

Davy contacted Kristin Congdon after she and Doug Blandy appeared on the Internet as having given a talk titled "The Bob Ross Phenomena" at the 2005 National Art Education Association conference in Boston. They wore Bob Ross T-shirts and talked about their experience taking a Bob Ross class in New Smyrna Beach, Florida. Davy was interested in what they knew about Bob. Years of emails about this book and Bob Ross ensued. In response to a question about his experiences with Bob Ross and why he became the Painterman, he wrote:

> I spent hours and hours researching Bob on the Internet, located the name of his company and his UK importers and the PBS station he filmed his Joy of Painting TV series from. WIPB in Muncie,

Indiana. It was obvious after contact with BRI [Bob Ross, Inc.], that they were only interested in you if you were to pay their course fees to become a Certified Bob Ross Instructor. I learned more from the friends of Bob at WIPB and some of the stories I learned about what happened after Bob's untimely death left me with a sour taste in my mouth. I've tried in vain to contact Bob's son Steve, who left the company after his dad died and is just unobtainable, but I did make contact with his best friend and first instructor Dana Jester, who too, had left the Bob Ross company after Bob's death. A lot of unexplained incidents led to Steve and Dana leaving the company which I found strange, but I have found newspaper stories to support some of the "stories" I was told in confidence, but I wouldn't repeat for fear of legal reprisals from BRI. I even began a fan club for Bob here in England which was a home PC produced newsletter promoting Bob, his show and his products. I had articles from WIPB and UK Ross instructors. . . . BUT although I sent copies to BRI in the USA . . . after the third issue (which in all was a half dozen folded leaflets printed on my home pc for about a dozen Bob fans and friends) I received a very "unpleasant" letter from the head of BRI advising me to close the fan club or face legal action. I had no choice but to do that . . . and although I was running the Bob fan club as homage to Bob and for no profit whatsoever . . . I was sorry the BRI company didn't see it for that and support rather than bully me into closing.

Davy reiterates that he doesn't see himself as a fine artist and only wanted to celebrate the legacies of Bob Ross and Bill Alexander. In order to continue doing so, he created his "Paintermandavyt" Facebook site. Davy also notes, "The first half dozen *Joy of Painting* shows were sponsored by Alexander Art although all mention of him later was removed from subsequent shows and publications . . . a sad end to a once great friendship."

It is clear from Davy's newsletters and his emails that Bob Ross has been a tremendous role model for him. Davy explains:

Thanks to Bob Ross, I met lots of new friends and learned the joy that showing someone how to paint in this basic wet on wet oil painting style, it brings such happiness to those that paint with you and have their first completed painting to show their family and friends. There is no greater feeling than being thanked for showing

them that skill, a legacy left us by Bob and Bill. It also meant I had a worthwhile hobby after leaving an office environment and led to me working and selling some of my paintings at a local Arboretum where a lot of my painting inspiration comes from. I also got involved in volunteering at animal rescue centers as Bob had done and again another past time to fill my retirement days. It's all about sharing the joy and the things I've done and people I've met as a direct result of first watching Bob in his TV show. I will forever be grateful to him for!

Davy clearly separates his uncomfortable experience with Bob Ross, Inc., with the pleasure that Bob Ross the man has given him. When asked what a book about Bob Ross should tell the world, he writes:

That he was truly a wonderful man and (although inspired himself by Bill's original technique) his ideas to teach the world to paint for all the good things it does for a body's heart and soul was genuine, even though it helped him raise his "happy buck" along the way. That his love of wild places and wild creatures was also genuine and even if "fine artists" and "galleries" sometime consider his work "starving artist" quality . . . a lot of "fine artists" began by watching Bob's show and thanked him for his inspiration. Of all the folk I've met or spoken to by phone or letter/email, they all agreed he was the man you saw on the TV and they had only love and praise for him. . . . [Y]es, he wanted his instructors to teach "his" way, but he was I believe, like Walt Disney . . . one of America's if not the World's greatest entertainers, educators and inspiring men of their generation.

Loving Bob Ross, for Davy, is not just about loving his ability to paint. Being able to paint is just a bonus. It is about loving the man and especially his way of speaking to his audience individually, "as if you were the only person in the world with him that day." Finally, what seems most important to note about Bob from Davy's perspective is that Davy changed his way of thinking about the world, making him Bob's number 1 fan in the United Kingdom. Davy now has opportunities he never thought he'd experience. For that, he writes, "I will be eternally grateful to the Afro haired quiet spoken guy who loved to play with squirrels, Robert Norman Ross."

Danny Coeyman: "Bob Was My First Teacher"

In middle school, Danny Coeyman used to love getting sick. Staying home to watch TV on a couch covered in sheets, he knew his mom would bring him Jell-O and let him watch "the boob tube" as he convalesced. It was then, on some random afternoon down with the flu, that Danny passed through reruns of *Andy Griffith* and bad afternoon cartoons. He came to stop on a magical man with an Afro, painting clouds.

Danny was keenly aware of how he was different from his middle school peers. Growing up strictly Catholic in Oviedo, Florida, and slowly understanding that he was gay, Danny was not optimistic about "fitting in." Perhaps Bob Ross's openness caused Danny to stay tuned for the entire episode, as Bob manifested trees and grasses from his brush. Danny was mesmerized. Danny, who hated sports and math, was beginning to focus on art as his life path. Danny perceived Bob as sexually ambiguous, soft, tender, and capable. Bob was shamelessly promoting that not only can you paint, but in the process you can also be yourself.

As a teacher, Bob gave Danny access to a world of painting he wouldn't otherwise know. In Danny's public school, oil paints were ignored as expensive, messy, and flammable. He had never worked with them at all. Bob, with his alla prima landscapes, taught painters how to apply thin paint onto the thicker layers below. Bob taught Danny tricks of atmospheric perspective and how to suggest a tree rather than depict it. But what struck Danny then was Bob's way of being in the world. Not as a teacher or a celebrity, but as a regular human being broadcasting the message that "you cannot make mistakes" and that, by extension, there is nothing wrong with you.

Like Davy Turner's experience, Danny's first exposure to art was painting plaster figurines with his mom or doing woodwork with his dad. In Danny's school, art was rotated with three other subjects (health and shop) in a class period called "Wheel." At home, his exposure to fine art came from reproductions of religious master paintings on holy cards and church bulletins. Danny's parents did buy him a Bob Ross paint kit as a Christmas gift. He attributes this gift to starting him down a lifelong journey of painting. However, in contrast to a faraway heaven painted by baroque painters such as Peter Paul Rubens or the prescriptive practices promoted in an art kit, and even in contrast to Bob's day-dreamy worlds of happy critters, Danny liked that Bob was using art to heal and

A Bob Ross Painting Party taught by Danny Coeyman

build interpersonal connections. Art made the real world exciting while simultaneously supporting health and happiness.

Danny surmised that through his broadcasts Bob was building communities of students, self-helpers, and the lonely, like himself. He knew that Bob left the US Air Force with its focus on hierarchy to pursue the development of an egalitarian community of painters. Danny believed that Bob's world was a place to leave behind the hierarchical machismo of everything from middle school gym to Vatican II.

In 2006, Danny received his MFA from Parsons, the New School for Design. While at Parsons, he studied portraiture on a full scholarship from the Jack Kent Cooke Foundation. Danny recognized Bob as an access point, a way of going further into art and community. Since middle school, Danny had linked up with many other networks and communities: gay ones, political ones, New York City ones, Buddhist ones, and Art World ones. The Bob Ross network still captivated Danny, and he would often talk to fellow artists about a shared love for the guy on TV who painted happy trees.

Danny focused his graduate school studies on considering the act of painting portraiture in new contexts. His objective was to make portrait painting fresh and relevant to contemporary artists and sitters alike.

Danny considered how sitting across from someone and painting them contributed to a sense of community, healing, and love. In pursuit of this question Danny began using the act of painting others as a form of therapy, or "witnessing their likeness." He supported his investigation with queer theory, performance studies, psychology, Zen Buddhism, and relational aesthetics. A culminating project focused on Bob Ross emerged.

Danny created a video performance that teaches the viewer to paint a portrait of Bob using Bob's landscape techniques in thirty minutes (http://www.youtube.com/watch?v=-HhCq9tvtYk). Sprinkling in his own painting tips, Danny shows how Bob's landscape techniques can just as easily produce a portrait. Bob's Afro is painted using his bush-painting technique. His shirt gains volume and wrinkles by using a palette knife, just as Bob used it to give form to mountains. The liner brush draws in fingers and details the way that Bob wiggled twigs onto tree trunks.

Danny shot the video in an empty room at Parsons then uploaded it to YouTube so that it could be viewed widely and for free. Some classmates were skeptical. They wondered if the work was ironic, if it was a critique of Bob or capitalism or art or whatever. Danny saw this questioning as fair. Why should a fine artist pay homage to a kitschy antihero? Irony, it seemed, was simply a way of taking something complex and presenting it simply, or glibly, for fun.

Following the release of the video, Danny designed an open studio. Danny made kits, burnt DVDs, and taught free classes on how to paint a Bob portrait. The idea was to tap into participants' affection for Bob and each other by thinking about why he was truly so great. It was another experiment at using portraiture—and nostalgia—to bond.

In Danny's opinion, reactions to the project have been overwhelmingly positive because of his decision to avoid irony in favor of something more "authentic." At the time of this writing, the video has received over thirty thousand views with no promotion beyond word of mouth. The video has been shown at a combination art gallery and bar in the Lower East Side, and there are plans to teach the Bob Ross method at a gallery in Williamsburg, Brooklyn.

Comments on the YouTube page that hosts the video include middle school insults and sincere gratitude. Some viewers cannot get past Danny's effeminacy. Many others note that Danny's project is a "true" homage to Bob. Some viewers acknowledge that they could actually paint

along with the video if they wanted to. Danny next considered what is the essential quality that made the project feel like Bob Ross?

Danny concludes that the answer is generosity. He recognizes that there is a tension in the project—and the larger Bob Ross network—that feels threatened by irony and commerce and thrives when genuine generosity is involved. Danny believes Bob's art is best interpreted as a kind of gift. The gift of Bob's teaching and life moves from Bob to his audience and then from his audience forward into the world again. Everyone can be connected by this action, if it is truly generous.

For Danny this idea of art as a gift seems to curb the idea that the audience is "being duped" into buying a product. While skeptical of Bob Ross, Inc., for its control of Bob's official brand, Danny believes that Bob's generosity, as communicated to his audience, is a radical affirmation of the importance of connection. Where there is generosity, where a gift is given, a connection is made.

Danny found support for this opinion in *The Gift*, by anthropologist Lewis Hyde (1979). Hyde describes how the circulation of gifts has formed bonds in tribes, communities, and networks over time, geography, and culture:

> If we take the synthetic power of gifts, which establish and main-
> tain the bonds of affection between friends, lovers, and comrades,
> and if we add to these a circulation wider than a binary give-and-
> take, we shall soon derive society, or at least those societies—family,
> guild, fraternity, sorority, band, community—that cohere through
> faithfulness and gratitude. While gifts are marked by motion and
> momentum at the level of the individual, gift exchange at the level
> of the group offers equilibrium and coherence, a kind of anarchist
> stability. We can also say, to put the point conversely, that in a
> group that derives its cohesion from a circulation of gifts the con-
> version of gifts to commodities will have the effect of fragmenting
> the group, or even destroying it. (1979, 96–97)

In his book, Hyde (1979) lays out a few fundamentals of his research. First, the act of gift giving has to be in a group of more than just two. It can't be a "give-and-take"; it must involve paying the gift forward. Second, it cannot be a gift that is held onto, it must continue to be shared within the community. Finally, Hyde notes that if the gift stops moving, it becomes property and loses its bonding power. Danny is committed

to paying it forward. His portraits have helped him build a "queer family" of loved ones—gay and straight, male and female, of many races and backgrounds. Painting them is a way of connecting them all together. Meanwhile, he is directing the programming at a small nonprofit that teaches art to homeless youth. After school, in inner-city shelters, he teaches kids about how to make art and how to love themselves. Guiding his teaching is the soft-spoken voice that he detected in himself—and in Bob Ross—back in middle school.

Networked Conclusion

Bob's work supports everyone from his business partners to the workers in Martin F. Weber Factories who manufacture his paints and the people who only know him from TV but feel a genuinely fond connection for the man. Buying a Bob Ross painting set from a clerk at a local arts-and-crafts store constitutes an unemotional, economic exchange benefitting a corporation. However, Davy and Danny illustrate that such an economic exchange can also lead to a gift exchange that connects them to others emotionally. The perspectives of Davy and Danny suggest the compelling, provocative, and contradictive impulses moving through the network of interests associated with Bob Ross. Both Davy and Danny recognize and emphasize that at least in part, and among some, there is an understanding and appreciation of the interrelationship that can exist between art and "gift" as theorized by Hyde (1979). Even so, both acknowledge that this network also includes a sizable commercial enterprise that includes Bob Ross, Inc., and those many artist teachers and commercial establishments that support art and art-making and fall outside of a gift economy. Davy and Danny grapple with reconciling the fact that Bob Ross and Bob Ross, Inc., gained economically by advancing interests through a network initially catalyzed through Bob's generous and charismatic personality with much more altruistic motivations and effects. However, as corporations go, Bob Ross, Inc., is not particularly large and the artists teaching the classes have very small individual commercial enterprises. While he was still alive, Bob's economic success did not come from the sale of his paintings on a luxury market. Rather, Bob Ross's fortune came through a collection of many individual purchases of affordable paint. It was bought through and by a network. So who "owns" Bob now? On the one hand, Bob Ross is now a brand and

intellectual property maintained and defended by Bob Ross, Inc., and not open to free use. It is a group of consumers in a market. Simultaneously, to many Bob Ross is a generous man who still inspires people like Davy and Danny to participate in gift giving as theorized by Hyde (1979). It is a *community* in which they teach in the spirit of Bob Ross (as does Davy) or give their work inspired by Bob Ross away freely (as does Danny).

Just as there are similarities between Davy and Danny, there are also similarities between Bob Ross and Andy Warhol. Although they spoke to different audiences, they focused on similar themes. This relationship is explored in the next chapter.

9

BOB AND ANDY

If Andy Warhol took the everyday and made it into art, then Bob Ross took art and made it everyday. Of the two, Andy Warhol's legacy in Art History is undisputed. His life story is a legend of growing up unknown in poverty and dying a famous millionaire. He went from obscurity to becoming a man so cool that even his hair and voice were iconic. And by his own hand and those of others, he produced hundreds of artworks that still cycle through international culture decades after his death.

All of this is equally true of Bob Ross. Even the biographical particulars are similar: Bob Ross was a poor kid growing up near Orlando, Florida; Warhol was a poor kid in Pittsburgh, Pennsylvania. Warhol made millions from his artworks, whereas Bob Ross's company made its millions from selling paint and instructional books ("Bob Ross PBS Instructor" 1995). Warhol was known for his white wigs and deflective wit, Bob for his Afro and day-dreamy aphorisms. Each was known for being generous, effeminate, and kitschy.

They each polarize the public and the Art World for very different reasons: Andy for mocking Art and Bob for popularizing it and making it seem easy. The difference is that Ross has not yet found a place in Art History, despite his popularity within American popular culture. Perhaps Bob's own "self-parodying" (Harris 2009) commercials for MTV best illustrate his saccharine appeal to mass audiences, completing a "painting" of the MTV logo by calling it "MTV, it's all just fluffy white clouds" ("Bob Ross MTV Promo" 2011). Bob intuitively understood that his affect of naiveté would be ironically entertaining to a youthful audience.

Bob like Warhol, by Danny Coeyman

Relationship to the Art World

Warhol has an even more ironic, hipster appeal, as evidenced by the quirky gifts left at a monument unveiled in his honor near the site of the Factory in Union Square. Instead of leaving the traditional offering of flowers, visitors left cans of Campbell's soup at the feet of the statue (Smith 2011). Yet to a mainstream American audience, Warhol may have been the tougher artist to swallow. He drowns in a can of tomato soup on the cover of *Esquire* in May of 1969. Exhibited at Museum of Modern Art (MoMA) in 2009, the iconic image shared a headline describing "the final decline and total collapse of the American avant-garde" (Rose 2008). Warhol is idolized by hipsters and collected by millionaires,

but demonized by others for his affiliations with sex, drugs, and money. Writing about Andy, Mark Stevens (2007) notes, "Artists can lionize him, culture warriors denounce him as decadent, gossips bedeck him with girly adjectives—*delicious, marvelous*—intellectuals entwine themselves in his ironies." In a way, Andy Warhol was the artist the mainstream loved to hate. No matter how you felt about him, he could not be ignored.

Contrasted with Warhol, Bob Ross ignored the contemporary Art World and was particularly critical of Abstract Expressionism (Harris 2009). His words echoed the skepticism of many Americans when he poked fun at Jackson Pollock, saying, "If I paint something . . . I don't want to have to explain what it is" (Harris 2009). In one of his television episodes he acknowledges the contemporary art scene with a disparaging joke. He begins to paint a simple blue sky. Dipping into a blob of crimson, Ross paints a gradient across the canvas until it glows with purples and reds. The color fields are like a blend of an early Mark Rothko and late Helen Frankenthaler. In a few minutes it will become be a sunset, but in that moment, he turns to the camera and smiles, "And already there, we have a masterpiece for the Museum of Modern Art. We're ready to stop right there" ("Foot of the Mountain" 1985).

As Warhol aimed his work for prestigious galleries and museums like the Museum of Modern Art in New York City, Ross's self-deprecating, podunk charm compelled his audience of American PBS viewers, hobby artists, and insomniacs to see him as the guy next door making sofa paintings. It was the warmer complement to the cool, dissociated persona that Warhol developed and finally perfected at the Factory. With each new TV episode and public appearance, Ross perpetuated his approachable, comforting image and inspired his own kind of factory: amateur artists across the nation using paints fabricated in real Martin F. Weber factories, churning out landscapes, and hanging them on their walls.

Their Artworks

Perhaps their similarities and differences are even clearer in their paintings. Bob Ross's work resonates in particular with the Warhol landscapes titled *Do It Yourself*, completed in the early 1960s. The works are large, hand-painted images of houses, boats, and flowers stylized to look like oversized paint-by-numbers. Within the series, Warhol sometimes

perfectly filled the outlines with flat, colored areas, as if carefully following instructions. Even so, the paintings are always finished with large portions left blank and peppered with numbers, as if waiting to be completed.

It's a noncommittal gesture, perhaps as a critique of the hokey way art can be a hobby, or maybe to underscore the fact that even an unfinished painting is capable of elevation to High Art. One can only finish the painting through a mental game of projecting color into it. But the work is meant for a gallery wall, where no one would be allowed to actually touch it. Despite its title, we will never get to "do it ourselves." And as viewers, we are left to deal with the frustration and allure of its flirty invitation.

Though playful, The *Do It Yourself* series has an aura of serious critique. It takes the iconic American dream of beauty, ownership, and leisure and reduces it to the stereotypical and boring nature of a blueprint. The numbered, ordered compartments offer an infantilized formula for painting: follow directions and stay within the lines. Here the childhood pleasure of coloring is turned into work, in service of a coherent, fine art image. And Warhol was no stranger to work. From his early career as a self-made commercial artist, and even his prolific laboring in the Factory, followed particularly in the 1970s with an explosion of commissioned portraits, Warhol made thousands of artworks. But his commercial and economic success thrived in an alchemical fashion. From soup to comic strips to images of money itself, it seemed he could take anything at all and make it valuable. Like the mythological King Midas, Andy's touch turned everything—and *anything*—into gold. And so an unfinished hobby painting transforms into a completed work of art.

Contrasted with Andy's complicated, empty wastelands of the American dream, Bob's work is a literal path to making art and to experiencing the process of physically painting. Where Andy offers us a cheeky "do it yourself," Bob warmly tells us, "You *can* do it."

Recalling the spiritual connotations within Bob's nature imagery, there is a peaceful stasis in his works. As with Warhol, his imagery borders on the boring and conventional, but it has a texture and a realism that make it accessible and warm. Painting with the techniques of realism, particularly in his use of atmospheric perspective, Bob crafts each painting to seem like a place that we could really inhabit. It serves as a window into an alternate world that is private and abundant, our own secret garden. Like Eden before the fall or a vacation getaway, these

pictures are wonderlands where there is literally no one around and nothing to do. Contrasted with the sterile and civilized, cartoonish imagery of Warhol's pictures, these paintings don't push against the viewer's eye; instead they invite us in. They don't resist us with their flatness and crisp lines that seem commercial and cold. Instead, they welcome us into pictorial space where we can take a break from labor, obligations, and status anxieties of commerce and modern life. They are places where the eye can relax and, by extension, the viewer can too. Though equally as calculated as a Warhol painting (and equally complex), the intention in a Bob Ross painting is to take refuge and rest.

Approaches to Work

But to create these idyllic worlds actually takes hard work. When each painting is completed, every inch is covered in pigment, as dutifully as a child finishing all the food on the plate or a worker punching in hours on a time clock. Where Warhol could print a silkscreen in emulation of a machine, Bob Ross asks us to pay attention to every detail, every nook and cranny of the canvas. The values presented here celebrate a different kind of labor than Warhol's alchemy. They support an idea of an honest day's work, followed by a hard-earned rest.

This idea, this attitude that painting requires work, is at the heart of Bob Ross's and Andy Warhol's differences. It seems like a reflection of the Protestant work ethic that links labor and holiness. In the Bible, after God made Eden, on the seventh day, He rested. And we too can rest in the Edens we paint when we follow Bob's example. Work here does not have to be suffering or difficult, it just has to be impassioned—while still pleasurable. Bob asks his viewers to do real manual labor, while Warhol shows us that even a parody of work can become valuable culturally and economically. Whereas Warhol's intellectual work and mental payoff is a white-collar pleasure, Bob's manual craftspersonship is distinctly middle class. You do Warhol's work with your mind and you do Bob's work with your hands. And to an American audience steeped in a Protestant work ethic, manual labor is labor you can trust.

Pierre Bourdieu documented the connection between aesthetics and class in the 1960s in a landmark book. *Distinction: A Social Critique of the Judgement of Taste* used sociological studies to find trends and connections between class, education, and the way that people viewed

artwork. In the book's introduction, Bourdieu notes, "Working-class people expect every image to explicitly perform a function, if only that of a sign, and their judgements make reference, often explicitly, to the norms of morality or agreeableness" (1984, 5). And in the United States, Christian ideas about work, painting, and value are very different between the academic specialists and the more general public that collects art for decorative and sentimental reasons.

Popularity and Populism

Whereas Warhol's work was driven by his own interest in popularity, Ross's work was driven by an interest in populism. Bob himself worked his entire career in shopping malls and on TV, both places of common commerce. Part of his brand and myth involves the sacrifices he made to share his work with others. He spent days on the road away from his wife. There were rushed weeks of producing his TV show on a low budget. Conversely, Andy engaged the world of luxury and reification, the process of giving things value by making them special and scarce. His work has more to do with privilege, popularity, and parties. Bob Ross's work has a different approach, demystifying art and making it un-special and approachable, even common.

It is this unsexy identification with the middle-class work ethic and democratic display of art that makes Bob's work difficult to imagine in High Art contexts. Ultimately, Bob Ross actively dis-identified with High Art and Art History because it would have made his painting elitist. And his audience was a group of people who wanted encouragement from someone they could relate to, maybe even feel superior to, in order to trust him more. Unlike Warhol, he represented not only middle-class fantasies, but also middle-class *values*, and so his work appealed to that same demographic. While the super rich bought Warhol's portraits of themselves, Bob's followers were buying his products with hard-earned dollars, which in turn made Bob a millionaire. Here again, Bob managed to make work into leisure, to make labor pleasurable. A great irony of Bob's success is that it used nature and images of transcendence and recreation to sell trademarked tools of labor.

Bob sold because he became his brand. Authentic as it was, he crafted a persona that would appeal to his target market of middle-class art hobbyists and broadcast it on TV. Bob Ross and Andy Warhol share a keen ability to mediate our experience of who they are through video

and film. As masters of branding and public figures, they understood and manipulated the media to reinforce our ideas of who they were. As artists, both relied on the moving image. After all, while many joke that they watch Bob mainly to fall asleep, it was Warhol who made a film of a man sleeping.

Media

Watching Bob Ross's use of direct, straight-on camera angles, it is easy to imagine *The Joy of Painting* as a Warhol screen test. Each episode opens with Bob Ross staring out at us from a black room beside a blank, white canvas. Stark and almost existential, there is nothing gratuitous in the camera shot to distract us from Bob's presence. Bob thought carefully about the image he projected on camera. He chose a simple button-down shirt and blue jeans so that, in ten year's time, he wouldn't be embarrassed by what he was wearing (*Bob Ross: The Happy Painter* 2011). This selection of clothing gave the show continuity and timeless-ness. Beyond his costume, everything Bob Ross performs in his videos is the same. He always stands on the left side of the canvas. He always paints for thirty minutes. He always starts with the names of each color scrolling across the screen. He invariably ends with a bright red signa-ture and says, "'Til next time, happy painting and God bless my friend."

Because of their formal constancy, Bob *himself* is the only real source of nuance in his videos. From the outset, a viewer can expect that this episode will be just like every other. If ever we leave this studio shot, we see footage of Ross feeding deer and raccoons and squirrels, rescue animals from his life in Florida. Everything we see reinforces our sense of knowing him deeply as a human being. Like in Warhol's *Sleep*, the viewer gets time to see the veins, the wrinkles, the little hairs on Bob Ross's arm. A long and sustained viewing of the program is like watching loved ones brush their teeth or eat a sandwich for the hundredth time. The predictability is either endearing or revolting, but either way it is intimate. And this intimacy is exactly what makes the show compelling.

Further Comparisons

Comparisons between Bob's and Andy's paintings and films complicate our ideas about their savvy and their art. It's a timely comparison. In

2012, The Metropolitan Museum of Art brought together Warhol paintings and works from other artists with similar motifs in an exhibition called *Regarding Warhol: Sixty Artists, Fifty Years*. Attacked by critics for its superficial exhibition of only blue-chip artists, the show illustrated the way in which class more than commerce has come to characterize Warhol's legacy. Critic Jerry Saltz (2012) wrote, "This is more like an auction sales room or a high roller's private museum than an exhibition." And Roberta Smith (2012), who is married to Saltz, simply titled her review of the show "The In-Crowd Is All Here." The show could have forged meaningful connections between Warhol and painters like Bob Ross. And yet, if Bob's work were exhibited at the Met next to a Warhol, it would seem out of place, lacking the reach and historical importance that these other works retain. But the truest difference between the artists is *who* they painted for. Warhol painted for Roberta Smith's "in-crowd," which includes economically successful artists and the ultra rich collectors who buy his work. And Bob painted for people who didn't belong to that group, people who might even see Roberta Smith and Jerry Saltz, a power couple—she is read in the *New York Times* and he served as an art judge on reality TV—as being part of that in-crowd themselves.

Despite how their work is seen and valued, it is fun to imagine a meeting between Bob and Andy taking place a few decades back. They had many opportunities to be aware of each other. Andy was a voracious watcher of TV, and Bob was the top PBS television show on television in 1991 (Stanley 1995). By that time, Andy had already become a Pop culture icon, getting publicity for everything from his art to his attempted murder by Valerie Solanas. It certainly seems that both Andy and Bob would agree with Andy's suggestion that "land really is the best art" (Warhol 1985, 168). Would Bob Ross have sat for a screen test? Would Andy want to make a Bob Ross painting?

If they had met, maybe they would have liked in each other what they shared in common. Bob might have enjoyed Andy's sinuous draftsmanship and love of nature. And Andy would have liked Bob's intuitive mastery of Pop culture, irony, and marketing. It is all too easy to hear Warhol in his trademark lilt, "Oh, Bob? He's woooooonderful."

The following chapter explores a different kind of relationship: the works of Bob Ross and Thomas Kincade. This comparison is markedly different from that of Bob and Andy.

◄ 10 ►

THOMAS KINKADE IS NO BOB ROSS

When first talking to various people about Bob Ross and this project, Bob is sometimes confused with Thomas Kinkade (1958–2012), who trademarked himself "The Painter of Light." On the surface, this mistake may be vaguely understandable. Both artists dressed in jeans and associated themselves with the everyday person. Kinkade is described in a *New York Times* article as "an ebullient, burly, mustached fellow in jeans who looks more like a construction worker than a multimillionaire artist" (DeCarlo 1999, AR51). Like Bob Ross, Kinkade has been hugely popular. In the same *New York Times* article he was described as "arguably the most commercially successful painter of the 1990's" (DeCarlo 1999, AR51). And Kinkade, like Bob Ross, painted landscapes, but his works are not the unspoiled views of Alaska's wilderness. Rather, they are garden scenes and charming British cottages or small houses adorned with radiant sunlight. As with Bob, the comforting titles of his works read like Hallmark cards: *Hometown Evenings* or *The Blessings of Spring*. Painted in pastels and depicting soft-focus idealizations of everyday life, there is a sugary sweetness to Kinkade's imagery. In spite of their huge success and profiles in national magazines, neither Ross nor Kinkade have received widespread attention in the capital *A* Art World.

The Critics

Recently, however, academics (like us) have begun to dissect their differences and similarities. In 2011, Duke University Press published *Thomas Kinkade, the Painter at the Mall*, a collection of essays from art historians and writers from major universities. Overall, the book critiques

Bob like Seurat, by Danny Coeyman

the Art World for ignoring Kinkade's work and beautifully examines the fullness of his work in our culture, but hardly praises Kinkade himself. Meanwhile, our research has found that folks in the Art World, the academic world, and the world at large are far less harsh with Bob. He seems to have more champions than critics.

When these men are compared, they literally clash. Take an image by Nashville artist Scott Guion, *Good vs. Evil: Bob Ross in Mortal Combat with Thomas Kinkade*, in which Bob and Thomas fight to the death in the middle of a canvas split by their different visions of the world. Scott Guion is a self-taught painter who creates fantasy scenes inspired by Walt Disney to Norman Rockwell. His style and influences are far more

linked to Kinkade's. And yet Guion equates Bob with good and Thomas with evil. In our interviews with folks from across the country, artists in particular demonize Thomas and treat Bob with a tenderness and nostalgia. So why do so many people love Bob and hate Thomas?

In part, the answer lies in their life stories. Now that both men have passed away, it is possible to trace the trajectories of their lives and companies to very different ends. Kinkade, like Bob, knew how to market his persona. Kinkade was a devout Christian who promoted the importance of family life. Married to his childhood sweetheart, he had four daughters, all of whom had the same middle name of Christian. Kinkade's sentimental message left the Art World unimpressed. But that same message brought the middle-class to his galleries in droves. In 1999, there were 248 Thomas Kinkade galleries across the country, and his work was selling like wildfire as the Art World, when they paid attention, balked.

Kinkade's works were digitally reproduced, and by 2002 he had sold 10 million digital reproductions. His artwork sold from $295 for paper lithographs to $10,000 for canvases that were manufactured and retouched at his factory south of San Jose, California. Common canvases, with no markings whatsoever by Kinkade, sold for $1,500, and works he had touched could fetch $500,000 (Safer 2001).

Writing for the *New Yorker* in 2001, Susan Orlean (a famed lover of all things quirky and slightly dark) profiled Kinkade with dry humor and unflinching honesty. Orlean quotes Kinkade as follows: "I believe in 'aspire to' art. I want my work to be available but not common. I want it to be a dignified component of everyday life. It's good to dream about things. It's like dreaming of owning a Rolex—instead, you dream about owning a seventy-five-thousand-dollar print" (2001, 128).

It's subtle, but a key word in Kinkade's quote is *print*. At the heart of his business model was his "passion to find a way to get prints to look like an original" (Safer 2001). Priced as luxury collectibles, these products may have confused those who bought his work in galleries in strip malls. Morley Safer profiled Kinkade on *60 Minutes* in 2001 and called Kinkade a genius of marketing.

Karen Breslau (2002) explained that at the factory "a digital photograph of each original is reproduced thousands of times onto thin plastic film that is then glued to canvases. They're sent to a studio where "highlighters" sit along an assembly line, dabbling oil paint onto set spots." One could easily smirk at this process, possibly equating it to mass-produced landscapes purchased decades ago at Woolworths to place above sofas,

but Kinkade had a way of making them more his own. Breslau explains that each of the ten thousand produced in the factory each month was "signed by a DNA pen" containing drops of Kinkade's blood and bearing a numbered certificate on the back to guard against forgery" (2002, 48). Kinkade's profile on *60 Minutes* showed a bustling factory of workers shipping, framing, and painting a few strokes on Kinkade's prints. On a publicity trip, Kinkade himself stands with a stack of prints as high as his head, signing their backs with a pencil to increase their value. The investment, it seems, was more in Kinkade the brand than Kinkade the painted object.

In 2000, his franchise took in over $2 billion, and his future looked bright (Marling et al. 2002, B4). Kinkade diversified, selling numerous other licensed objects ranging from coffee mugs, calendars, novels based on his paintings, and picture puzzles to movies about his life, Christmas stories, and La-Z-Boy recliners. In the early 2000s, a subdivision inspired by Kinkade's paintings was developed in Vallejo, California. Dubbed "the Village at Hiddenbrooke," it features cottages named after his daughters and street names that echo his painting titles to literally bring Kinkade's paintings to life (Pearson 2011). Kinkade's company, the Media Arts Group, which went public in 1994, talked about plans to expand into a theme park and two more housing developments. About his goals for the future, Kinkade remarked, "Anything Martha Stewart has done, we can do. Anything Walt Disney has done, we can do" (quoted in Breslau 2002, 48). Kinkade understood that his branded imagery could become an empire of commerce, remarking to Morley Safer (2001), "You can have a Thomas Kinkade sofa under your Thomas Kinkade painting . . . in your new Thomas Kinkade home in your Thomas Kinkade subdivision." Thomas would often represent himself as an artist in the same lineage as Walt Disney and Norman Rockwell. Savvy about cross merchandising, he created an entire line of paintings based on Walt Disney films. And just as he snuck portraits of himself and his wife, Nanette, into his works, over the years Kinkade included portraits of Rockwell throughout his paintings. He believed he understood something about popular Americans' tastes, as he explained, "I represent the forefront of an entirely new trend, a populist movement that takes images people understand and creates an iconography for our era" (quoted in DeCarlo, 1999 AR51).

While many critics dismissed him and his following, some in the Art World tried to make sense of his efforts. Karal Ann Marling explained,

"They [Kinkade's artworks] are suffused with nostalgia, but the people I've interviewed about them think his paintings create a sense of safety and light in a darkened world" (Marling et al. 2002, B4). She also noted that they were void of anything controversial and that a religious message was vaguely implied as he included the number to Bible verses in his works and placed his wife's initials in the pictures, suggesting closeness to his family. While most critics—including those in *Thomas Kinkade: The Artist at the Mall*—used his popularity to reflect on visual culture, and others simply ignored him, Marling noted the little to no attention he received as a painter in his own right and responded that he deserved more press since he was clearly "a major cultural phenomenon" (Marling et al. 2002, B4). Citing the article written by Susan Orlean, she wrote, "*The New Yorker*, the snottiest of American magazines, wrote a kind of exposé—as through the rest of us didn't already know this. This is popular art, this is how it's made, and all of a sudden, all of these people who've never heard of Thomas Kinkade—presumably they never go to the mall—are insulted by this art movement they know nothing about"; Marling goes on to state the obvious: "He's really tapped a deep wellspring of need" (Marling et al. 2002 B4).

Kinkade echoed the statement in terms of his numbers. Who could argue with the vast number of sales he had made? Kinkade insisted:

> *The No. 1 quote critics give me is "Thom, your work is irrelevant." Now, that's a fascinating, fascinating comment. Yes, irrelevant to the little subculture, this microculture, of modern art. But here's the point: My art is relevant because it's relevant to ten million people. That makes me the most relevant artist in this culture, not the least. Because I'm relevant to real people. (quoted in Orlean 2001, 130)*

Mark Pohland agrees that a real need, for real people, has been tapped, but relates Kincade's work to old ideas about craft, saying that it provides owners with something lovely, but has no ability to pose questions. Brooke Cameron agrees that he's not doing anything new; his work, she says, follows in the tradition of Currier and Ives, but they aren't real like a Currier and Ives. While some have insightfully argued that it's a judgment based in the distinction between art and kitsch (Boylan 2011), Kinkade's greatest criticism is that there is no challenge to his work and no new ground being covered. Instead of being an artist,

Cameron concludes, he is a businessman (Marling et al. 2002, B4). But his success with business was not lasting.

Unfortunately for Kinkade, as the economy started to sour, his company began spiraling downward. His galleries were closing at record speed, and shares of his stock plummeted, causing critics to ask why an artist's company would "be traded on the New York Stock Exchange when most artworks depend on scarcity?" (Breslau 2002, 48). After several lawsuits and a settlement outside of court that cost millions, the company filed for bankruptcy protection. To add to Kinkade's troubles, the FBI began a probe to determine if the Media Arts Group intentionally mislead gallery owners to invest in the crumbling franchise ("Thomas Kinkade's Death Launches Dispute over Legacy" 2012).

Several papers reported that Kinkade himself had spiraled as well. A recent separation from his wife, reports of sexual harassment, public urination at Disneyland, and a relapse into alcoholism forced Kinkade to defend his image. A few years after his company filed for bankruptcy protection, Kinkade passed away in his historic cottage in California. Toxicology reports indicate that Kinkade died of an accidental overdose of alcohol and Valium. After learning of his death, some rushed to Kinkade galleries to purchase his remaining works ("Thomas Kinkade's Death Launches Dispute over Legacy" 2012), but eventually many of his collectors felt duped and tried to unload their purchases on eBay.

The Paintings

Clearly there are differences in the life stories of Bob Ross and Thomas Kinkade. So much of Bob's life is unknown, and the fullness of Kinkade's life is not just a question of who took legal action against him or how he died. What, we ask, can be ascertained in Kincade's work itself? Here again, a second glance at the paintings of Bob and Thomas reveal striking differences in the ways these men approached nature, America, and spirituality. More importantly, those same attitudes are reflected in the ways they shared their art.

Kinkade's marketing spiel articulates his work as an expression of the beauty of nature, the need to return to simplicity, and the grace of God's light. Sunsets and sunrises were the vocabulary of that message. He seemed deeply inspired by the natural world. He was proud of the fact that he sketched from life and that his sketchbooks full of nature

and inspiration were the size of "little hymnals." ("Thomas Kinkade—Art Techniques inside Ivy Gate Studio" 2012). His work on his website in 2012 was a bona fide survey of mountains and clouds, misty foliage, dappled shadows, luminous grasses, and rippled water reflecting broken light.

But ensconced in all this nature, in a large majority of his paintings, Kinkade paints something that Bob never does: cottages, manors, castles, and estates. Kinkade consistently colonized his natural world with buildings, detailed down to their mortar and bricks, their rooflines gathering the eye as a focal point. While Bob painted empty shacks, Kinkade's homes are well kept, fancy, and inhabited. These imaginary houses cast glows of light and emit plumes of smoke like they are full of happy families. Outside, canoes, snowmen, and sleighs reveal the dealings of a day that, in the hoary gradients of a bucolic dusk, are peacefully drawn to an end.

Why do these houses matter? Because they are desirable, quaint, and beautiful. And because they are not yours. Like the Rolex or the Kinkade painting itself, they are monuments to aspirational consumption. They are property. Said best, Kinkade did not paint nature, he painted real estate. And the nature that surrounds these properties—trimmed hedges, manicured lawns, and rustic gardens—becomes property as well. They are boundaries and displays of wealth. It is not surprising that an entire gallery of paintings on his website is simply called "gates." When Kinkade paints a tree it isn't landscape, it's *landscaping*.

One wonders who lives in these imaginary homes, beyond their gates, gazebos, and gardens. And what goes on behind the glowing windows of their cottages? Another survey of Kinkade's website reveals a shocking reality. In all of the works exhibited on his website, not a single person in the foreground of a Kinkade painting is not white—not one. Even in all the blotchy impressionism of his backgrounds, not a single arm, not a single face, is not squiggled in a neon peachy-cream.

This eerie whitewash carries over even into paintings of crowded events like the Indianapolis 500 and diverse cities like San Francisco and New York. Kinkade often avoids America's culture by painting scenes from before 1940 (McElya 2011). But even a 2008 painting of Yankee stadium has all white players and fans. On the field and even on the bench, these pinkish figures look nothing like the real lineup of the 2008 Yankee team of Anthony Rodriguez and Derek Jeter.

Even when Kinkade paints in the *plein air* tradition his figures are white. With the exception of a series of paintings depicting Israel,

Kinkade's observations of places as unique as Hawaii, France, and Italy were filtered—from direct observation—to depict only white bodies. Wherever he is on the globe, and even at Times Square, the fabled crossroads of the world, Kinkade sees through a lens either so naïve or so racist that people who don't share his skin color simply don't exist. "The Painter of Light" becomes the painter of white.

And what kind of lives do Kinkade's figures lead? Kinkade proposed they were lives of peace, quiet, and blessings. Unsurprisingly, there are no same-sex couples. There are no signs of poverty. There are no extended families. There is nothing to suggest that anything other than a white, straight, able-bodied, nuclear family is even *possible*. Rooted in a kind of nostalgia for a past that never existed, Kinkade's vision of a simpler life is an imaginary world where the complexities of contemporary America aren't merely misrepresented, they *aren't represented at all*.

Why do so many people hate Kinkade? Because so few people could actually live in his fantasy world. Even Norman Rockwell's figures and Walt Disney's characters would stick out like sore thumbs in these towns. Like the gated suburbs he built to house like-minded devotees or the couple buying their first Kinkade print for their home in a gated community or the cottages he painted hidden behind gates, these paintings illustrate places where people feel "safety, familiarity, and control" (Pearson 2011, 160). But they aren't seeking gated refuge from stress or protection from the dangers of spiritual temptation. They're hiding from anyone who doesn't look like them. Beside the glow of his roaring fires, Kinkade's perfect humans might leaf through a hymnal, dry socks from a recent outing in the snow, or quietly copulate in the missionary position to build their nuclear family. But unless you're white and affluent, don't come knocking on their door.

Even when Kinkade removes real estate from the focal point of his painting, he tops off the landscape with a symbol of Christianity. In *Sunrise 2000*, a large cross dominates a scene of transcendent sunrays. A similar painting, *The Cross*, caps off a mountainous landscape by topping it with a cross. Like the *ichthys* (the Jesus fish symbol) that Kinkade incorporates into his signature, these Christian symbols abound like a logo, a mark that panders toward well-meaning, everyday Christian Americans who like pretty pictures and have disposable income. Others agreed.

Norman Yatooma successfully made an arbitration claim against the Media Arts Group on behalf of a gallery couple that claimed Kinkade

convinced them to invest thousands of dollars in a gallery and then ruined them financially. Yatooma was particularly critical of the way Kinkade used Christianity in convincing his clients to join the franchise: "Most of my clients got involved with Kinkade because it was presented as a religious opportunity," Yatooma said in a phone interview. "Being defrauded is awful enough, but doing it in the name of God is really despicable" (Jett 2006).

It may seem like we are being harsh. After all, before all the legal action, at the height of his fame, Kinkade claimed that one in twenty homes had one of his paintings. That's 5 percent of American families. Imagine it as a Kinkade picture. Let's call it *Everyday American Town at Dusk*. The US Census Bureau shows that 76 percent of Americans were Christian in 2008 ("Table 75. Self-Described Religious Identification" 2013). So in a village of twenty homes, one would be a Kinkade cottage full of glowing light. You can see it now, nestled in the valley below, tucked away behind a curlicue gate with ivy. And what else goes into this landscape? Five homes would house non-Christians. Who knows what Thomas would do with those? But how would he paint homes for other Christians that for economic, racial, or social reasons—or just for reasons of taste—had not bought into Kinkade's world? How would he beautify their apartments, shacks, and homes? Would he find it fit for God's light to peek through their clotheslines and noisy, outdated washing machines as they air their dirty laundry? Could he mix a darker colored skin or show a childless gay couple sipping cocoa? Would children be allowed to play unattended on the neon green of their lawns instead of paraded around like property? Imagine this wonky village and the single Kinkade house within it: a vision of repression branded as morality. This America, this hodgepodge of Christians and Jews and atheists, Muslims and Buddhists, is the one that truly exists and is a far cry from the harmonious homogeny that Kinkade depicted with soft-edged imagery and hard-lined exclusivity.

To be very clear, our criticism is not that Kinkade was a Christian or used Christian imagery in his painting. It's that the marketing of his work used Christian imagery to conceal purely capitalist values. Those values alienated him from Christians and Art connoisseurs and regular folks at the mall—95 percent of Americans in all. Unlike Kinkade, whose business was amassing wealth, the biblical Christ embraced a life of poverty and hung with the poor, the sick, and an egregiously sinful (albeit repentant) group of disciples and followers. These are folks who are not

likely invited for tea at the cottage beyond the garden gate. They would know nothing like Kinkade's lived reality as a successful entrepreneur and millionaire with several houses. And when Kinkade claims to speak a universal message of God's love with images of exclusive real estate, he strips away the radicalism and beauty of the more traditional Christian message of love for all of God's children.

Perhaps this is best illustrated in the particularly bizarre Kinkade painting entitled *The Good Shepherd's Cottage*, where an open-armed (and very peach) Jesus welcomes a herd of sheep—literal sheep—to the threshold of a glowing cottage. One imagines Jesus barefoot or sandaled beneath his robe, even as he stands on a trim and tidy entryway of perfectly laid brick and manicured flowers. But we can't imagine the sheep actually entering the cottage. Would they plop their hoofs into the plush upholstery of Kinkade-licensed La-Z-Boys? The image is so jarringly incongruous that it almost feels like a photo-shopped hoax.

Bob's imagery could not be further from Kinkade's when it comes to ideas about spirituality and ownership. Not only are Bob's mountains and streams unclaimed by any particular religious imagery, they're unclaimed entirely. His natural world is completely undeveloped. When Bob paints a landscape, it belongs to no one and everyone. Though at times a path, bridge, or rickety dwelling might sneak into his works, these are rustic, broken down, and uninhabited. They are not real estate, and they are not property. They are human interventions to help navigate the landscape more safely or seek shelter in an oncoming storm. Practically speaking, they direct the eye into the work and give it flow, just as Kinkade's do with great mastery. But in terms of content, they are as different as a Danielle Steel chateau and Henry David Thoreau's cabin. Who might live in Bob's shacks? In his program, Bob suggested they were for travelers seeking shelter, wanderers seeking rest, and critters holed up in the rafters. By extension, in the language of PBS, these shacks are for "viewers like you."

Meeting the Artists

We mention PBS now because it is pertinent to how Kinkade and Ross interfaced with TV viewers. Consider how one might first "meet" Thomas Kinkade and get a sense of his personality. His face was part and parcel of his marketing, disseminated through outlets in malls, shown on an

Internet site, and distributed in Christian bookstores. Both Morley Safer and Susan Orlean describe Kinkade's whirlwind appearances at galleries to bump up sales. But most people would only know Kinkade's face from his TV segments on QVC, a television channel devoted to selling jewelry, art, kitchen equipment, and other products. On a show like this, Kinkade would talk to customers, ostensibly spreading the message of simple living and God's love, while a box on the left corner of the screen told you the exact cost and quantity remaining of each print (Safer 2001). Below, a clock would be counting down the minutes remaining to call before these limited editions sold out. On *60 Minutes*, Kinkade estimated to Morley Safer that he made over $1 million in just one hour on the QVC Channel.

So much of Kinkade's salesmanship technique makes him seem like he's hawking overpriced snake oil. Perhaps the most laughable example is how, in galleries and on QVC, Kinkade or his sales reps would dim the lights in the room to show how the highlights in the painting glowed. This luminosity, which any oil painter can achieve with glazing techniques, is the foundation of his trademark as the "Painter of Light." It's just the way light works; it's no different than a runner wearing light clothing at dusk to reflect headlights and avoid getting hit by cars. But on QVC it is touted as a near miracle. It's magic, or so it seems, and Kinkade behaves like a cheap illusionist who just vanished a volunteer's quarter but won't roll up his sleeves. And also won't give the quarter back.

Bob is often described as magical too. But he rolled up his sleeves as a matter of habit. He made his work and his techniques the focus of his art, and he made them completely transparent. And episode after episode, he taught them to his audience without flourish or misdirection.

It's interesting that Bob's PBS segments are just as much his artwork as his paintings, while a tape of Kinkade on QVC would feel empty, like packaging. Contrasted to Kinkade's array of objects available for purchase, Bob Ross's paintings actually came to be owned by very few people. Indeed, compared to those who watch, very few people even make their own versions of them. Bob's documentary marveled that only 4 percent of his viewers ever even make a painting (*Bob Ross: The Happy Painter* 2011). Clearly, Bob affected people with his TV show more than his paintings. That doesn't mean the paintings are irrelevant, it just makes them a means to an end that isn't based in consumption. You get to know Bob by painting with him, psychically on your couch or in real life at an easel. Unlike a charlatan's, his brand of magic was less flashy

and more direct. His is the magic of leavening bread or a hatching egg. It's not a trick; it's just an intense focusing on something mysterious that feels like learning. Or gratitude. Or a miracle.

In interviews and on QVC, Kinkade said he wanted his paintings to remind people to slow down and enjoy life. But it was Bob who helped people do so. Kinkade said he painted nature so that everyone could enjoy it, but it was Bob who encouraged us to experience sunsets and snowstorms and to appreciate them by painting them. Of course, QVC and PBS perfectly complement these opposing artists' missions, and it shows. Instead of dollars, Bob flashed the names of colors across his screen. And although Bob's PBS episodes always ended with a quick acknowledgement for Martin F. Weber paints, Bob was not selling copies of his paintings; he was selling the tools to make your own originals. Honestly speaking, by the end of an episode, most of Bob's viewers had already gotten what they came for. What he gave away for free was what most of his viewers wanted: his captivating view of the world—his magic.

Talent versus Teaching

Until now, we haven't compared Bob and Thomas in terms of talent. Bob's sister-in-law, June Wozniak, says he didn't paint anything other than the landscapes he made on TV, and Kinkade also seemed too busy to paint for leisure. Looking at the work they made for the public, it certainly seems that Kinkade benefited from his study of fine arts before leaving Berkley (Orlean 2001) and was a talented draftsman. For what it's worth, Kinkade's paintings have a level of detail, range of subject matter, and an expanded feeling of depth that are more believable and nuanced compared to much of what Bob Ross painted (or chose to paint in order to teach). Truth be told, Kinkade's ability to eek an emotive ambiance out of light is a well-honed ability.

Considering his gifts as an artist, could Kinkade have shared his talents as a teacher? Would people have liked him more if he told us how he made all that dappled light? The closest he ever came was a video called *Art Techniques inside Ivy Gate Studio*. Welcoming us by noting that he paints (and lives) in a historic cottage in the "California Craftsman style of architecture," Kinkade leads us from his front lawn into his studio. "If there is one question I'm asked more than any other, it is how I do my paintings," he says warmly ("Thomas Kinkade—Art Techniques

inside Ivy Gate Studio" 2012). Once inside, Kinkade shows us how he uses acrylics to paint under-layers and oils to paint texture on his works. It's a distinction that echoes the fabrication process he uses to make his prints. He continues with demonstrations on varnishing his paints from a spray paint can and spends several minutes describing how he airbrushes "halos" onto the work. It's corny, totally unscripted, and even a little sweet. This is not the same slick Kinkade giving a sales pitch or dimming the lights on QVC. Or so it seems.

But very soon it is clear that Kinkade is not teaching us to paint; he is showing us how *he* paints. He is affirming his competence. He never instructs the viewer, he simply shows off his tools—and his house. Kinkade's thirty minutes inside Ivy Gate Cottage move us from studios to desks to libraries (compared to Bob's empty studio in his videos), where he talks about being left-handed and how he likes to sketch in church. It's a bit like the mock humility of a celebrity's show-and-tell on MTV's *Cribs*. Toward the end of the video, Kinkade talks about carrying the torch of God's light in a lineage that includes master painters like Leonardo da Vinci. Here he leafs through impressive leather-bound books of old master nativity scenes and talks about how he "would like to be remembered as someone who taught others to paint" ("Thomas Kinkade—Art Techniques inside Ivy Gate Studio" 2012).

By the end of the video, one thing seems clear: Kinkade needed to dodge the major criticisms that were being launched against him—and his company—as a hack. Kinkade explains that the video is in celebration of a new venture called Thomas Kinkade Studios, while showing clips of his "students" (a small group of painters who are trained to imitate Kinkade's style). Yes, he admits, others do make his paintings for him, but really he's helping them learn to paint. His rhetoric continues with a reminder that apprentices aren't a new concept anyway, and the screen helpfully flashes the phrase *atelier system*. Kinkade touches his hand to his temple and seems to reminisce: Why, even Leonardo da Vinci worked on paintings with his mentor, Andrea del Verrochio. And he turned out to be a *genius*.

Kinkade may believe he is a master and a master teacher, but the idea seems half-baked and awkward when compared to da Vinci. The teaching comparison shows off Bob's talent, not as an artist per se, but as an educator. Where Bob encouraged others to take his techniques and make their own works, Kinkade's workers literally trace their brushstrokes over his printed versions. It's a nuanced distinction, but

an important one. Both artists offered a house style, a way of depicting the world through a lens of ideals. But Bob's teaching was to move beyond that style and paint your own way. Kinkade needed his painters to paint like him. Even more telling, he needed them to think like him, to be him. Revealingly, everyone in his businesses, from salespeople to his master retouchers, was required to memorize facts about Kinkade's life. They could recite his daughters' names and stories about his life with Nanette and would recount them while doing touch-up events at galleries (Orlean 2001). These aren't self-actualized painters, they are clones. They are proxies, disseminating Kinkade's brand identity and trained to upsell, suggesting more paintings that Kinkade collectors might like to purchase to complement their growing collection (Orlean 2001).

In yet another bizarre twist of the Kinkade Studio, his company website warns potential collectors about frauds: "Thomas Kinkade is the number one collected artist in Asia as well, however, neither Thom nor his company see any proceeds from those sales. Since the countries who often produce these fraud pieces have no copyright laws" ("Thomas Kinkade Fraud—What You Should Know before Purchasing" 2011).

Copying seems odd, but it's more common than people may know. Famous as a village of extremely talented artist copiers, Dafen Village in China is one place to procure an unauthorized Kinkade that looks like an original. Like their American counterparts on the assembly line at Thomas Kinkade Studio, these Chinese artists make a living by replicating famous Western artworks for Western audiences. It's yet another quirk of the fallout from an "Age of Mechanical Reproduction" first theorized by Walter Benjamin (1970) in 1936. Although Kinkade's company does not agree, we smile at the thought that three "original paintings" might coexist in the world at any moment: the original oil by Thomas's hand, the authorized and printed reproduction by the hands of his assistants, and the hand-painted and unauthorized copy by talented imitators. Issues of authenticity, class, and labor float like a glowing, ahem, *halo* around his work. But if Kinkade is a teacher in any sense of the word, it is in the way his work accidentally spawned a niche of equally capable painters, one-upping his business model and outselling him half a world away.

Ownership versus Stewardship

Along with their differences in how they developed their skills as teachers and painters, Ross and Kinkade differ most dramatically on what their audiences do with their art after it leaves the artist's studio. Kinkade's legacy seemed sealed not so much by bankruptcy or people trying to dump their paintings on eBay. Rather, it seemed fated when, upon learning of his death, many of his fans rushed to buy up the remaining lot of his works. It's an act that is shrewdly imitative of the way the upper class buys works from deceased blue-chip painters. In a world where it is fun to hate artists like Thomas Kinkade, Damien Hirst, and Jeff Koons for making it rich in smarmy ways, one also has to admit they have an enviable savvy that other artists may not. Books like Thomas J. Stanley's best-selling *The Millionaire Mind* (2001) constantly assert that successful people manifest their wealth by changing their outlook on wealth. Time and again, the message in our culture is that acting like you're rich will make you so. Amazingly, the same author refined the message even more a decade later, telling his readers to *Stop Acting Rich and Start Living Like a Real Millionaire* (Stanley 2011).

Banking on folk wisdom may not actually pay off. Who knows what Stanley will require of his readers in another ten year's time. But when so many believe the truism that artists are usually only valued after they die, perhaps the mad dash to collect Kinkade was a way of imitating the upper class's "savvy." Snatching up a Kinkade after you see he's dead on the news is like snatching up one last Twinkie before Hostess goes out of business. It's an investment, a form of anticipating value because of future scarcity.

Susan Orlean's article feels prescient because it questioned the motives of Kinkade's collectors at the height of his fame in 2001:

> *People like to own things they think are valuable, and they are titillated by the prospect that the things they own might be even more valuable than they thought. The high price of limited editions is part of their appeal: it implies that they are choice and exclusive, and that only a certain class of people will be able to afford them— a limited edition of people with taste and discernment.* (2001, 128)

It sounds like a paradox, but Kinkade is selling a kind of middle-class luxury. People of all classes decorate their walls, but where they get the

decorations indicates something of their upward social mobility. What distinguishes a Kinkade print from a print bought at Michael's, a thrift store, or a garage sale is that it promises to be an investment. This art is a form of capital that accrues. One young woman that Susan Orlean describes purchased her first Kinkade in a gallery; she had just inherited money from her grandmother and "didn't want it to just disappear" (2001, 124). These prints were seen as objects that would retain value—maybe even get more expensive over time—and look pretty over the sofa.

This tendency to collect as an investment is becoming part of popular wisdom, not just a strategy for the upper class. And just like Tickle Me Elmo, the Stock Market, beanie babies, or tulipomania, these pretty paintings are as valuable as people believe them to be. It's a bubble, and it breaks. And when everyone starts agreeing that something is not so great after all, the people who suffer are the ones who still own them when this game of hot potato ends. The pressurized environment of Kinkade consumption relied on the idea that his success proved his worth. And when people stopped believing, his paintings became a case of the emperor's new clothes. Suddenly his magical paintings evaporated into a paltry, colored Xerox glued to canvas. Or, maybe more precisely, the paintings became prints. Like any other market of infatuation, the folks who can read the hype—and generate it—are the ones who walk away with the money. In his heyday, Kinkade was at the helm of that marketing machine. So then, how come Kinkade passed away in financial troubles and defending his reputation?

Kinkade purported to be the epicenter of a vast network, a group of equals in God's love, positioned at the epicenter of a very large circle of fans and beloved coworkers. In reality, his business model was not a circle, it was a pyramid scheme, leeching money from the folks who believed in his cottages. And he hoarded the money to purchase vacation homes. As folks below him started to drop out, the pyramid crumbled.

Instead of ownership of paintings, Bob Ross offered his fans the ability to paint. It's like the difference between giving people fish or teaching them to fish. Only Kinkade was selling fish, not giving them away. Bob articulates his art as a form of stewardship, not ownership. It's a different sense of owning something, a kind of investment that pays off by paying forward. You don't wait for your painting to increase in worth, you imbue it with your own sense of value.

You can't sink money into creating a Bob Ross painting and hope that it makes you rich based on supply and demand curves. Richness

for Bob's followers has nothing to do with money; it is a qualitative idea. When you invest in Bob you actually invest in yourself; you buy his paints and you try to make something with them on your own. If you fail, you fail because of your own limitations or your decision to stop trying, not because something outside of you crashed or deflated or got sued. If tomorrow you discovered Bob died of an overdose of alcohol and Valium or had peed on a statue in Walt Disney Land, you'd still be able to paint a great picture that meant something to you. The value of your painting is proportional to the investment you put into it. It's up to you to give it meaning and to work hard at it. The harder you work, the more you get back. It's directly proportional. There are no exponential returns, but there is also no way to lose it all.

In a larger sense, this feeling of stewardship extends into Bob's remarkable ability to hold together a community, even after his death, with his vision of the land he painted. His company and his fans promote his message in their own ways on the Internet and through marketing. But Bob is still very much a television figure, and that point is important. Bob still hasn't "jumped the shark." Some people don't even know he's dead because they see him regularly on PBS. And when we see Bob on TV, we see a man who praises us as caretakers. Gently teaching us, encouraging us, and reminding us of the value of work and of rest, Bob asks us to be stewards of our world. And just as in his imagery, Bob saw Nature and each person as something special to preserve. Keeping the land clean is not only good for you, it's good for the future generations that you'll never meet or know. It's an act that is both generous to you and to others. And taking care of each other wasn't something to paint into pictures; it was something to do in real life. To Bob, we are all God's critters.

There's a reason Bob's paintings can't be bought. He gave them away as gifts. Even when they were destined for auction, Bob himself never saw a kickback on the money his works raised. Kinkade also did charity auctions of drawings that he made in front of live audiences. One video on YouTube tellingly shows us how. While on stage, minutes after plugging a film version of his life story, Kinkade draws for about five minutes on a pre-framed piece of paper while pattering with the audience about Norman Rockwell. It's a sales pitch about how much he wishes he could have seen Rockwell draw and how his audience is going to want to buy this drawing as a unique memento of their "connection" now that they've watched him sketch in front of them. Kinkade ends by noting that a

"portion" of the proceeds will "go to charity." Percentages and charities aren't mentioned specifically, and Kinkade soon leaves the stage. It's hard to see how he has connected to either the charity or the audience at all ("Part 3—Thomas Kinkade Prescott Event" 2009).

Status versus Experience

These issues of wealth and sharing are important to us because they shed "Light" on the true difference between Kinkade and Ross. It's the difference between their own self-images and why they thought they were culturally valuable as ambassadors of their work. Each had achieved a kind of cult status and a level of wealth in their lives that is undeniable. But Kinkade saw status as something that is gained from wealth, a richness that is hoarded or reinvested in capital. For Bob, status was an affirmation of his likeability, an admiration gained from others by passing on a wealth of experience.

This notion of status merits some serious reflection because it inflects much of the criticisms the Art World receives. As more contemporary artists begin to develop wealth that rivals their collectors, critics, like Robert Hughes (2008) in the documentary *The Mona Lisa Curse*, have explicitly expressed loathing for artists who do well in the market and collectors who don't value the content of work they purchase. Art has often been riddled by the relationships between its owners (who tend to make a lot of money) and its makers (who tend to range in economic success). In *Ways of Seeing*, John Berger (1972) created four TV episodes and a book that traced the relationship between art and status in the history of the Art World. He equates the development of oil painting with the depiction of property as status. He argues that as it became easier to paint convincing detail, a painting's main function became the exhibition of its owner's wealth. All those still lifes of cornucopias, goblets, and quail suddenly feel like ostentatious displays of "stuff."

The Art World is no different today. And artists have tackled their complicity with its economics in interesting ways. For provocateurs like Barbara Kruger, it can be lucrative to bite the hand that feeds you, to critique an institution from "within." To others like Tino Sehgal, it can be gratifying and complicated to sell a luxury commodity that doesn't physically exist. Others, like Jeff Koons, ratchet up the ostentation associated with fine art by fabricating large sculptures so sleek and cold

and colorful that people feel a combination of awe and envy in their presence.

Artists have to eat. But it has not stopped them from examining the politics of museums, galleries, auctions, and collectors. Rooted in institutional critique, Marxism, political change, nihilism, and identity politics, their artwork can bristle with a sense of radicalism. But as Luis Althusser (1971) notes, this work is always subsumed, stripped of its content, and re-inserted into museums and galleries as an object of commerce and status. It's a process he calls "interpallation." When something is critical of culture, when it threatens a capitalist impulse, it can be defanged, packaged, and returned to culture as a product. Think of how Punk became Hot Topic. Or how most people know Che Guevara as the political-looking guy on T-shirts. When criticism is sold, it sells out.

Artists who embrace this kind of "selling out" are almost always attacked as selfish and untalented. The higher their status, the more they are attacked. It is no wonder then, that Andy Warhol is one of the most polarizing artists of our time. He is quoted by many as saying, "Making money is the best art" (Warhol 1977, 92). What Koons and Kinkade have done is just an extension of what Andy Warhol did when he started to make Fine Art with factory means. But Andy was not selling images of beef flanks or orange rinds on elegant tables. Culture had moved past finely rendered still lifes in oil as the benchmarks of status. Warhol was selling jarringly colored pictures of rich people. And he was selling them right back to those same rich people.

In 1963, when Andy (by now famous) was asked by Ethel Scull, a socialite and collector, to make her portrait, he took her to a pinball arcade on 52nd and Broadway in New York City. He put her in a photo booth and reportedly told her, "Now start smiling and talking, this is costing me money" ("Ethel [Redner] Scull" 2013). The finished portrait, *Ethel Scull Thirty-six Times*, is an example of a new kind of status that collectors could purchase: unique art experiences.

By letting herself be subjected to a vulnerable situation and then surviving, Ethel was having an experience like we might have on a roller coaster or in a haunted house. In the final image, she is colorful, lively, and poised. She betrays nothing of the embarrassment or mistreatment that Warhol's belligerence might have inspired. Ethel triumphs at the hands of America's master of cool, and in so doing, she reasserts her ability to tame him, or to interpallate. It's as if by "slumming it" in a cheap, nasty photo booth and emerging unscathed, she's showing us just

how rich she is. She brings with her an aura, a protective bubble, and remains untouched by the reality in which Warhol forced her to engage. Moreover, the experience was unrepeatable and entirely her own. It was Scull who told the story of her voyage into denigration by Andy, and the painting is a memento of the trip.

Nowadays this is a Facebook phenomenon. We take pictures of our food, but we don't taste it. We have thousands of friends, but we don't know how we even know them. We update our "status" by posting pictures of who we want to be seen to be. And this interest in what others think of us, and how to manipulate their image of us, is at the heart of much of the imagery we create and consume. There is a reason that people secretly hate when someone posts about a fancy meal they just ate or shows us photos of their recent vacation. From molecular gastronomy to zip lining, we are a society that collects pictures of fancy experiences—often without even experiencing them—solely to say to others that we did them. Said another way, we create an image of ourselves and sell it as a sign of a unique and desirable experience. As a society, we often produce images to promote envy.

Collections imply display. Display implies envy. For Ethel Scull, a "status update" was the procurement of a Warhol portrait that would eventually be in a museum collection at the Metropolitan Museum of Art. For Kinkade, it would have been to actually have a show in a major museum collection (Alderson 2011). And for Kinkade fans, it was selecting and growing their art collection over the sofa or throughout their house.

The mad rush by the middle class to buy up Kinkade's works was just one more chance to participate in a status update. Everything about Kinkade's branding reinforced this. His marketing broadcasted the notion that his works belonged with only good Christian families, his imagery showcased aspirational real estate, and his prices linked his paintings to luxury. As Christians and as capitalists, buying a Kinkade could make people *seem* enviably "good" without actually requiring them to change at all. To help them along the way, Kinkade interpallated in advance by calling them heirlooms and investments. There were no real values in his work except as objects of status.

In his *60 Minutes* profile, Morley Safer (2001) interviewed Cindy and Ron Duboise, a white middle-class couple in California who had collected 138 Kinkade paintings in nine months. They're an extreme example, but they make the point all the more clear. While touring their home,

Mrs. Duboise showed off her "inspiration wall" and her "cottage wall" to Safer; these walls were literally full of Kinkades. Cindy admitted she felt addicted and loved his paintings and how they made her feel. The closest she comes to describing that feeling is when she adamantly agrees with Safer, who suggests they are "warm and fuzzy."

The rest of the interview proceeds like a tour of a museum. Cindy speaks with a "shame on me" smile about the $150,000 dollars she has already spent on Kinkade's work along with her husband. She then opens a closet to reveal nearly sixty more Kinkade paintings in bubble wrap that simply won't fit on the walls. For his part, Ron shows a "back wall" where he collects Kinkade's prints of San Francisco. "That's my wall," he tells Safer. In their bathroom, the Duboise family has hung a grouping of Kinkades over the toilet. Ron agrees with Cindy that they don't have room to show any more paintings and talks about his home as if it is a gallery when he notes, "We're on a rotation schedule right now" (Safer 2001).

Like other members of the Kinkade Collector's Society, the Duboise family is attracted to the way that Kinkade markets galleries, openings, and exhibitions as symbols of status that his followers can participate in. Acting rich isn't just for the upper class. Clearly, for the Duboises and many others, curating and exhibiting the works is part of the fun of owning them. And for Kinkade, who would encourage his sales teams to fill *all* the walls of his devotee's homes, convincing people to see their homes as galleries was very good for business (Safer 2001).

Kinkade outsold Warhol because he exploited the status anxieties of folks who couldn't afford them (Safer 2001). It may be fun to imagine Warhol laughing to the bank with Ethel Scull's dollars because we know she had so many. But Kinkade got people to fork over money they may not have had on the promise that it would make them *seem* like savvy, affluent, good Christian people. It isn't sustainable, and it isn't funny. The saddest part is that the Duboise couple would have been just as good, just as Christian, and probably more affluent had they never bought into the Kinkade brand to begin with.

Kinkade hated critics for judging his fans. But Kinkade treated them as a market niche, not like real people. Hating Kinkade does not mean hating middle-class people or Christians. In fact, it may mean quite the opposite. For his part, Bob Ross offers a world where academics and believers and art lovers and hipsters alike have come to feel comfortable and connected. It's a world where there is abundance without status. Where everyone belongs.

Certainly, Bob Ross can be used to *seem* wry, sophisticated, or ironic. To tell someone you love Bob is to claim to be someone: countercultural, Marxist, hipster, or sentimental. It's still a way to say something about who we want others to think we are. But it doesn't only mean that, and it doesn't end there. Rather, Bob's own marketing and art is unique and special because it conflates ownership with experience, consumption with production. You cannot (easily) own a Bob Ross painting; you can only make one. And in making it, you are changed. With Bob you have a real and human experience, contrary to a high-status image of a quirky or exotic experience. Frustration, doubt, and the joy of mastery await the viewers who undertake his invitation to paint. Whatever the outcome is, it's a true, lived experience that reveals something of who you are. Unlike status, it is an internal, imageless shift, more psychological and harder to articulate. Unlike a painting, an experience cannot be owned and cannot be taken away.

The only way into Kinkade's limited edition network is to buy in. Like his multileveled pricing structure, the price you pay, the picture you choose, and the way you share it with others reveals your worth. But anyone can enter a Bob Ross community, and at any level. Status in the Bob Ross network comes from your ability to give wealth away, not display it. And the wealth that is distributed is invisible, immaterial, and invaluable. It is transmitted through teaching and gifting. You teach your way of making art, or you share a tip. Perhaps you give a painting to a neighbor, or you suggest that a depressed or sick friend take up painting lessons. These actions accrue value but not worth. They pull you into the circle.

Like the ideas of gift economy laid out in our chapter on his network, connecting to Bob is as simple as watching his TV show because it feels like being given something you didn't ask for. It's a gift; it's spontaneous, shocking, and magical. Unlike Kinkade's show on QVC, *The Joy of Painting* is mediated to produce psychological and emotional transformation. That's the art. No one else can see it, judge it, or envy it because it happens inside you.

Bob and Andy and Thomas

Among the imagery of Warhol, Kinkade, and Ross, audiences may see some similarities. In contrast to the everyday world, all of their pictures

are a little too colorful, a little too saccharine, a little too simple. Where Warhol distances himself from the ironies of his work with a knowing wink, Kinkade distanced himself from the ironies of his work by denying them. In the end, Warhol feels like a prankster, but Kinkade feels like a fraud.

But Bob embraced the ironies of his art wholeheartedly. Bob's value is that he actually, genuinely believes in the possibility of creating the happy world he paints. We might think he's just as delusional as Kinkade, but we love him for staying true to his message beyond the studio walls—and for making it a world that anyone can belong to. As we consider their legacies, we see how their lives were shaped by the values of their art, and each achieved a measure of status in culture. But the difference is in how they measured their success. Warhol made history and Kinkade made millions. But Bob—good old Bob—made friends.

The next chapter broadens its focus as it explores Bob Ross's relationship to the Art World.

BOB ROSS LIVES

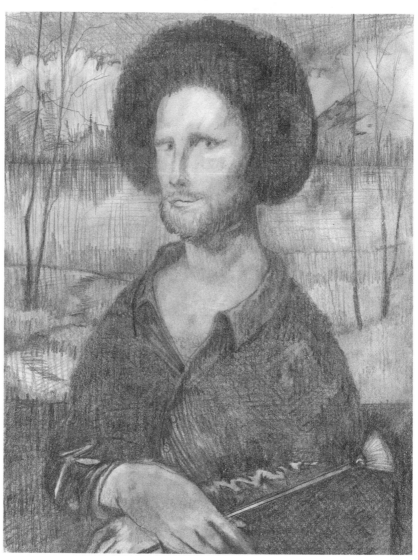

Bob like Da Vinci, by Danny Coeyman

⊸ 11 ⊶

THE ART WORLD IN THE MIDST OF BOB ROSS

Critics, curators, art historians, and collectors determine which artists make it into the Art Canon. Art Theory generally underlies and drives the determinations. All this, as previously noted, is in part, related to class systems. But some artists, such as street artists and graffitists, make it into the Art Canon. So if Bob Ross hasn't made it into the established contemporary Art World, it would be good to determine why that is. Comparing him to other artists who get recognition is one way of looking at his exclusion from the Art World. Doing so within the context of contemporary Art Theory is also useful.

Art Pranks

While we were writing this book, many of our friends and colleagues wondered if we really like Bob Ross's work; others wanted to know if we might be writing this book as an Art World prank. The answer to those questions is that we do like Bob's work (in similar ways that we like Andy Warhol's work) and that while this is not a prank, we do enjoy pranking and believe it has some use in the Art World. Additionally, we think it useful to look at pranks in relationship to Bob Ross.

The Art World is full of pranks. Ann Landi (2011) notes that pranks in the Art World are more extensive than jokes, which ask for an immediate response. On the contrary, pranks make people think. And according to Sarah Archino (see Landi 2011), who gave a presentation on a 2010 College Art Association panel on the topic, if pranks are to function successfully, they should have a lowbrow aspect to them. Landi

claims that some critics might think of works by Damian Hirst or Andy Warhol to be pranks, but she cautions, "Wasn't Damien Hirst deadly serious when he floated that shark in a tank of formaldehyde? And wasn't Warhol when he presented his Brillo boxes and soup cans in an art gallery?" (2011, 93). Art World pranks can call into question why we value one thing over another; they can also question the power structure of who does the valuing.

Just as the Guerilla Girls (an anonymous feminist performance group) questioned who is included in major art museums, galleries, and private collections, Bob Ross understood that his work and his teachings flew in the face of the art establishment. His blue jeans and Afro were used to identify with everyday people, and the words he spoke in his teachings were sometimes tongue-in-cheek about those who would reject him and "his people." He clearly spoke in juxtaposition to the Art World, but, like the Guerilla Girls, Andy Warhol, and Damien Hirst, he was dead serious.

While Bob Ross may not have thought of his work as pranking the Art World, he certainly recognized that the art establishment wasn't going to accept him. A prank involves a trickster, and Bob Ross wasn't tricking anyone. Bob was sincere in his desire to spread joy through painting. And with pranks there are those who are in on the joke and those who aren't (M. Smith 1996). From Bob's position, there was no hidden agenda, although making money was also clearly a goal, but no artist can be faulted for trying to make a living through his or her art.

As to our potential involvement as pranksters, we acknowledge the fact that pranks involve some discomfort for the subject of the pranking, perhaps even the desire to humiliate or terrorize a victim (Hansen 2012). In this case, those being pranked would have to be our readers, and as authors we have no intention of promoting hidden and uncomfortable kinds of experiences—they simply aren't in keeping with a Bob Ross approach to life. Nonetheless, while we don't consider this book to be an art prank, we do hope that the ideas expressed in these pages will linger, as we encourage readers to think about what it is we value and why, especially with regard to class systems. But if pranks unset the social status of a situation and make people think, then we're all for it. We encourage critical thinking about art, how it functions, and what it is we appreciate and why.

The Decentralization of Art

While Bob Ross, Inc., might think its organization is the pivotal point from which all Bob Ross activities flow, this is not the case. The television program diminishes any real control over who creates paintings in the Bob Ross style; and the Internet, whether the organization likes it or not, takes Bob's message away from the powerbase of Bob Ross, Inc. Likewise, many art movements and art groups emphasize the fluidity and flow of art processes, involving numerous people who might not have otherwise thought of themselves as artists. This fluidity is apparent in the Occupy Wall Street (and Occupy other cities) movement as everyday people make signs, dress in costumes, and perform actions that are being labeled as art (or Art?). Like the Bob Ross methodology that passes from one person to another, often without the intervention of the formal organization, these are largely leaderless social structures that function in a mostly horizontal manner. Earlier models of decentralized community activities that are now thought of as art involve political street parties, graffiti, and street art, and Paper Tiger TV, formed in 1981 to create and air collectively produced activist videos that critique the mainstream media (Scholz 2005).

Art museums not only engage with the community in new and democratic ways, they also bring in experts to help solve problems in the world at large. In the summer of 2011 in New York City, for example, the New Museum of Art partnered with the Museum of Modern Art and the Guggenheim to address issues such as housing, waste management, and the mortgage crisis, greatly expanding their more conservative missions of preserving, educating, and exhibiting art. Experts in areas such as urban planning, engineering, and landscape design played with ideas about how to creatively transform a city. The focus was on "transforming the audience experience—from the relatively passive act of looking to the more active ones of speaking up and pitching in" (Cembalest 2011, 44). The dialogue, then, becomes two-way. Proposals are subsequently drawn up that will look at the relationships that need to be addressed between multiple systems for new ideas to take place. Public space and public systems are at the crux of the discussions. The goal is problem solving, a process that was clearly one of Bob Ross's missions. When you make decisions about what goes on your canvas, you gain control of your life. You recognize that you are powerful. This newly gained power can

manifest itself in other parts of your life. Bob was living proof of that. Davy Turner, the "Painterman" from the United Kingdom, also confirms how Bob's message works. Part of taking control over your life involves allowing yourself to make critical judgments that can both engage art and expand beyond it.

Ideas about bad art are sometimes presented in museums and galleries. Some museums have taken on the very idea of celebrating "bad art" with great success. For example, the Museum of Bad Art in Boston showcases work that it calls "too bad to be ignored" (Stankowicz and Jackson 1996). Importantly, amateurs who have learned only a little painting technique, not unlike a beginning Bob Ross painter, make the art shown in this museum space. Curator Scott Wilson writes that "the most common error is made by those who equate bad art with bad taste" and that "talent and technical skill will not exclude work from our gallery" (1996, vii). In keeping with this approach, the catalogue for *Art Too Bad to Be Ignored* showcases works that employ both an element of sincerity and failure. Displaying this kind of work presents an earnest message coupled with technical mediocrity that Wilson calls "some evidence of artistic control, lack of perspective, garish color choices, unusual subject matter, and an inappropriate frame"; these combine to make compelling pictures (1996, vii). While Bob Ross's own work is quite skilled in its use of atmospheric perspective and employs monochromatic motifs to achieve legible landscapes, it shares a level of earnest failure with its "bad art" counterparts that often make it seem less sophisticated or redundant. Perhaps this is best illustrated by how Bob Ross painted over and over again without changing styles or becoming better at rendering the landscape itself. Said simply, as a painter he never "grew."

While it may not immediately be apparent that Bob Ross's goal was to problem solve or emote sincerity, his words and his actions certainly lead us to that conclusion. He embraced all living things. He deeply wanted us to be creative and take power over our lives. He taught us how to see, but not just in ways that focused on painting. His goal was more expansive. He wanted us to attend to the natural world, care for animals, and believe in our creative selves. Bob Ross may indeed be corny, and his works might be considered kitsch, but what great corn and kitsch he gave (and gives) us. He created it and passed the message on. And it has been heard by millions of people all over the world. Not only does he encourage people to paint, he asks them to positively interact with the world. Artists who now work in this manner are said to engage in "relational aesthetics."

Relational Art and Aesthetics

Many contemporary artists are making a name for themselves by promoting participatory activity with their art. In essence, their work only succeeds when audience members engage with the work and new models of sociability are formed (Bourriaud 2002). In doing so, they become part of the work. This approach to work is referred to as relational art, and it is more about formations than forms (Bourriaud 2002, 21). Coming from the French, this kind of art has been increasing in its popularity since the turn of the twenty-first century, when it got started (Kennedy 2010). Nicolas Bourriaud (2002), the French theorist who champions relational aesthetics, claims that Modernism, basing itself in conflict, disqualified the past as it focused on the future. In contrast, according to Bourriaud, today's work "is concerned with negotiations" (45). In so many of our global social spheres we recognize that solutions to problems (i.e., political, social, environmental) are found not through conflict or breaking away from a way of doing things, but by new kinds of assemblages and relationships among distinct but different groups of people (Bourriaud 2002, 45). Therefore, like Bob Ross, the artist grounded in relational aesthetics aims to create new social alliances. Bob Ross brings together all kinds of individuals, across class and educational backgrounds. He thrives in countries all over the world.

Since the early 1990s, Rirkrit Tiravanija, for example, has made work that focuses on the activity instead of the objects. In museum and gallery spaces all over the world, he has prepared meals for visitors, produced live radio shows, constructed apartment spaces for living, and set up educational spaces for instruction (Hirsch 2011). In one work, *Untitled (shall we dance)* (1993), Tiravanija sets up a turntable and record of "The King and I" and invites couples to waltz to the music. Five puppets depicting artists including Tiravanija and Philippe Parreno, who also creates works that are participatory, sit on a shelf as if watching the action. If Tiravanija makes objects, they are modest in nature (Hirsch 2011).

Carsten Höller, like Tiravanija, is another key artist whose work fits into this category. Höller, for instance, makes installations that engage participants physically with his works. His metal slides, exhibited at both the Tate Modern in London and the New Museum in New York City in 2011, are a key work that exemplifies relational art. The work becomes a community event as visitors use one of his slides. Some critics have suggested that Höller uses his participants as if they were lab rats, but

others disagree. Interestingly, those who have met him say he is a gentle man, like Bob Ross. Höller is also easily distracted. Rachel Spence (2011) reports that when having a discussion with him, she had to suggest they move away from the sounds of a barista so they could focus on the interview. Höller explains that his work draws on science, which allows us to get "our outer world's under control," while he acknowledges that some other world also exists (Spence 2011, 16). This approach is analogous to Bob Ross's ideas about using a canvas as a place where you have control, while recognizing that art can lead you to places, often fun places, where discovery can happen. Even Bob Ross's simple encouragement that viewers make noises as they paint reinforces this idea of magical transportation. For example, he would often tell viewers to make "swishing" noises when painting waterfalls. Bob Ross's closeness to animals can also be compared to the fascination Höller has learning about insect communications (Spence 2011, 16). Both artists respect nonhuman animals.

So important are people's relationships to each other in relational aesthetics that Tino Sehgal creates art that has no object. Or we should say that he uses humans as his art material. Sehgal insists on the immateriality of his work, which is grounded in live actions that are based in sculpture. His work is not photographed; there are no labels and no press releases announcing his exhibitions. There is no official opening or start and end date to his shows. The work is all based on the interactions of people, as he believes that the world already has too many material objects and he doesn't want to add to any more unnecessary consumption (Lubow 2010).

Sehgal's work, in spite of its immateriality, can be sold. But it is sold in an unconventional manner. Arthur Lubow explains:

> *Since there can be no written contract, the sale of a Sehgal piece must be conducted orally, with a lawyer or a notary public on hand to witness it. The work is described; the right to install it for an unspecified number of times under the supervision of Sehgal or one of his representatives is stipulated; and the price is stated. The buyer agrees to certain restrictions, perhaps the most important being the ban on future documentation, which extends to any subsequent transfers of ownership. (2010, 26)*

While Sehgal may be extreme in his disregard for the object, many other artists work in a similar, although perhaps not as a radical,

manner with regard to objects. For example, in 2010 Rivane Neuen-schwander encouraged museumgoers at the New Museum in New York City to write their wishes on brightly colored ribbons that were then placed on a large wall. When they posted their wish, they exchanged it for someone else's (Rosenberg 2010). Around the same time, the Whit-ney Museum exhibited a work by Christian Marclay that encouraged visitors to become more aware of the sounds in our environment by creating a space where participatory play was encouraged and no clear authoritarian voice was present; museum visitors were invited to draw on a chalkboard covered with musical staves while listening to under-ground music (Smith and Chinen 2010). In 2010, in Vancouver, British Columbia, on the third floor of the Playwrights Theatre Center, Theo Sims, an artist and self-taught carpenter, constructed a 12 by 20 foot plywood box as a mock-up of the Candahar, a Belfast pub. Made to look "authentic," it had beer taps, a bench that balanced on beer kegs, and buzzers that informed the barhop that a fresh pint was ready. The main difference between the original bar and the Vancouver artwork was that the one in Belfast served Guinness and the Vancouver bar served beer made by the city's Whistler Brewing Company. Because this was a the-ater and not an actual bar, beer was purchased using tickets instead of coins. Two real bartenders served the beer, dressed in fedoras and Irish sweaters. In essence, they were barmen playing themselves. The goal was to encourage social interaction as participants think about cross-cultural conversations (McGrath 2010). Correlations can easily be made between the theater/bar and Bob Ross's classes. His work opens up con-versation about art, artists, and art studios. Bob Ross, his paintings, and his teaching spaces may be real, but in many respects, they also pose as the "real" thing. Bob recognizes that he is not a professor or an elite art school artist/educator. While he poses as the artist, he becomes the artist. The same thing happens to his students.

Many artists specifically use teaching as their own artistic medium. They include Adrian Piper, Joseph Beuys, Martha Rosler, and Bruce High. In the late 1960s, Joseph Beuys waived admission requirements for his students at the Düsseldorf Academy of Art, where he taught. The idea that anyone and everyone should be able to attend his school even-tually lead to him being fired. In 1975, Martha Rosler released a video, *Semiotics of the Kitchen*, in which she named kitchen utensils from A to Z, demonstrating their use. Its deadpan camera smacked of the same instructional videos that Bob Ross was making, but her slightly violent

use of the utensils underscored Rosler's interest in the ways women had been repressed by them. Later, Adrian Piper made a video to instruct her viewers about her racial background. Made in 1988, *Cornered* situates her behind a desk, dressed conservatively with pearls around her neck. She speaks calmly and directly into the camera as she asks viewers to join her in solving the problem of racism. The Bruce High Quality Foundation University, founded in 2011, offers classes in art and other subjects for free, based entirely on a collaborative, collective model developed by the students and administrators together. No doubt, there is something of Bob in all of these artists' approaches to teaching, helping viewers and participants to see themselves differently while giving them real skills to make art and live better lives.

There are other ways that artists and museums are embracing participatory activities. This is a huge shift from a quiet approach to looking at art as a way of receiving a message or a sense of transcendence. For instance, in 2010 Dia Beacon featured the work of Franz Erhard Walther. His *Action Pieces* look like sleeping bags and tents. Remarkably, Dia allowed viewers to actually enter and "activate" the artworks by wearing, lying inside of, crawling through, and otherwise interacting with the works. Clearly, the prohibition of "look but do not touch" is being challenged by museums more regularly. The Indianapolis Museum of Art is also recreating itself as a place where interactive creativity takes place as they spent $25 million on redesigning the one-hundred-acre Virginia B. Fairbanks Art and Nature Park. In the summer of 2010, visitors were invited to travel in a rowboat on a lake to visit art students who were living on a floating sculpture. In another work, visitors could play basketball on a court that was also an abstract sculpture designed by Marco Castillo and Dagoberto Rodríquez (Litt 2010). At the Baltimore Museum of Art, meditation practices have taken place by Alexander Calder sculptures, and the Tampa Museum of Art has held meditation sessions lead by Buddhist monks (Earhart 2011). Numerous other examples could be noted, but what is important to be aware of here is that more active programming is clearly the direction that many artists and art institutions are currently taking. Bob Ross's encouragement to create and participate is not unlike all these examples. Participants might not be good at meditating (it's hard to do and it takes a lot of practice) or even playing basketball, but the involvement of the general public clearly becomes part of the creative work. In a like manner, Bob Ross students might not be good painters, but what is important is that they engage.

Some of the artworks just described might not sound like art to the reader. Tastes in art vary as we learn to see objects and art processes in different ways. Taste is most certainly influenced by cultural factors. In 1976 Anita Silvers wrote, "Whether or not we find ourselves aesthetically appreciating certain objects may depend upon our being concerned with the relevant conceptual issues, and, in turn, our conceptual concerns may be determined by our participation in institutions and by our cultural milieu" (453). Tastes in contemporary art seem to be swinging toward artists who function as facilitators of community, a trend that Suzi Gablik (1991) longed for in the early 1990s as we developed the ability to move beyond the Cartesian ideas of art as one thing and life as another. Gablik recognized that relatedness is the starting point for forming community, a necessary step that needs to be taken in that art world to rid us of the notion of the artist as individual genius, apart from the rest of the public (1991, 114).

And while many of us might cling to the idea of art's ability to move us away from our daily lives, relational aesthetics is perhaps drawing attention in our contemporary world because it is needed. We want to make our world better, and artists are using artist processes to do just that. Bourriaud (2002) claims that many contemporary artists are facilitating connections among people due to deep-seeded beliefs in the value of democratic participation. Bourriaud writes, "For art does not transcend everyday preoccupation, it confronts us with reality by way of the remarkable nature of any relationship to the world, through make-believe" (2002, 57).

Bob Ross always saw his paintings as a way of facilitating connection. It therefore comes as no surprise that his work is popular at this time when meaningful relationships and community are in short supply and people crave something that will help connect themselves both to undisturbed nature and others. His work is not only about the performative act of bringing people together. His paintings matter. In keeping with the tenants of relational art, immateriality is not the point. Relational art is not a return or rehashing of conceptual art. It's just that the object holds no supreme position (Bourriaud 2002, 47). Many people enjoy Bob Ross paintings because they feel connected to the artist, his message, and the way in which he delivers his message.

If Bob Ross's work can't be evaluated without the experience of his teachings and the connections he makes to others who participate, as is true with other contemporary artworks that are seen through the

lens of relational aesthetics, the painting (object) is not necessarily important as a discrete thing. What Bob Ross has primarily done, then, is to orchestrate social exchange. His paintings become "props whose formal qualities are almost beside the point" (R. Smith 2010, C19). Like so many other relational art artists, Bob Ross could be seen as someone who paints for the experience of bringing others together, and not for the act of making excellent paintings. One important question for art and art education today is to ask whether art today "is primarily a mirror of larger contexts, whether social, historical or architectural" (R. Smith 2010, C23). Fortunately, good art can raise more questions than it answers. Bob Ross's work, when viewed through contemporary issues and aesthetics, does just that. Additionally, its emphasis on participation mirrors other movements, both past and present.

Do It Yourself (DIY) and the Arts and Crafts Movement

The current DIY movement has affinities with the Arts and Crafts movement, which started in Britain with ideas rooted in the writings of John Ruskin and William Morris. It gained momentum in the late 1800s and spread around the world after World War II. David Gauntlett notes that it resonated in the United States because it meaningfully connected "with American notions of self-reliance, individualism, community, and romantic connections with nature" (2011, 17). The Arts and Crafts movement was democratic in that it was unpretentious, optimistic, and embraced everyone. It rejected the dehumanization of the industrial age, which mass produced items without individual expression. Helping the movement progress, from 1901 to 1916, Gustav Stickley published *The Craftsman*, which, over time, developed America's own way of approaching the Arts and Crafts movement. According to Gautlett, "Stickley invented, or rather revived, the concept of 'open source'—the system by which software developers today share unprotected code in the belief that others should be freely able to use it and improve it" (49). DIY, part of the Arts and Crafts movement, moved through the *Whole Earth Catalog* and continues through Web 2.0, zines, and all kinds of step-by-step books and television shows, such as those produced with Bob Ross as the star. Although the Bob Ross organization works to keep Bob Ross and his teachings controlled and carefully copyrighted and trademarked, his message has spread around the world like wildfire. Controlling his

philosophy and teachings is like trying to keep film or music from entering the hands of Chinese youth who want access but don't want to pay. Regardless of legal and organizational methods to keep Bob Ross contained and owned, like Elvis, he lives in the everyday fabric of creative people from all walks of life.

Numerous examples of DIY can be found today as individuals take pride in creating something handmade and unique. Clubs, organizations, and numerous kinds of activities are associated with DIY. Some of the DIY movement also involves how-to books and readymade kits. Gregory Sholette (2003) writes about what he calls garage kits that include comics, action figures, zines, mash-ups, and numerous websites. Sholette calls this category of creative work "dark matter" because it "functions in relation to the institutional art world [Art World] in a way similar to the mass of invisible substance that, according to cosmologists, makes up over ninety percent of the universe" (2003, 83). It is pervasive, but largely ignored; it is also important to the elite Art World. Still, garage kits, home crafts, and other hobby work, such as Bob Ross painting, exist rather autonomously from the high Art World. One engages in "dark" creativity out of desire and not economic necessity. Many categorize it as "low culture" dealing with "low subject matter," like Bob Ross paintings. However, no matter how you think about Bob Ross and his teachings, they have clearly filled a relevant space for millions of people and the momentum doesn't seem to be dying down. If the Art World continues to disassociate itself from the Bob Ross phenomenon, the current logic of this disregard can surely be questioned. As the United States and huge portions of the rest of the world become more economically unequal and politically estranged, questions about who we are and what we value are bubbling to the surface. These kinds of discussions should give us all hope.

Our last chapter addresses Bob's legacy. It is a summary of all the myriad ways in which Bob Ross can be positively viewed.

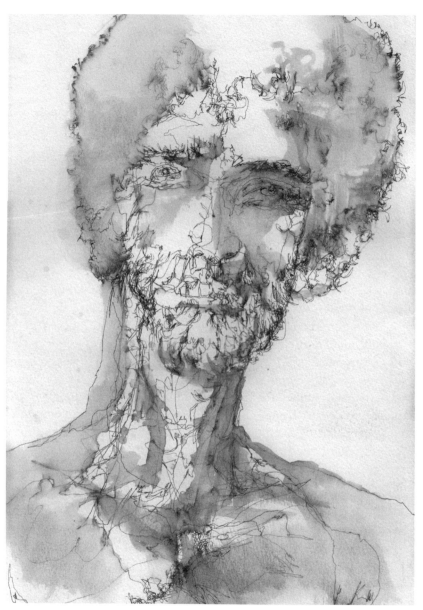

Bob like Danny, by Danny Coeyman

⊸ 12 ⊸

BOB ROSS'S LEGACY

Bob Ross seems to be as popular today as he ever was, maybe more so. While many people seem to like his paintings—marveling at how someone can render a colorful landscape in such as short time—there is more to the Bob Ross phenomenon than his paintings. The only way to understand his popularity is to look at his art, performance, and teaching approach from a variety of perspectives. It is also important to examine the many and varied permutations of Bob Ross by his fans. No one way of analyzing this soft-spoken, Afro-wearing white man will do him justice. He was born at the right time, after Grandma Moses had set the stage for the everyday painter and television had made it possible for us all to learn from a talking screen. From his early days to now, years after his death, his work and popularity seem somewhat, well, interesting.

Interest

The ongoing interest in Bob Ross is not entirely a focused interest in Bob Ross the artist and educator. It is also an interest in the response to Bob Ross as more and more people are drawn into the allure of the world that Bob Ross helped to create. As Sianne Ngai (2012) points out, interest in someone with talent can go beyond the specific. For instance, the interest the public had in Susan Boyle's singing debut on the April 2009 television show *Britain's Got Talent* was not just an interest in her. Once Boyle's debut was made into a YouTube video, it became an interest in what Ngai calls "Other People's Aesthetic Pleasures" (2012, 28). It is the audience reaction, coupled with the singer's performance, which have made the Susan Boyle phenomenon. What we like about her performance is not just her talent to sing a beautiful song. Rather, it is also

her singing a song as so many other people watch her in surprise and delight. The attraction, most YouTube watchers will remember, was that someone so seemingly unstarlike could be so talented. It was our recognition of her as a star in spite of her dowdy looks and unpolished presentation that helped make us love her. By way of the YouTube video, she made us aware of our own reactions and our myopic understanding of talent. We attend to her with interest for this reason and because we recognize that others did as well. We could say the same of Bob Ross. Those of us who love Bob, do so partly because we enjoy the phenomenon of Bob Ross; his participants become part of the aesthetic. It's interesting, but it's more than that.

Along with that which is cute and zany, Ngai refers to the interesting as a lesser aesthetic category, and she links these three categories to economic class. Ngai writes, "They are compelling reminders of the general fact of social difference and conflict underlying the entire system of aesthetic judgment or taste, making that underlying condition transparent in ways in which other aesthetic categories do not" (2012, 11). We like the Susan Boyle phenomenon, in part, because it involves us as audience members. Our reactions surprise us and cause us to question ourselves. While the original act took place on television, the YouTube video was carefully edited to fit the form of an online video, a media form Virginia Heffernan claims is used to quickly amaze audiences with "stunts, pranks, violence, gotchas, virtuosity, upsets and transformations" (2009, 16). We respond, therefore, with both shock and delight as Susan Boyle makes us question our values and tastes. The video of her singing "I Dreamed a Dream" gives us, at least those of us who are academically educated about Art, an opportunity to think about how our expectations have been framed by media and the Art World. Disruption causes interest. And interest, according to Ngai, is associated with that which is commonplace and everyday, much like the ubiquitous landscapes by Bob Ross and his followers. But when masses of people, first from the middle class but increasingly from all educational backgrounds and walks of life, respond as they have with both Susan Boyle and Bob Ross, something more than the merely interesting has taken place. Our involvement and response becomes part of the aesthetic, as it does with relational aesthetics. We are now participating in a way that makes the Bob Ross phenomenon about all of us rather than just Bob. In this way of thinking, Bob doesn't belong only to himself; instead, he is connected to the world and his legacy is now part of our greater creative activity.

Our response to Bob is a response to the Art World and our relationship to it. Our delight in loving him causes us to question our values, our art organizations, and ourselves.

Bob Ross, the man and the artist, his media and his message, all come together to engage, motivate, and activate a response in so many of us. From that response we create a new way of thinking, a new community, a new painting, and a new way of being in the world. We might also create new kinds of art organizations. We may speak more softly or parody Bob's soft approach to make a point. We may question class systems or the Art World's elitism. We may engage in critical dialogue about who is recognized as an artist and who is not. We might rethink ideas about the land and our interactions with it. And perhaps most importantly, we don't really need to admire or love his paintings to become enthralled with the ever-expanding Bob Ross phenomenon.

Bob Ross, Inc.

As stated in the introduction, we have tried not to do anything to infringe on Bob Ross, Inc., and what they legally own. We know that this book would have been different if access to people and archives associated with the company had been provided. We would have been able to include more details about Bob Ross's life and the people who were important to him. Details associated with the ways in which the company continues to cultivate interest in the man would have been available. Particularities associated with the certification program and the manufacture of Bob Ross art materials could have been better described. We believe that in many ways this book will support the goal of Bob Ross, Inc., of providing access to Bob Ross and what he has to offer. Overwhelmingly, our words are positive, and we imagine that the owners and administrators will largely be pleased. While we have attempted to explore Bob Ross's legacy, we have shied away from any extensive exploration and critique of Bob Ross, Inc. That job could be picked up by someone who knows more about corporations and the legalities of writing about a business that is so tightly controlled. In today's legal environment, corporations have the same status as people. If it is a person, we would personify BRI as tight-lipped.

Bob Ross, Inc., is dutiful in its oversight of Bob Ross's legacy. However, we have demonstrated that the phenomenon associated with the

man and his legacy has taken on a highly creative life of its own. We do hope that Bob Ross, Inc., will soon recognize that the power of Bob Ross is about cultivating his legacy in the company of others who also hold him in high regard. We urge the company to explore the possibility of being a commercial enterprise while simultaneously participating in the gift economy that has also become associated with Bob Ross. Economic reward can continue to come from promoting Bob Ross's teachings and his art materials while at the same time people can more openly live in the world Bob Ross attempted to create without fear of reprisal. It means that they can, in more diverse ways, voice their enjoyment—even love—for the man who taught them to create and believe in themselves. It would also mean that Bob's real power could be further unleashed.

The Art World

When we began this book project, we wondered why Bob had been ignored by the Art World. Our research lead us to look at his paintings and consider how that system's elitist attitudes about painting might sentence him forever to the realm of kitsch. But quickly it became clear that Bob the person and persona were also part of his practice. As a cultural phenomenon, as a teacher, and as an artist, Bob is clearly more than his paintings.

In our text, we took some close looks at Bob through the lenses of cultural studies, pedagogy, and Art History. In all of these contexts, Bob is a complicated and fascinating example of trends that shape these fields today. As these realms of knowledge begin to find new language for the groundbreaking work of artists, perhaps it is time for others to seriously reflect on his nuanced relationship to the Art World and the world at large.

Emerging terms like "relational aesthetics" are now legitimating such diverse practices as cooking, talking, and teaching in art (and Art) contexts. While Bob actively dis-identified with the Art World and instead focused on anti-elitist messages that would not alienate him from his market and viewership, his work is an example of a highly considered relationship between an artist and an audience. To that end, Bob Ross was ultimately a mediator, a lens that offered his viewers a unique vision of the world. He masterfully and consistently crafted contexts that would enhance his viewer's understanding of his work and strengthen their

connection with his persona. As a video artist, a performer, a celebrity, and a brand, Bob taught us how to look at his paintings meaningfully.

The Real World

While he painted landscapes with an effortless and formulaic flair, Bob's whisperings held prescient messages, foretelling movements that would soon sweep over our culture. What he said, when he said it, and how he said it is of great historic value. But perhaps more important, Bob's words back then still have something relevant to say to creatives today. He offers these teachings for those who dare to paint and for anyone who endeavors to creatively learn or to engage their cultural landscapes.

Think Green

Bob Ross saw nature as worthy of stewardship. Delighted by the ways in which trees and clouds could seem human, Bob was either so innocent or so profound that he viewed nature as inherently human. He gave trees feelings. He delighted that cypress trees had roots called cypress "knees." And in making trees equal to beings a bit higher up on the food chain, he anticipated everything from the ethos of the Green movement to the recent scientific discovery that humans share roughly 50 percent of their DNA with bananas.

Labor, Don't Work

Bob Ross turned work into labor. By claiming that work could be meaningful, Bob inflected the Protestant work ethic with a kind of hippie ease. Lewis Hyde argues, "Work is what we do by the hour. It begins and ends at a specific time and, if possible, we do it for money. . . . Labor on the other hand sets its own pace. We may get paid for it, but it's harder to quantify" (1979, 63–64). Bob similarly made it possible to see painting as labor, as something one could work at with estimable results and still enjoy as an effort.

For others Bob made painting an affordable means of recreation. And for some, he made painting a way of earning money as instructors in his school. Not surprisingly, because of his ubiquity on TV, he was also

a significant figure who nourished artists who work in the field of so-called Fine Arts today.

At the heart of his program, and by his own example of success, Bob encouraged people to pursue their passions, to turn avocations into vocations, and to answer callings that might never have been heard. He may not have made a killing, but Bob made a living. Bob made it possible for artists to see painting as an important job that they could do. Bob ushered in a new generation of painters and makers just as cultural thinkers began to notice the rise of the creative class. Today we trace his example to Etsy vendors, who sell their crafts online and boast about it under a blog called "Quit Your Day Job."

Use Technology to Connect

Bob Ross used technology as a democratic medium. He encouraged active participation from his viewership in the form of painting along at home, writing into the show, and even having their work displayed on the screen. At a time before the Internet, this level of interactivity made it possible for ordinary people to show their works to members of a community they had never met. Bob built a community of strangers, known and unknown to each other, but bound by a sense of his work as a "gift." The deliberate push toward interactivity with the audience and his customers was like proto-social media, like today's theme-based chat rooms and niche markets created and sustained by shared passions. Today bloggers and iPhoners "tweet" messages to each other. No doubt Bob would have loved the comparison between his viewership's dialogues and birdsong.

Humanize Your Persona

Bob Ross found a way to navigate the dehumanizing tensions of that same technology by creating an image of his personality that reflected his personal values. Instead of being ostentatious or flashy, Bob managed to become famous as a tranquil, quiet soul. Phil Donahue (*Bob Ross: The Happy Painter*, 2011) remarked that Bob was the kind of performer who, counter-intuitively, spoke so lightly and so gently that people *noticed* him. Bob was just being himself, but once it became a trope of how he was, Bob engaged in a kind of hyper-sincerity that others have similarly used to craft personalities as "Personalities." Specifically,

Bob actively parodied his sincerity and therefore made it a hallmark of his persona.

It's a tactic that others used as well. Authors like David Foster Wallace, who used labyrinthine footnotes in his writing to process his need to be genuine, made it a central aspect of his work. Singer Dolly Parton added lyrics about makeup and plastic surgery into her songs and spoke candidly about her artificial self as a way of branding herself as genuine. Each was aware of the ironies, but by making sincerity a central motif in their work, each asserted with a kind of hyper-awareness that who they seemed to be was who they were.

Knowing that he would show up on screen as a copy of a copy, Bob used self-stereotyping as a way to move authentically through a culture based on status and easily digestible images. Because he parodied himself on commercials for MTV, seeing Bob teased on cartoons like *Family Guy* only make him seem cooler.

Expect Imitation

Bob Ross saw imitation as an asset, not a threat. Like an artwork theorized by Walter Benjamin (1970), Bob's art could have lost its "aura." And just as his mentor Bill Alexander may have feared, Bob skillfully taught students to imitate techniques that he himself had borrowed. Bob retained an aura of sincerity and value, a sense of being a unique and gentle soul on the television set.

In fact, by embracing that broadcasting, he achieved a sense of being the original Bob Ross. Even after his death, and contrary to his company's fears that he would lose his value as intellectual property, Bob's "aura" remains securely intact precisely because so many have repeated his image as a meme, used it and repeated it and sought to make it their own. Today licenses like Creative Commons allow for that same fluidity, and artists are beginning to see how being used, spoofed, or kit-bashed is a powerful form of imitation as flattery.

Be Generous

Bob Ross left behind a model for generosity within a capitalist system. At a time when Ronald Reagan was president and Jeff Koons was becoming popular, Bob contrarily built up a community based in a gift economy while simultaneously sustaining himself in a traditional economy of

buying and selling. In fact, Bob may have recognized the necessity of a market economy as a "node" in the network of people who enhance a sense of community by contrasting them with the more industrial nodes of his factory network.

As artists form collectives and seek to push against capitalist power structures, festivals like Burning Man, and movements like Freeganism seek fringes where a simpler life might be possible. Bob managed to promote a truly generous message in the midst of public popularity and economic gain. It was his use of a gift economy that made him a millionaire. Consider the fact that only 4 percent of his viewership ever painted (*Bob Ross: The Happy Painter*, 2011). For the other 96 percent, just watching him was a satisfying enough experience. Bob's work had two audiences that only slightly overlapped. There were those who watched because of his personality and their love of the show. They got the good stuff, and they got it for free. But Bob's second audience—his market share—sustained the whole company. As artists begin to sell "relics" and "documentation" of their more ephemeral, radical art practices, perhaps Bob's example of generosity allows artists to eat, audiences to feel nourished, and others to bankroll the entire system without feeling like sell-outs.

Envision Something Better

Bob Ross opened up the access of information, knowledge, and education to a hugely diverse audience. He made learning itself into a process that could be healing, cathartic, and empowering. He asserted that the worlds he painted were his and that you should paint yours. In asking others to envision what they wanted and giving them the beginning tools to make that vision shareable, he asserted that what you envision is what you can become. Today books like *The Secret* make the idea of manifesting your inner reality even more popular to people today.

Bring Your Everyday into Your Art

Bob Ross built a multidisciplinary practice that included educating, painting, and creating moving images. As an artist, his message definitively affected his aesthetics. His paintings were simple because his pedagogy required simplified painting techniques that were easy to replicate. His television show was orchestrated as a timeless, darkened, void-like studio, which reinforced intimacy with his body and even

suggested spiritual and sexual possibilities. His logo literally conflated Bob as image and man—every inanimate object in his packaging, from brushes to kits to the tombstone on his grave, is marked with a simplified but naturalistic icon of his perpetually smiling face. Across the board, Bob's aesthetic choices are sophisticated and effective and rely on how they look to help communicate his vision, his goals, and his mission. Bob offers working artists who teach or have day jobs the idea that every aspect of their lives can be integrated into their artwork. Within the scope of artistic practice, this is even more clear. Today, almost every contemporary artist blogs, writes, performs, teaches, or studies a discipline that informs his or her creative labor or helps pay the rent. Bob makes it possible to see that as a good thing.

Discover Something Wherever You Are

Bob Ross made the "outside" a hip place to be. We might be upset that Bob isn't honored by the Art World, but Bob never was. He relied on emotional and economic support from his viewership to find and connect with his most invested supporters in the same ways that companies are now beginning to niche-market their products. As the Internet makes advertising more customized and products for smaller demographics spring up, more people are beginning to create for an audience of a few. Self-publishing, selling to friends, and crowd-sourcing financial support are all finally possible because communities have arisen out of other's unsanctioned, surprise creativity. The Art World, in a sense, is just one more niche in the market of art.

Figures like Lady Gaga inspire people to perform their weirdness, and products like the Snuggy seem to satisfy needs we never knew we had. As these fads come and go, society seems to be shocked by the breakthrough success of the quirky, weird, and queer. The Art World is catching up in its own way, as museums begin to sell works by the untrained or people with mental illness, often called "Outsiders." Work by Henry Darger, whose drawings were discovered after his death, can reside in the permanent collection at the Museum of Modern Art and sell for $80,000 at the Outsider Art Fair. Bob was too popular to be "discovered" and put into those markets as an Outsider, but he was content to remain far away from the Art World and seemed to find his own inner validation in making his work. For many, that is the compelling allure of these increasingly popular Outsiders.

Be Joyful

To echo Bob's famous assertion that this is your world, this is also *your Bob*. Whether you see him as a hack or a hero, you gain from him whatever you put in. It's a paradox, a generous demand. It requires an act of projection. But for those who don't dismiss Bob for his formulaic paintings, a second glance at Bob's full art practice will always spur another connection, another question, another delight. It is a hallmark of a generous and complex work of art.

Perhaps Bob is too contemporary to be considered critically by the fields of Art History, pedagogy, and cultural anthropology right now. Since he didn't engage these fields in his life, his death two decades ago might seem to require some marinating before anyone can definitively say how he trickled through high and low cultures. More honestly, it is probably an issue of class and elitism that keeps him from gaining the attention of these disciplines. But we insist that he not be forgotten in the meantime, for he has much to contribute to all three.

In her essay "Art Ethics," which reflects on the exclusion of Thomas Kinkade from the Art World, Anna Brzyski notes that Kinkade could have been one of the greatest artists of the Art World: "If Kinkade winked, if he gave us an indication of ironic detachment, criticality (on however minimal a level), or even campy complicity . . . and that he was, in fact, one of *us*, instead of one of *them*, he could be celebrated as one of the most significant artists working today" (2011, 255).

Like Kinkade, even more sincerely than Kinkade, Bob firmly inhabits the world that he created without any winks. His consistency inside the studio and out, his sincerity as the same guy you see on TV, makes him easy to love *as a person* for fine artists and untrained enthusiasts alike. But this same lack of irony, Brzyski would argue, is exactly what has made him seem insignificant *as an artist* to the people who write and police Art History.

Hipsters now supply that irony in full force, simultaneously using Bob as an admission of their nostalgia and of their awareness that nostalgia is a vulnerable thing to feel. From William Shakespeare to Judith Butler to Facebook, human beings have always marveled at how their self-awareness turns all the world into a stage. Many have a nagging feeling that we are all, always, helplessly performing.

Brzyski (2011) notes that irony and criticism are hallmarks of Art in the Art World because of a belief that art should make us reflect more

knowingly about this complicated stage we call the world. She traces the idea back to Georg Wilhelm Friedrich Hegel. Said simply, he argued that Art, because it is a representation of reality, gives us just enough distance from real reality to critique it. Art is a way of taking a step back, getting a bit of critical distance from the lives we are immersed in, and letting us judge. Hegel's idea makes Art into a way of knowing. We use it to create knowledge, and knowledge, so it goes, is the stuff of true history.

But Brzyski (2011) says it's not that simple. She believes that the Art World uses Hegel and other well-meaning thinkers, like Theodore Adorno and the snobbier Clement Greenberg after him, to reinforce distinctions between kitsch and fine art. These ideas might seem old, but they're at the heart of how the art system currently distinguishes between Fine Art and stuff. Collectors purchase objects at high prices that signify the cultural value of those objects, and writers explain how some tendency for insight, knowledge, or downright navel-gazing has been detected within these special objects. Whether it's in the artist, in the work, in the way the audience receives it, or even in the structure of how the art is made and sold, critics will scour an artwork until they locate an irony, a critique, a crack in the surface. And that is where they plant their stamp of approval that what they are seeing is indeed Fine Art.

Bob is complicated, but not ironic. He isn't critical. There are no cracks. Instead, Bob articulates art as an immersive part of experience and imagination. There's no room for critical distance in a Bob Ross painting. And that is, indeed, scary. Just in terms of status, it subverts people's self-images of sophistication. But more importantly, it can mean believing wholeheartedly in being duped into sentimental places, apolitical places, self-less places.

Instead of self-reflexive "knowledge," Bob offers us joy—in painting, in rescuing animals, in making the most of your day, in surviving cancer, in clouds, in trees, in *everything*. It's a somatic feeling. It's sensual. It's an experience, not a representation of an experience. It's completely immersive. To trust Bob is a spectacularly vulnerable thing to do. To paint with him, in the fullness of that spirit, is to lose one's self to happiness, to drop one's self-awareness, irony, and ego and participate and believe fully in joy.

They may be excused as kitsch, but Bob's paintings aren't paintings. Bob's paintings are excuses to practice Joy. And that is where future generations will detect the art in Bob's life. He created a meaningful, complicated art practice that supported a simple, accessible vision of happiness. It's an Emersonian, back-to-nature, rigorous notion of simplicity as

goodness. Bob could have been a despot, exploiting those who bought into his comforting vision, but from all we have learned, he used that power to heal and inspire rather than repress and deny. He could have holed himself up in a happy place of self-delusion, but we believe he felt compelled to engage the "real world" complexities of life with incredible intelligence. It was all done to share one possible way of being joyful, of connecting with others and caring for them.

Bob leaves behind hundreds of artists who will now navigate other worlds, crafted by their own sensibilities and desires. And whether they treat self-expression as ironic or incomplete or invaluable, Bob taught them that painting is an occasion for Joy.

That's Bob's legacy: Joy. It's sublime, seductive, and inspiring. It cannot be owned; it cannot be ironic. It's healing, it's connecting, and it's beautiful. And most of all, when it is sincere, Joy is always radical.

REFERENCES

CHAPTER 1

Bourriaud, Nicolas. 2002. *Relational Aesthetics*. Dijon, France: Les presses du reel. Originally published in French in 1998.

Florida, Richard. 2002. *The Rise of the Creative Class & How It's Transforming Work, Leisure, Community, and Everyday Life*. New York: Basic Books.

Kimmelman, Michael. 2005. *The Accidental Masterpiece: On the Art of Life and Vice Versa*. New York: Penguin Press.

Kowalski, Annette. 1989. *The Best of the Joy of Painting with Bob Ross, America's Favorite Art Instructor*. New York: Quill, William Morris.

Kowalski, Joan. 2012. Email correspondence with Kristin G. Congdon, March 30.

Packer, ZZ. 2012. "Keeping It Weird." *Smithsonian* 42, no. 9 (January): 17–19.

Wozniak, June. 2012. Phone conversation with Kristin G. Congdon, November 13.

CHAPTER 2

Alexander, William. 1981. *A Personal Guide to W. Bill Alexander's the Magic of Oil Painting II*. Huntington Beach, CA: KOCE-TV Foundation.

Bob Ross. 2013. *Wikepedia*. Accessed January 19, http://en.wikipedia.org/wiki/Bob_Ross.

Bob Ross: The Happy Painter. 2011. DVD. Directed by Sherry Spradlin. Roanoke, VA: Blue Ridge PBS.

"Bob Ross PBS Instructor." 1995. *Washington Post*, July 8, C8.

Bob Ross, Incorporated. 2013. "Bob Ross, Television's Favorite Artist." Accessed February 11, http://www.bobross.com/about.cfm.

"Here's What You Have Been Waiting For!" 1988. *Brush Strokes*, November/December, 1.

IMDb. 2013. *Biography of Bob Ross*. Accessed January 18, http://www.imdb.com/name/nm1470679/bio.

Kowalski, Annette. 1993. *Bob Ross' New Joy of Painting: A Collection of His Favorites*. New York: William Morrow.

———. 1997. "How the Joy Began, Part II." *Brush Strokes*, March/April, 1, 3.

———. 1998. "Part 11: How the Joy Began: Uplinking the Joy of Painting." *Brush Strokes*, November/December, 3, 11.

———. 1999a. "How the Joy Began: Part 14: 'Florida, We Will Return.'" *Brush Strokes*, May/June, 1, 3.

———. 1999b. "How the Joy Began: Part 16: Bob Ross . . . East Coast Distributor." *Brush Strokes*, September/October, 1, 3–4.

———. 2003. "'A Decision to Be Made' Part 34: How the Joy Began." *Brush Strokes*, January/February, 1, 3.

———. 2005. "Bob Ross and How the Joy Began: Part 39: 'Aquatic Diners.'" *Brush Strokes*, May/June, 3, 5, 10.

Nitrozac & Snaggy. 2010. "The Joy of Tech." Accessed July 16, 2012. http://allthingsd .com/20100621/alternate-universe-bob-ross/.

Ross, Robert. H. 1991. *More Joy of Painting with Bob Ross*. New York: HarperCollins.

"Saying Goodbye to an Old Friend, Our World Will Never Be the Same." 1995. *Brushstrokes*, July/August, 1.

Shrieves, Linda. 1990. "Bob Ross Uses His Brush to Spread Paint and Joy." *Orlando Sentinel*, July 7, http://articles.orlandosentinel.com/1990-07-07/lifestyle/90070601 22_1_bob-ross-joy-of-painting-pbs.

———. 1995. "Painter Bob Ross Dies at 52." *Orlando Sentinel*, July 8, http://articles .orlandosentinel.com/1995-07-08/news/9507080443_1_bob-ross-joy-of-painting-happy-little-trees.

"Spontaneous, Limitless, Free: Graffiti: Expression of Human Emotion." 1993. *Brush Strokes*, March/April, 7.

Stanley, Alessandra. 1991. "TELEVISION; Bob Ross, the Frugal Gourmet of Painting." *New York Times*, June 23, section 2, 35.

Wozniak, June. 2012. Personal communication with Kristin Congdon by phone, November 13.

CHAPTER 3

Alexander, William, and V. L. Lee. 1981. *A Personal Guide to W. Bill Alexander's the Magic of Oil Painting II*. Huntington Beach, CA: KOCE-TV Foundation.

Bob Ross, Inc. 2013. Bob Ross Teacher Training Program. Accessed January 25, http:// www.bobross.com/BobRossTeacherTrainingUS2013.pdf.

Chodorkoff, Daniel. 1983. "The Utopian Impulse: Reflections on a Tradition." *Journal of Social Ecology* 1, no. 1. http://www.mindfully.org/Sustainability/Utopian-Impulse .htm.

Gelber, Steven M. 1999. *Hobbies: Leisure and the Culture of Work in America*. New York: Columbia University.

Kowalski, Annette. 1993. *Bob Ross' New Joy of Painting: A Collection of His Favorites*. New York: William Morrow.

Mayer, Ralph. 1991. *The Artist's Handbook of Materials and Techniques*. 5th ed. New York: Viking.

Novak, Barbara. 1974. *American Painting of the Nineteenth Century*. New York: Praeger.

Peabody, Elizabeth. 1835. *Record of a School*. Boston: Samuel N. Dickenson.

Peters, Michael A., and John Freeman-Moir. 2006. "Introducing Utopias: Concept, Genealogy, Futures." In *Edutopias: New Utopian Thinking in Education*, edited by Michael A. Peters and John Freeman-Moir, 1–21. Rotterdam: Sense.

Ross, Robert H. 1991. *More Joy of Painting with Bob Ross*. New York: HarperCollins.

Stanley, Alessandra. 1995. "TELEVISION; Bob Ross, the Frugal Gourmet of Painting." *New York Times*, June 23, section 2, 35.

Wenzel, David. 2004. Personal communication with Kristin G. Congdon and Doug Blandy, July 1.

CHAPTER 4

Bavender, Christine. 1991. "TV's Painting Guru Charms Audiences." *Muncie Star*, May 19, A9.

Campbell, Joseph. 1989. *An Open Life*. New York: Harper and Row.

Congdon, Kristin G., and Kara Kelley Hallmark. 2012. *American Folk Art: A Regional Reference*. Santa Barbara, CA: ABC-Clio.

Dolby, Sandra K. 2011. *Self-Help Books: Why Americans Keep Reading Them*. Champaign: University Press of Illinois.

Doss, Erika. 1999. *Elvis Culture: Fans, Faith, and Image*. Lawrence: University of Kansas Press.

Florida, Richard. 2002. *The Rise of the Creative Class & How It's Transforming Work, Leisure, Community and Everyday Life*. New York: Basic Books.

Ivey, Bill. 2008. *Arts, Inc.: How Greed and Neglect Have Destroyed Our Cultural Rights*. Berkeley: University of California Press.

Kimmelman, Michael. 2005. *The Accidental Masterpiece: On the Art of Life and Vice Versa*. New York: Penguin Press.

Lao Tzu. 1992. *Tao Te Ching*. Translated by Stephen Mitchell. New York: Harper Collins.

McGrath, Charles. 2011. "Can a Picasso Cure You?" *New York Times*, May 25, C1, C7.

The New Hendrickson Parallel Bible, KJV, NKJV, NIV, NLT. 2008. Peabody, MA: Hendrickson Publishers, Incorporated.

Newman, J. 2011. *Bob Ross: The Happy Painter*. DVD. Directed by Sherry Spradlin. Roanoke, VA: Blue Ridge PBS.

Rogers, Carl. 1961. *The Characteristics of a Helping Relationship*. New York: Houghton Mifflin.

Schor, Mira. 1997. *Wet: On Painting, Feminism, and Art Culture*. Durham, NC: Duke University Press.

Stachelhaus, Heiner. 1991. *Joseph Beuys*. New York: Abbeville Press.

Wenzel, David. 2004. Personal communication with Kristin G. Congdon and Doug Blandy, July 1.

CHAPTER 5

Bob Ross: The Happy Painter. 2011. DVD. Directed by Sherry Spradlin. Roanoke, VA: Blue Ridge PBS.

Find a Grave. 2013. *Find a Grave.* Accessed January 4, http://www.findagrave.com/.

GAMESPOT. 2013. *MTV's Celebrity Deathmatch Gameplay Movie 1: Jerry Springer vs. Bob Ross.* Accessed January 4, http://www.gamespot.com/mtvs-celebrity-deathmatch/videos/mtvs-celebrity-deathmatch-gameplay-movie-1-6077414/.

Jasinski, Aaron. 2012. Personal communication by phone with Doug Blandy, November 23.

Kaplan, Scott. 2006. Personal communication with Doug Blandy in Columbus, Ohio, October 26.

Kimmelman, Michael. 1995. "Art View: The Master of Creation in 26 Minutes." *New York Times,* July 23, http://www.nytimes.com/1995/07/23/arts/art-view-the-master-of-creation-in-26-minutes.html.

Know Your Meme. 2013. *Home.* Accessed January 4, http://knowyourmeme.com/.

Lee, Kalvin, director. 2006. *The Boondocks: Riley Wuz Here.* United States: Sony Pictures Home Entertainment.

PBS Digital Studios. 2013. *Happy Little Clouds: Bob Ross Remixed.* Accessed January 4, http://video.pbs.org/video/2260534667.

Wood, Scott, director. 2000. *Family Guy: Fifteen Minutes of Shame.* United States: Fox.

CHAPTER 6

Blow, Charles M. 2012. "Don't Mess with Big Bird." *New York Times,* October 6, A17.

Bob Ross: The Happy Painter. 2011. DVD. Directed by Sherry Spradlin. Roanoke, VA: Blue Ridge PBS.

Boddy-Evans, Marion. 2013. *The Bob Ross Method of Painting: Love or Hate It?* Accessed January 27, http://painting.about.com/b/2007/01/30/the-bob-ross-method-of-painting-love-or-hate-it.htm.

Bruder, Jessica. 2012. "Burning Man's Cry for Help." *New York Times,* March 30, A25.

Dan. 2007. "Is Bob Ross Helpful or Harmful to Artists? Look at the Bob Ross Method of Painting." *Empty Easel* blog. January 29, http://emptyeasel.com/2007/01/29/helpful-or-harmful-the-bob-ross-method-of-painting/.

Dorje, Rig'dzin. 2001. *Dangerous Friend: The Teacher-Student Relationship in Vagrayana Buddhism.* Boston: Shambhala.

Gauntlett, David. 2011. *Making Is Connecting: The Social Meaning of Creativity from DIY and Knitting to YouTube and Web 2.0.* Cambridge, MA: Polity.

Gruwell, Erin. 1999. *The Freedom Writer's Diary: How a Teacher and 150 Teens Used Writing to Change Themselves and the World around Them.* New York: Random House.

Illich, Ivan. 2002. *Deschooling Society.* London: Marion Boyars.

Ivey, Bill. 2008. *Arts, Inc.: How Greed and Neglect Have Destroyed Our Cultural Rights.* Berkeley: University of California Press.

Kowalski, Annette. 1993. *Bob Ross' New Joy of Painting: A Collection of His Favorites.* New York: William Morrow.

Kozal, Jonathan. 2008. *Letters to a Young Teacher.* New York: Three Rivers Press.

Neill, A. S. Summerhill. 1960. *A Radical Approach to Child Rearing.* New York: Hart Publishing Co.

The Ninety-Second American Assembly. 1997. *The Arts and the Public Purpose.* Harriman, NY: Arden House.

Skidelsky, Robert, and Edward Skidelsky. 2012. "In Praise of Leisure." *Chronicle Review,* June 22, B12–B15.

Warner, Slyvia Ashton. 1986. *Teacher.* New York: Touchstone.

CHAPTER 7

Abramovic, Marina. 2012. *Marina Abramovic: The Artist Is Present.* DVD. Directed by Matthew Akers. Music Box Films.

"Are Crayola and Silly Putty Products Nontoxic Even If Ingested?" 2013. Crayola We Can Help (blog). Accessed January 25, http://www2.crayola.com/canwehelp/contact/faq_view.cfm?id=86.

Baudrillard, Jean. 1994. *Simulacra and Simulation.* Translated by Sheila Faria Glaser. Ann Arbor: University of Michigan Press.

Bellos, David. 2012. "My Daily Read: Contemporary Habits on Page and Screen." *Chronicle of Higher Education,* March 23, B2.

Benjamin, Walter. 2001. "The Work of Art in the Age of Mechanical Reproduction." In *Continental Aesthetics; Romanticism to Postmodernism: An Anthology,* edited by Richard Kearney and David Rasmussen, 166–81. Oxford: Blackwell Publishing. Originally published in 1936.

Black, Al. 2012. Personal communication with Kristin G. Congdon in Fort Pierce, Florida, September 19.

Cash, Stephanie. 2011. "Everyone's a Critic (or Curator)." *Art in America,* no. 5, 40.

Congdon, Kristin G. 2004. "Stories about the Highwaymen: Insights about All of Us." *Visual Arts Research* 29 (1): 13–21.

Congdon, Kristin G., and Kara K. Hallmark. 2012. *American Folk Art: A Regional Reference.* Westport, CT: ABC-Clio and the Greenwood Group.

Cooke, Ariel Zeitlin. 1999. "Andy and Autism." *Artnews* 98 (5): 32.

Cotter, Holland. 2010. "700-Hour Silent Opera Reaches Finale at MoMA." *New York Times,* May 31, C1, C7.

Dargis, Manohla. 2011. "In Defense of the Slow and the Boring." *New York Times,* June 5, AR10.

———. 2011. "A Youngster with a Key, a Word, and a Quest." *New York Times,* December 23, C1, C10.

Dissanayake, Ellen. 1992. *Homo Aesthetics: Where Art Comes from and Why.* New York: Free Press.

Florida, Richard. 2002. *The Rise of the Creative Class and How It's Transforming Work, Leisure, Community, and Everyday Life.* New York: Basic Books.

Halle, David. 1993. *Inside Culture: Art and Class in the American Home.* Chicago: University of Chicago Press.

Handy, Bruce. 2012. "My Fabulous Boring Book Collection." *New York Times Book Review,* July 8, 27.

Harris, Neil. 1994. "The Passing of the Great Space." In *Vision of America: Landscapes as Metaphors in the Late Twentieth Century,* edited by Martin L. Friedman, 86–99. Denver: Denver Art Museum and the Columbus Museum of Art. Distributed by Harry N. Abrams.

Itzkoff, Dave. 2011. "Dylan Paintings Draw Scrutiny." *New York Times,* September 28, C1, C8.

Ivey, Bill. 2008. *Arts, Inc.: How Greed and Neglect Have Destroyed Our Cultural Rights.* Berkeley: University of California Press.

Kimmelman, Michael. 2005. *The Accidental Masterpiece: On the Art of Life and Vice Versa.* New York: Penguin Press.

Komar, Vitaly, and Alexander Melamid. 1998. *Painting by Numbers: Komar and Melamid's Scientific Guide to Art.* 2nd ed. Los Angeles: University of California Press.

Madoff, Steven Henry. 2002. "A Viewable Fast, Enforced by Knives." *New York Times,* November 10, AR1, AR37.

Maitland, Sara. 2008. *A Book of Silence.* Berkeley: Counterpoint.

Martin, Steve. 2010. *An Object of Beauty.* New York: Grand Central Publishing.

Newman, Ira. 2008. "The Alleged Unwholesomeness of Sentimentality." In *Arguing about Art: Contemporary Philosophical Debates,* 3rd ed., edited by Alex Neill and Aaron Ridley, 342–53. New York: Routledge.

Painters Painting. 1973. DVD. Directed by Emile de Antonio. New Video.

Peters, Gary. 2009. *The Philosophy of Improvisation.* Chicago: University of Chicago Press.

Plagens, Peter. 2011. "Condo Elevates New Museum." *Art in America,* no. 4, 35–36.

Pollock, Barbara. 2012. "Copy Rights." *Artnews* (March): 76–83.

Pollock, Jackson. 1951. *Jackson Pollock Painting.* Directed by Hans Namuth and Paul Falkenberg.

Richter, Gerhard. 2012. *Gerhard Richter Painting.* DVD. Directed by Corinna Belz. Kino Lorber Films.

Schor, Mira. 1997. *Wet: On Painting, Feminism, and Art Culture.* Durham: Duke University Press.

Sennett, Richard. 2008. *The Craftsman.* New Haven: Yale University Press.

Smith, Carnell. 2012. Personal communication with Kristin G. Congdon in Winter Park, Florida, July 20.

Stovall, Jimmy. 2012. Personal communication with Kristin G. Congdon in Ft. Pierce, Florida, July 25.

Tallman, Susan. 2009. "The New Real: The da Vinci Clone." *Art in America*, no. 2, 75–77.

Tremlett, Giles. (2009). "Goya's *Colossus* Actually Painted by His Assistant, Says Expert." *The Guardian*, January 27, http://www.guardian.co.uk/world/2009/jan/27/goya-colossus-spain-prado.

Tucker, Marcia. 2008. *A Short Life of Trouble: Forty Years in the New York Art World.* Edited and with an afterword by Liza Lou. Berkeley: University of California Press.

CHAPTER 8

Hyde, Lewis. 1979. *The Gift: Creativity and the Artist in the Modern World.* New York: Vintage.

Turner, Davy. 2005–2013. Personal communication by email with Kristin G. Congdon.

CHAPTER 9

"Bob Ross MTV Promo." 2011. YouTube video. Posted by OldSchoolVHS on January 25. http://www.youtube.com/watch?v=Q7G3m4OpnV4.

"Bob Ross PBS Instructor." 1995. *Washington Post*, July 8, C8.

Bob Ross: The Happy Painter. 2011. DVD. Directed by Sherry Spradlin. Roanoke, VA: Blue Ridge PBS.

Bourdieu, Pierre. 1984. *Distinction: A Social Critique of the Judgement of Taste.* Cambridge, MA: Harvard University Press. Originally published in French in 1979.

"Foot of the Mountain." 1985. *The Joy of Painting, Season 8, Episode 8.* WIPB, Muncie, IN.

Harris, Scott. 2009. "Happy Accidents and the Legacy of Bob Ross." *Washington Business Journal*, February 9, http://www.bizjournals.com/washington/stories/2009/02/09/smallb1.html?page=all.

Rose, Sara. 2008. "MoMA Puts Iconic Esquire Magazine Covers on Exhibit." *USA Today*, April 23, http://www.usatoday.com/travel/destinations/2008-04-23-esquire-covers-moma_N.htm.

Saltz, Jerry. 2012. "The Met's 'Regarding Warhol' Has Nothing to Say." *Vulture Magazine*, September 16, http://www.vulture.com/2012/09/saltz-on-the-mets-regarding-warhol.html.

Smith, Roberta. 2011. "Andy Warhol Commemorated in Chrome on Union Square." March 31. http://artsbeat.blogs.nytimes.com/2011/03/31/andy-warhol-commemorated-in-chrome-on-union-square/.

———. 2012. "The In-Crowd Is All Here." *New York Times*, September 13, http://www.nytimes.com/2012/09/14/arts/design/regarding-warhol-at-the-metropolitan-museum.html.

Stanley, A. 1995. "The Master of Creation in 26 Minutes." *New York Times*, June 23, section 2, 35.

Stevens, Mark. 2007. "The Endless Fifteen Minutes." *New York Magazine*, February 1, http://nymag.com/arts/art/features/27330/.

Warhol, Andy. 1985. *America*. New York: Harper & Row.

CHAPTER 10

Alderson, Julia. 2011. "A Temple Next Door: The Thomas Kinkade Museum and Cultural Center." *Thomas Kinkade: The Artist in the Mall*, edited by Alexis L. Boylan, 165–90. Durham: Duke University Press.

Althusser, Louis. 1971. *Lenin and Philosophy and Other Essays*. London: New Left Books.

Benjamin, Walter. 1970. "The Work of Art in the Age of Mechanical Reproduction." In *Illuminations: Essays and Reflections*, edited by Hannah Arendt, translated by Harry Zahn, 219–53. London: Jonathan Cape.

Berger, John. 1972. *Ways of Seeing*. London: British Broadcasting Company and Penguin Books.

Bob Ross: The Happy Painter. 2011. DVD. Directed by Sherry Spradlin. Roanoke, VA: Blue Ridge PBS.

Boylan, Alexis L. 2011. Introduction to *Thomas Kinkade: The Artist in the Mall*, edited by Alexis L. Boylan, 1–28. Durham: Duke University Press.

Breslau, Karen. 2002. "Paint by Numbers." *Newsweek*, May 13, 48.

DeCarlo, Tessa. 1999. "Landscapes by the Carload: Art or Kitsch?" *New York Times*, November 7, AR51.

"Ethel (Redner) Scull (born 1921)." 2013. The J. Paul Getty Museum. Accessed January 25, http://www.getty.edu/art/gettyguide/artObjectDetails?artobj=133850.

Hughes, Robert. 2008. *The Mona Lisa Curse*. Documentary. Oxford Film & Television, September 18.

Jett, Cathy. 2006. "Virginia Kinkade Dealers Prevail in Arbitration." *Fredericksburg Freelance Star*, September 21, http://fredericksburg.com/News/FLS/2006/092006/09212006/220020/.

Marling, Karal Ann, Cameron Brooke, and Mark Pohlad. 2002. "Deconstruct This: Thomas Kinkade Paintings: Despite Elitist Gripes, He's America's Most Popular Artist." *Chronicle of Higher Education*, February 22, B4.

McElya, Micki. 2011. "Painter of the Right." In *Thomas Kinkade: The Artist in the Mall*, edited by Alexis L. Boylan, 54–80. Durham: Duke University Press.

Orlean, Susan. 2001. "Art for Everybody: How Thomas Kinkade Turned Painting into Big Business." *New Yorker*, October 15, http://archives.newyorker.com/?i=2001-10-15#folio=124.

"Part 3—Thomas Kinkade Prescott Event." 2009. YouTube video. Posted by Thomaskinkadetv, March 26, http://www.youtube.com/watch?v=eI7EvpXT5B0.

Pearson, Christopher E. M. 2011. "The Urbanism of Nostalgia." In *Thomas Kinkade: The Artist in the Mall*, edited by Alexis L. Boylan, 143–64. Durham: Duke University Press.

Safer, Morley. 2001. "Kinkade." *CBS 60 Minutes* video. Uploaded November 25, http://www.cbsnews.com/video/watch/?id=7380252n.

Stanley, Thomas J. 2001. *The Millionaire Mind*. New York: Andrews McMeel Publishing.

———. 2011. *Stop Acting Rich and Start Living like a Real Millionaire*. New York: Wiley.

"Table 75. Self-Described Religious Identification of Adult Population: 1990, 2001, and 2008." 2013. United States Census Bureau. Accessed January 25, http://www.census.gov/compendia/statab/2012/tables/12s0075.pdf.

"Thomas Kinkade Fraud—What You Should Know before Purchasing." 2011. Thomas Kinkade Signature Gallery (blog). April 13, http://www.thomaskinkadeonline.com/blog/2011/04/13/thomas-kinkade-fraud/.

"Thomas Kinkade—Art Techniques inside Ivy Gate Studio." 2012. YouTube video. Posted by Thomas Kinkade, November 5, http://www.youtube.com/watch?v=PAA7VeTa2js.

"Thomas Kinkade's Death Launches Dispute over Legacy." 2012. YouTube video. Posted by CBSNewsOnline, August 20, http://www.youtube.com/watch?v=loWLMmcQBro.

Warhol, Andy. 1977. *The Philosophy of Andy Warhol (From A to B and Back Again)*. New York: Mariner Books.

Wozniak, June. 2012. Phone conversation with Kristin G. Congdon, November 13.

CHAPTER 11

Bourriaud, Nicolas. 2002. *Relational Aesthetics*. Dijon, France: Les presses du reel. Originally published in French in 1998.

Cembalest, Robin. 2011. "It's Not Just a Museum, It's a Think Tank." *Artnews* 110 (7): 44–45.

Earhart, Nick. 2011. "Om Is Where the Art Is." *Artnews* 110 (9): 34.

Gablik, Suzi. 1991. *The Reenchantment of Art*. New York: Thames and Hudson.

Gauntlett, David. 2011. *Making Is Connecting*. Malden, MA: Polity Press.

Hansen, Gregory. 2012. "Pranking and Tall Tale Telling within Florida's Old-Time Fiddling Tradition." In *Routes and Roots: Fiddle and Dance Studies from around North Atlantic*, edited by Ian Russell and Chris Goertzen, 51–72. Aberdeen: Elphinstone Institute, University of Aberdeen.

Hirsch, Faye. 2011. "Passport, Please." *Art in America*, no. 6 (June/July): 79–83.

Kennedy, Randy. 2010. "Unlocking New York, One Date at a Time." *New York Times*, June 24, C1, C6.

Landi, Ann. 2011. "The Jokes on Us." *Artnews* 110 (11): 92–95.

Litt, Steven. 2010. "Please Touch: At the Indianapolis Museum's New Art Park, Play's the Thing." *Artnews* 109 (6): 54.

Lubow, Arthur. 2010. "Live Sculptures? Conceptual Encounters: Tino Sehgal Makes Art that Leaves behind No Trace: The Immaterialist." *New York Times Magazine*, January 17, 25–28.

McGrath, Charles. 2010. "In Canada, an Artwork with Its Own Barkeeps." *New York Times*, February 22, C1, C6.

Rosenberg, Karen. 2010. "Inspired by Wishes, Memories, Dirty Shoes." *New York Times*, June 25, C21, C24.

Scholz, Trebor. 2005. "New-Media Art Education and Its Discontents." *Art Journal* 64 (1): 95–108.

Sholette, Gregory. 2003. "I Am NOT My Office." *Art Journal* 62 (2): 82–87.

Silvers, Anita. 1976. "The Artwork Discarded." *Journal of Aesthetics and Art Criticism* 34, 441–54.

Smith, Moira. 1996. "Prank." In *American Folklore: An Encyclopedia*, edited by Jan Harold Brunvand, 587–89. New York: Garland.

Smith, Roberta. 2010. "Art? Life? Must We Choose?" *New York Times*, July 2, C19, C23.

Smith, Roberta, and Nate Chinen. 2010. "Are They Installations with Sound or Graffiti with Music? Yes!" *New York Times*, July 24, C1, C3.

Spence, Rachel. 2011. "Just Höller." *London Financial Times*, December 18, Life and Art, 16.

Stankowicz, Tom, and Marie Jackson. 1996. *The Museum of Bad Art: Art Too Bad to Be Ignored*. Needham, MA: Backyard Computing,.

Stickley, Gustav. 1901–1916. *The Craftsman* (British magazine).

Wilson, Scott. 1996. Introduction to *The Museum of Bad Art: Art Too Bad to Be Ignored*, by Tom Stankowicz and Marie Jackson, vii–viii. Needham, MA: Backyard Computing.

CHAPTER 12

Benjamin, Walter. 1970. "The Work of Art in the Age of Mechanical Reproduction." In *Illuminations: Essays and Reflections*, edited by Hannah Arendt, translated by Harry Zahn, 219–53. London: Jonathan Cape.

Bob Ross: The Happy Painter. 2011. DVD. Directed by Sherry Spradlin. Roanoke, VA: Blue Ridge PBS.

Brzyski, Anna. 2011. "Art Ethics." In *Thomas Kinkade: The Artist in the Mall*, edited by Alexis L. Boylan, 238–58. Durham: Duke University Press.

Byrne, Rhonda. 2006. *The Secret*. New York: Atria Books.

Heffernan, Virginia. 2009. "The Susan Boyle Experience." *New York Times Experience*, June 28, 16–17.

Hyde, Lewis. 1979. *The Gift: Creativity and the Artist in the Modern World*. New York: Vintage Books.

Ngai, Sianne. 2012. *Our Aesthetic Categories: Zany, Cute, Interesting*. Cambridge, MA: Harvard University Press.

ABOUT THE IMAGES

You know, it's harder than it looks. Sitting down to paint a few land-scapes for this book, I remembered how it was to have the kit, the brush-es, the comforting voice on the screen, and to still be deathly afraid of messing up. After years of painting, after earning an MFA and teaching art to little ones for years, I have forgotten what it feels like to choke—to want something magical to happen but to also be afraid that it won't.

Weirdly enough, that's what makes Bob Ross inimitable. He's got a practiced confidence that actually is unique and impressive. My brushes barely eked out the right shapes for trees. I found myself breathless and frustrated and totally worried. I was working against a deadline, covered in oil paint, and truly unsure if I was making a Bob or just a blob.

People critique the paintings; and anything this bright, this idealized, and so overfull with gradients is bound to feel saccharine. But I respect the paintings even more now after trying to copy them. People think Bob didn't grow, and so I chose two of his more complicated paintings, from the end of his TV series, to show just how much he could do in thirty minutes. Both of these pictures have a subtly balanced, asymmetrical composition, wonderful tonality and atmospheric depth, and a kind of monochromatic nuance. After I completed them I truly did feel proud. Beyond intellectual understanding, I got it.

If painting Bob's work was a bit like being young again, then making the illustrations for the book was like being a teenager, going through the Louvre, and doodling beards and Afros on all my favorite paintings. It only seemed fitting for a book like this to continue the copying motif and inject Bob's iconic face into some of the Art World's greatest hits.

I was surprised by some of the connections that emerged. Bob as a Buddha drops his hand in a mudra called "Calling the Earth to Wit-ness" even as the buttons on his shirt align with his chakras. Leonardo

da Vinci's sinuous, smoky *Mona Lisa* exudes a sexual fluidity that echoes Bob's softness and charm. And Paleolithic Bob floats with a grace and childlike simplicity that made me think of the magic and joy that comes with inhabiting our own, invented worlds as kids. Even in crafting a conceptual portrait of Bob with definitions from *Urban Dictionary* and *Merriam Webster*, I saw connections between a bob as a haircut, an act of lightly tapping, and an everyman. Ross, by definition, is even better: "awesome to the max."

Each drawing is matched with a chapter to further those connections. Georges Seurat's fuzzy, impressionistic drawing style seems perfectly suited to a discussion of Thomas Kinkade. Turning Bob into a portrait with the gridded technique made me think of Chuck Close, counted cross-stitch, and jpegs. I put it with the network chapter accordingly. To avoid copyright infringement of the intellectual property protected by Bob Ross, Inc., I turned to the Internet frequently to find other people's portraits of Bob. Using their art as source material, I was happy to see how many versions of Bob are out there in cyberspace. He truly lives on.

Along those lines, for the chapter on Bob's legacy, I made a simple drawing of Bob while watching one of his shows. The technique I chose—which I use in all my own artwork—is called blind contour. Artists learn it in drawing 101 and it consists of drawing a single, uninterrupted line without looking at the paper. It's meditative and deeply connecting and simple. It's Bob-like. Staring into his eyes as he talked was trippy and beautiful and only confirms my love for him. For you, I hope these pictures help you laugh, wonder, and connect with Bob as well.

As for me, it's snowing outside. A big blizzard has just hit Brooklyn. As soon as these are finished I am going to tug on a coat and some sturdy shoes and go stomp around the park. Dendritic tree limbs will look like little veins, lightning, or river deltas. Birds will shape themselves into letter *M*'s and *S*'s and patches of ground will be covered in their own brilliant coats of "magic white." All along, Bob's voice will still be hanging in my head, gently pointing out all that beauty and grace.

As an artist, he got me painting. But what I love most about Bob now is how he makes me want to stop painting, put down my brush, get out in the world, and just notice.

Danny Coeyman
February 12, 2013

ABOUT THE AUTHORS

Kristin G. Congdon is Professor Emerita of Philosophy and Humanities at the University of Central Florida. She has published extensively on folk art, community art, and feminism in an effort to celebrate artists who have had little visibility in the art world. Her authored or coauthored books include *American Folk Art: A Regional Reference* (2012), *Just Above the Water: Florida Folk Art* (2006), and *Community Art in Action* (2004). She has also been senior editor of *Studies in Art Education* and *The Journal for Research in Art Education* and is a principal co-investigator of ChinaVine, an interdisciplinary project that documents China's cultural heritage.

Doug Blandy is a professor and senior vice provost for Academic Affairs at the University of Oregon. His research and teaching address art education experiences in community-based settings that meet the needs of all students within a lifelong learning context. His research and teaching also concentrate on the relationship between art, education, gender, community, and place. Blandy's research has been published in *Studies in Art Education* and *Art Education*, among other journals in the field. He has coedited five anthologies addressing topics in art education. Blandy is principle co-investigator of ChinaVine, a primarily web-based project associated with interpreting China's cultural heritage.

Daniel Coeyman uses art to connect with people. For over a decade, he has painted friends, family, and lovers with unflinching honesty and tenderness. His work explores how portraits help people become naked and feel real today. As an educator, storyteller, and collaborator, he seeks to celebrate "bruised fruits"—people who feel unaccepted or unlovable—and champions the truth that fully accepting and loving one's humanity is both profoundly beautiful and hard. He earned his MFA from Parsons, The New School for Design, in 2006 after receiving a Jack Kent Cooke Fellowship and lives in Brooklyn beside a park full of happy trees.

INDEX